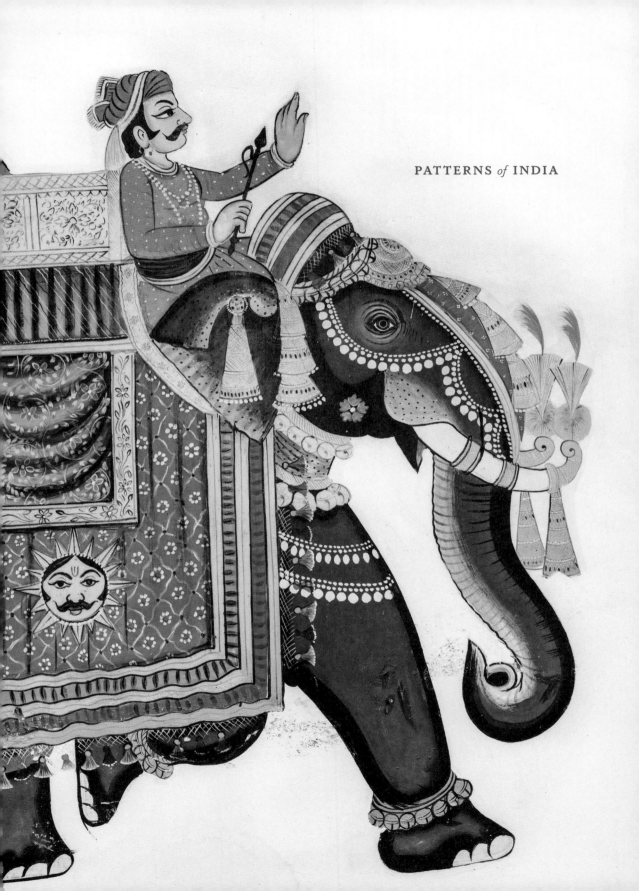

PATTERNS *of* INDIA

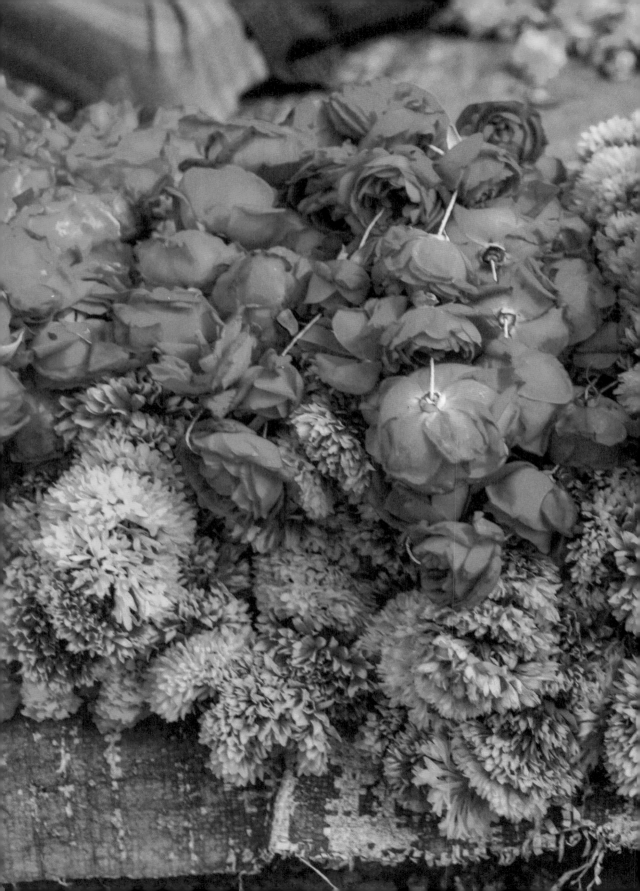

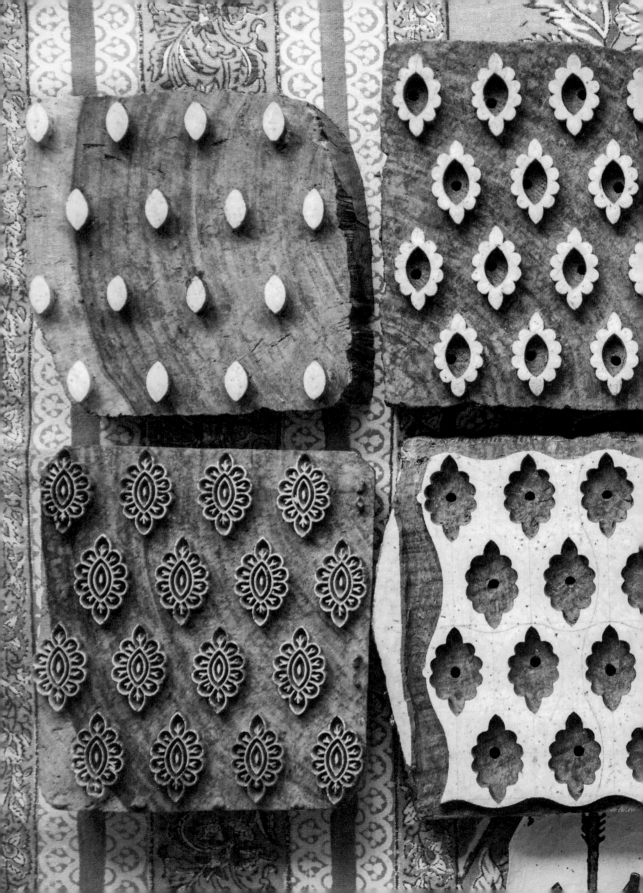

CHRISTINE CHITNIS

PATTERNS of INDIA

A JOURNEY THROUGH
COLORS, TEXTILES & *the* VIBRANCY
of RAJASTHAN

CLARKSON POTTER/PUBLISHERS

New York

Published in the United States by Clarkson Potter/ Publishers, an imprint of Random House, a division of Penguin Random House LLC, New York. clarksonpotter.com

CLARKSON POTTER is a trademark and POTTER with colophon is a registered trademark of Penguin Random House LLC.

Author's Note: I believe in asking for permission before taking a portrait. Certain cultures have strong feelings about what it means to have a picture taken. Individuals in this book who appear in a portrait—meaning they are clearly the subject of the photograph—were asked for their consent. I do my best to always photograph from a place of respect and cultural awareness.

Library of Congress Cataloging-in-Publication Data

Names: Chitnis, Christine, author.

Title: Patterns of india : a journey through colors, textiles, and the vibrancy of Rajasthan / Christine Chitnis.

Description: New York : Clarkson Potter, Publishers, [2020]

Identifiers: LCCN 2019010900 (print) | LCCN 2019011864 (ebook) | ISBN 9780525577102 (ebook) | ISBN 9780525577096 (hardcover)

Subjects: LCSH: Textile fabrics—India—Pictorial works. | Textile fabrics—India—Rajasthan—Pictorial works. | Rajasthan (India)—Pictorial works.

Classification: LCC TS1403 (ebook) | LCC TS1403 .C45 2020 (print) | DDC 677.00954/4--dc23

LC record available at https://lccn.loc.gov/2019010900

ISBN 978-0-525-57709-6
Ebook ISBN 978-0-525-57710-2

Printed in China

Book design by Mia Johnson
Cover photography by Christine Chitnis

10 9 8 7 6 5

First Edition

FOR VIJAY, VIKRAM & MEERA
with ALL MY LOVE

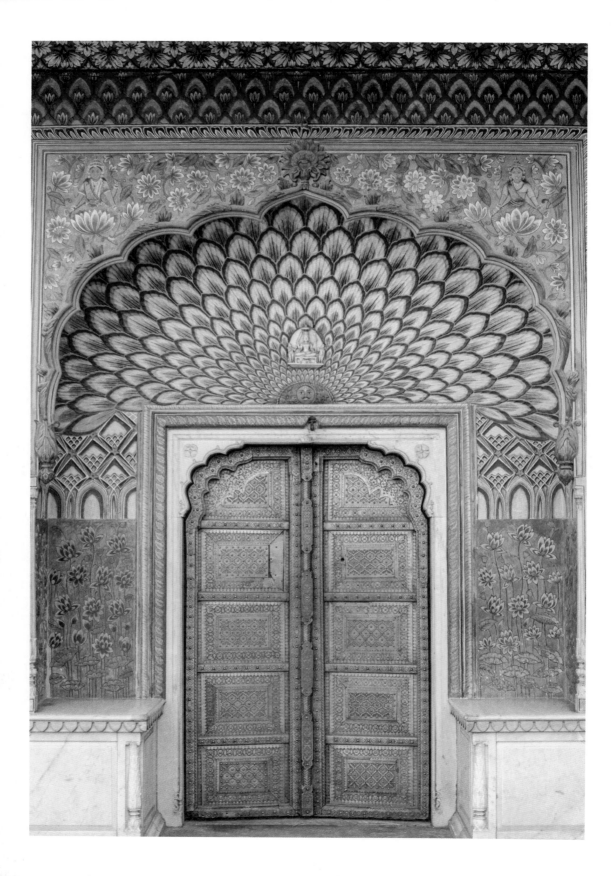

CONTENTS

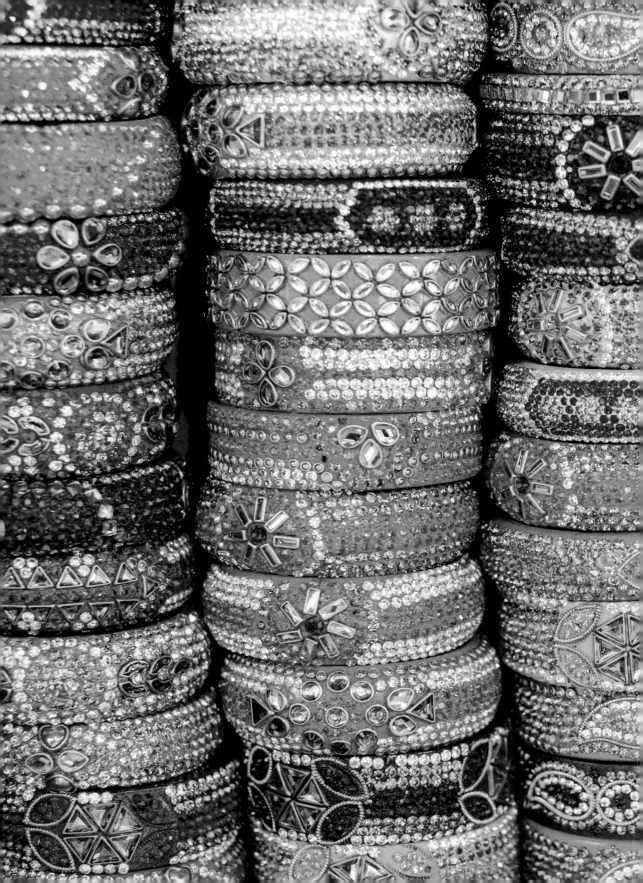

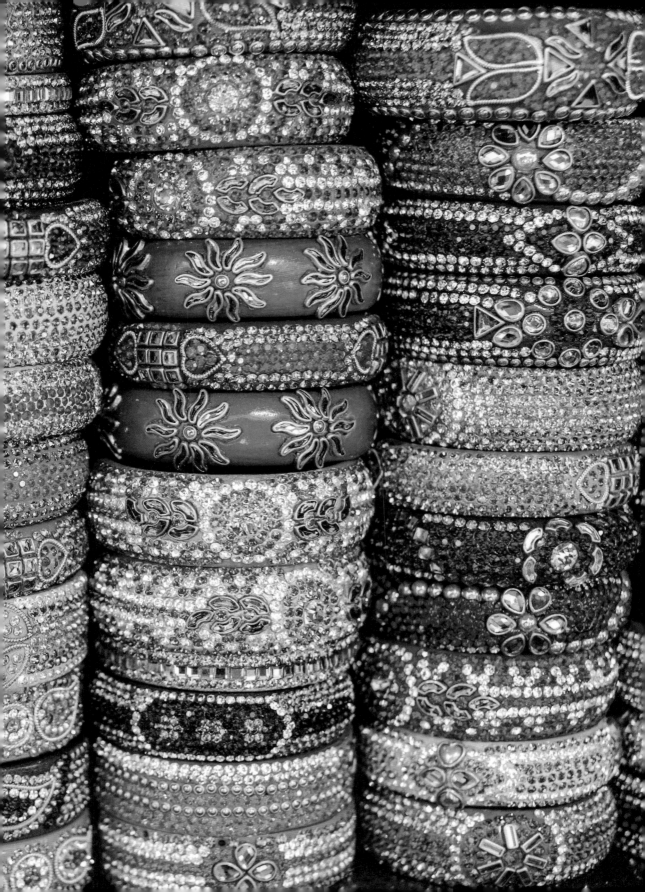

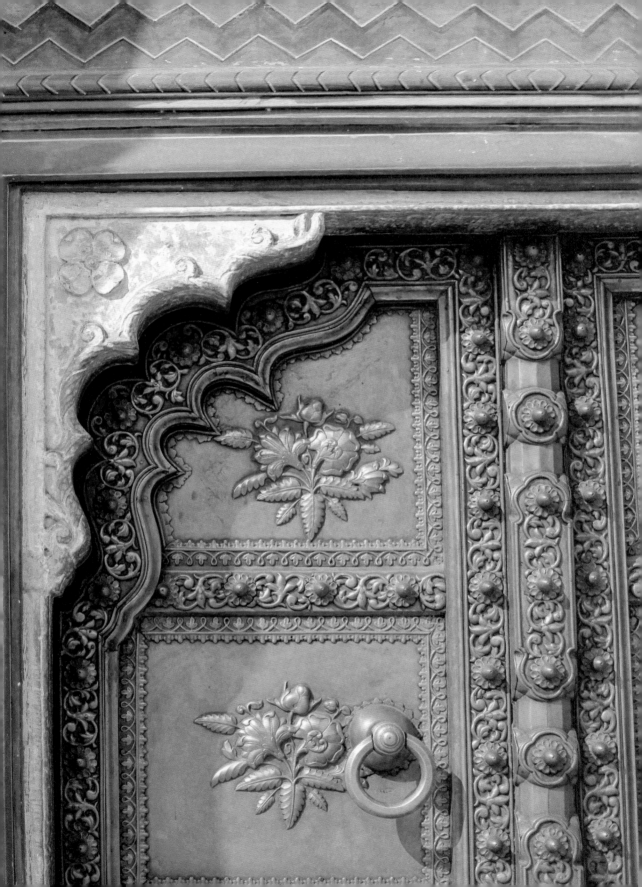

FOREWORD

———•———

 n *Patterns of India*, Christine Chitnis explores Rajasthan while
taking us on a visual journey using color and pattern as a narrative.
In its essence this collection of photographs, coupled with
Christine's deep emotional connection to India, embodies a broad
spectrum of experiences.

Rajasthan, a state imbued with opulence and royalty, has a colorful
and romantic heritage. This is reflected in the magnificent architecture
of its palaces and forts, in the legendary exploits of its heroes, in the
powerful rhythms of its music and dance, and in the vitality of its craft

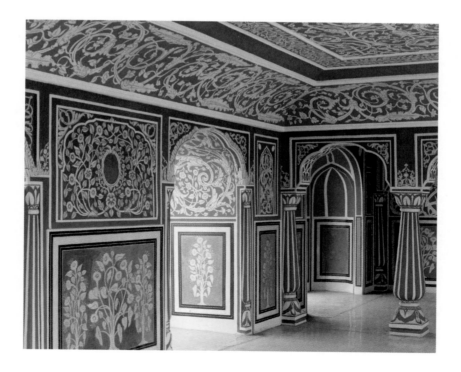

traditions, the aesthetics of which are echoed in the dress of the people, which display vibrant hues and richly patterned details. As a professor of fashion and textiles, I have spent years studying the connection between color and pattern with special reference to Rajasthan. Many of the visuals in the book are everyday sights and presented here through the lens of these two elements.

Color, which is used to link the diverse culture and people of the region, conveys moods, seasons, customs, and ceremonial occasions. The vibrant red in Rajasthan, favored for its auspiciousness, is seen widely in women's dress, men's turbans, and the flag of the temples. It is used widely as a color for wedding rituals and religious ceremonies and denotes happiness and well-being. Saffron, traditionally donned by Rajput warriors defending their lands on the battlefield, is a color associated with valor. A profusion of yellows and oranges are used to celebrate the Indian New Year and during festivals such as Gangaur, one of Rajasthan's most important festivals, which celebrates love, marriage, and devotion to the goddess Gauri. Pastel colors add coolness to the seething hot summer months, while green welcomes the lush monsoon season.

Patterns provide context to the colors and communicate stories, which may be explicit or tacit. The compositions use floral, foliage, birds, animals, and geometric patterns. These are varied in their inspirations and mirror political, social, and cultural scenarios of different time periods. While every color is imbued with meaning, it is often within the details of the pattern that the full story comes to light.

Whether you are from India or you want to travel there, this book presents Rajasthan as an authentic experience, which I am sure you will treasure.

DR. VANDANA BHANDARI

Professor, National Institute of Fashion Technology, New Delhi, and author of *Costumes, Textiles and Jewellery of India: Traditions in Rajasthan*

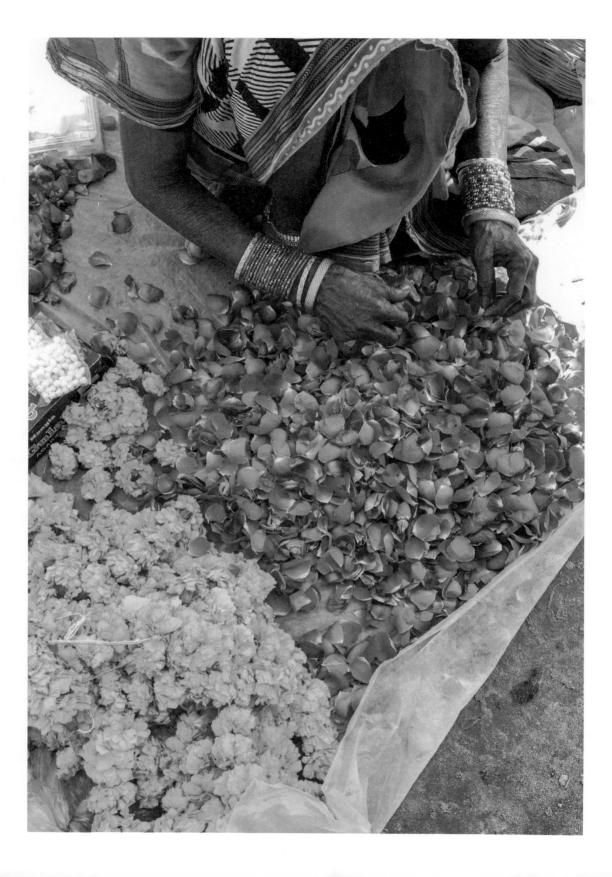

INTRODUCTION

———•———

While it is impossible to encapsulate a country as vast and culturally diverse as India, there is a tie that binds, weaving from the pink-tinged architecture of Jaipur to the shimmering Golden City of Jaisalmer. Color—in rich, vibrant hues—defines every aspect of life in India, be it religion, politics, food, art, or dress. As a photographer, I was instantly drawn to its unique color wheel and especially intrigued by the way the same hues seem to echo throughout the country. The fuchsia draping fabric of a sari matches the vibrant chains of rose offerings at the *mandir* (Hindu temple). Burnt-orange towers of spices in the marketplace are reflected in baskets of marigolds lining flower stalls. A field of dyed indigo fabric drying in the desert heat resonates with the brightly painted blue buildings of Jodhpur. Color and pattern exist in a symbiotic relationship. Pattern, when it is applied with detail and precision, can convey meaning and tell a story. Decorative motifs range from simple compositions of dots, lines, rings, and geometric patterns to more complex and meaningful designs that include elements drawn from village life and religious texts. This dynamic combination of color and pattern is most striking in the vibrant northwestern region of Rajasthan, India's largest state.

Prior to India gaining independence from Great Britain in 1947, Rajasthan (Land of Kings) was a region comprising more than twenty princely states, a feudalist desert stronghold of royal affluence. The Rajputs, who rose to prominence in the area as early as the seventh century AD, were fierce warriors and zealously independent Hindus, and they successfully fended off waves of foreign invaders. When the imperial power in neighboring Delhi shifted in the sixteenth century to Akbar, the powerful Mughal sovereign who would gradually enlarge his empire to include nearly the

← A woman prepares rose petals and marigold blooms for offerings.

entire northern Indian subcontinent, many Rajput rulers formed military and marital alliances with him. By acknowledging Akbar as emperor, they were allowed to retain their ancestral territories. The era of stability and creativity that followed this fusion of Rajput and Mughal heritage, coupled with growing wealth and consistent court patronage, had a great impact on, and is reflected in, Rajasthan's art and architecture: floral and organic patterns, wall paintings, and fluted pillars are trademarks of the Rajput style; stone inlay filigree, mirror-glass mosaic work, geometrical patterns, and the use of arches and domes speak to the Mughal influence.

Rajasthan is home to many of India's famous landmarks; featured in this book are the Hawa Mahal, the Jaipur City Palace, the Amer Fort, the Mehrangarh Fort, the Umaid Bhawan Palace, and the Udaipur City Palace. Despite its bustling, modern cities and royal grandeur, more than 80 percent of its people live in rural areas and make their living through agriculture or livestock herding. Not far from the cities are villages seemingly untouched by modern times, where traditional arts and handicrafts, such as hand block printing, embroidery, and weaving, are kept alive.

My own travels through India have been deeply influenced by my husband Vijay's familial connection to the country. Mangalore, a port city in the southwestern state of Karnataka, was home to Vijay's mother's family; his father's family was from Kolhapur on the banks of the Panchganga River in the western state of Maharashtra. Both of his parents were raised in Bombay, but they spoke different languages and were raised with different religions— his Hindu father spoke Marathi and his Catholic mother spoke Konkani. Their common language was English. Soon after their marriage in 1964, they immigrated to England and then to Canada, where my husband was born and raised. Vijay's parents didn't teach him about their homeland's languages, religions, or customs. Being raised in an immigrant family with no strong connection to his parents' history or culture, he felt a growing void as he tried to reconcile his upbringing as a minority in Canada with his Indian heritage. Searching for the missing pieces of his identity, he left home in his twenties and traveled to India. He settled in the northeastern state of Assam,

→ A woman bundled in bright layers to ward off the chilly morning air feeds her flock of goats in a village outside Udaipur.

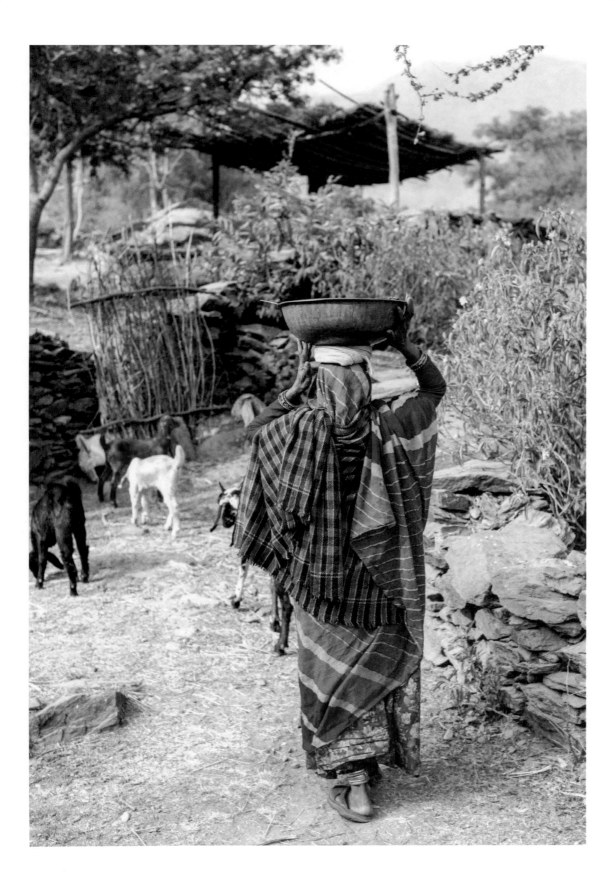

just south of the eastern Himalayas, and lived a simple, monastic life. He immersed himself in the languages and culture that had eluded him during his childhood: he learned to speak Hindi and Bengali, and began his study and practice of Hinduism. After nearly a decade in India, Vijay made his way back to Canada in 2001, and eventually to the United States, where we met, married, and started our family.

I traveled to India for the first time as a newlywed and have returned almost every year since: pregnant with my first son and, most recently, with my daughter; when my sons were toddlers and when they were school age. We are raising our children, Vijay, Vikram, and Meera, to be proud of their Indian heritage. They have had the privilege of exploring India and their ancestry with joyous hearts and adventurous spirits, while Vijay and I work to expand their cultural knowledge. My family enjoys sightseeing during our travels, visiting palaces, forts, and museums, but we spend the majority of our time experiencing everyday life in markets, temples, and friends' homes. This intimate perspective is what I hope to reflect in this collection. To be a traveler is to pay heightened attention to the ordinary, and that is what I strive to celebrate in my photography: the ordinary moments that feel extraordinary.

This photographic collection offers a glimpse into Rajasthan's rich use of color and pattern; it is not meant to be a comprehensive historical or cultural study of the region's arts and crafts and it would take many lifetimes to explore a country as vast as India. Indian art forms are complex and layered subjects. Because of the diversity of the population—across regional, geographical, and religious divides—there are myriad interpretations and representations of symbols and colors. But as I combed through my archives trying to choose photographs to include in this book, one thing became clear to me—very specific color stories were at play in Rajasthan, and patterns occupied a central role.

No matter where we live, our lives are filled with color and pattern, but as we move through the world at an increasingly frenzied pace, we often fail to notice them. I hope this collection reminds you to look for the beauty that surrounds you, whether it is in the form of a magnificent architectural feat or a humble household object.

SAND-STONE

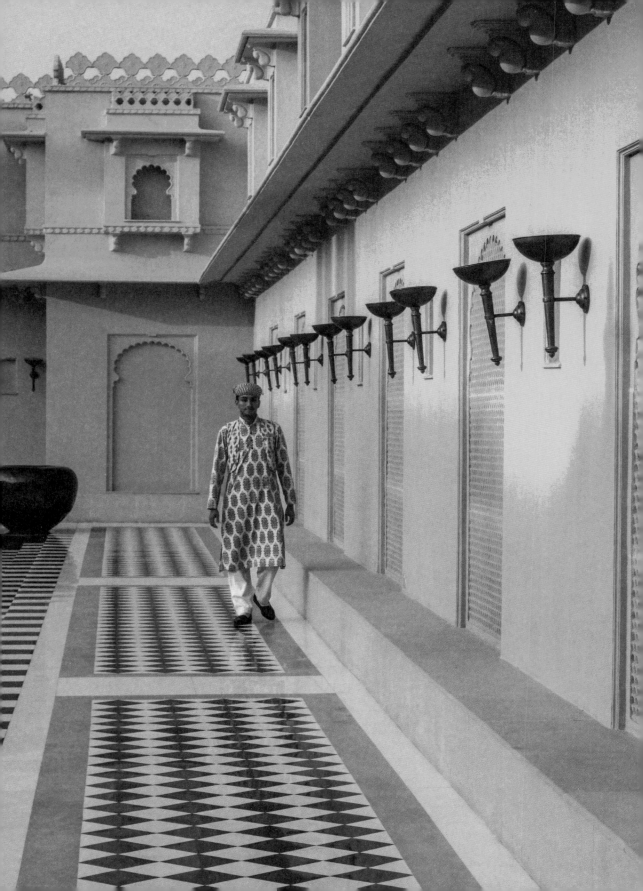

Rajasthan, a desert state, is proof that a range of inspiring hues can be found in the neutral family. Many of the majestic forts and palaces pay homage to the arid landscape with their sandstone and marble facades. Both the Mehrangarh Fort in Jodhpur, which looks to be carved from the very cliff upon which it sits, and the Lalgarh Palace in Bikaner, known for its intricate latticework, are resplendent in burnished red sandstone. Golden sandstone was used to build the Umaid Bhawan Palace, the residence of Jodhpur's former royal family, as well as a hotel. Jaipur is home to the Amer Fort and the Hawa Mahal, both constructed with red and pink sandstone. These palaces and forts offer a nearly unending supply of surface area ripe for embellishment; art, craft, and architecture seamlessly merge, and the whole becomes far greater than the sum of its parts. A palace with no decorative work—no paintings, no carved stonework, no mirror inlays— would be a lifeless shell. The surface ornamentations bring to life the story of the people who live within its walls.

Rajput wall paintings are found in nearly every palace across Rajasthan and often tell complex stories of battles fought, victories won, and marital alliances forged. The ancient paintings still adorning palace walls today are a testament to the early painters and dyers who used natural materials that have withstood the test of time and exposure to the elements. Until the dawn of chemical-based paints in the nineteenth century, artisans used pigments from plant and mineral sources that they ground and mixed themselves.

Because Rajasthan is a land rich with granite, marble, slate, quartz, sandstone, and other natural minerals, stone carving has a long history in the region, and most palaces sport intricately carved lattice screens with geometric ornamental patterns called *jalis*. Offering protection from the harsh desert sun, while still allowing for the flow of fresh air, *jalis* also maintain the privacy of women in purdah. Practiced by Hindus and Muslims, purdah is both a social and a religious practice of secluding a woman, either by physical separation or by clothing that conceals her form and covers her skin. The Hawa Mahal (Palace of Breeze) was constructed for this very

← One of the most luxurious hotels in the world, the Oberoi Udaivilas in Udaipur is modeled after a traditional Indian palace.

purpose, so that the ladies of the royal court could watch the goings-on in the streets below while remaining unseen behind the delicately carved *jalis*.

Just as a sandstone fort offers a neutral canvas to decorate with colors and patterns, the parched desert landscape of Rajasthan offers an achromatic backdrop that allows the vibrant towns and villages to shine. The Rajasthani people's desire to embellish their surroundings can be seen in everything from the sacred cattle with their brightly painted horns to delivery trucks that are often so festooned with paintings, garlands, and tassels you might be left wondering if the driver can safely see the road.

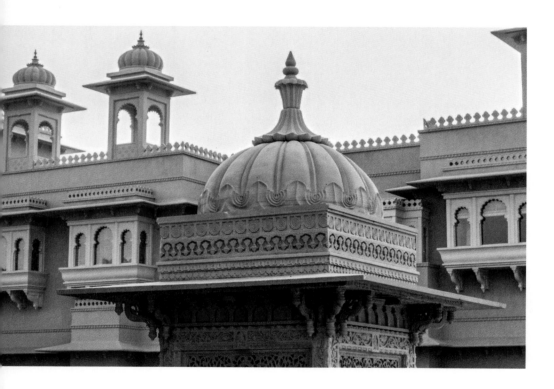

↑ Rooftop turrets offer stunning views of Lake Pichola and the fifty-acre waterfront property of the Oberoi Udaivilas.

→ An example of *jalis* (latticed screens), seen at the Mehrangarh Fort.

⟶ These arches, located in the second courtyard of the Amer Fort, sit upon a colonnade, or rows of columns.

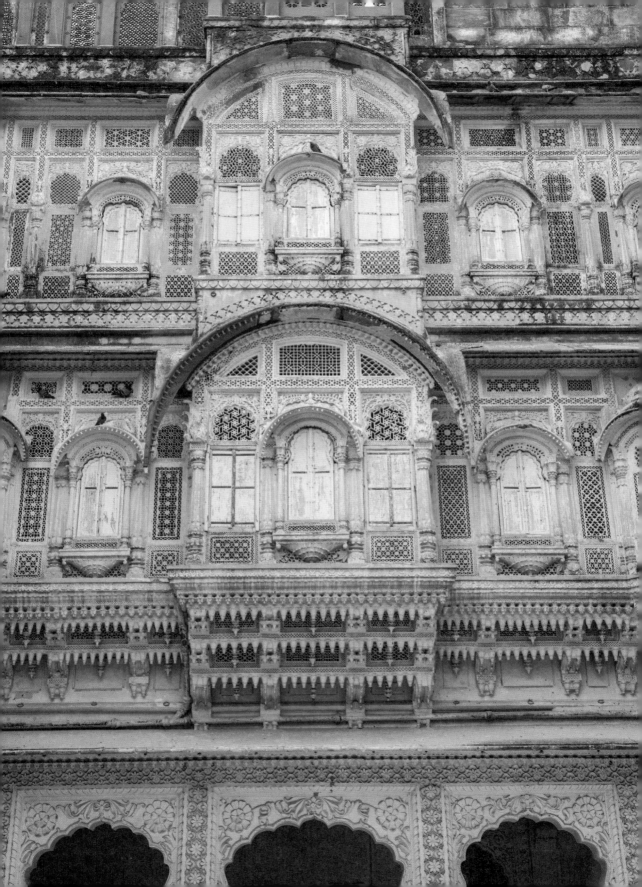

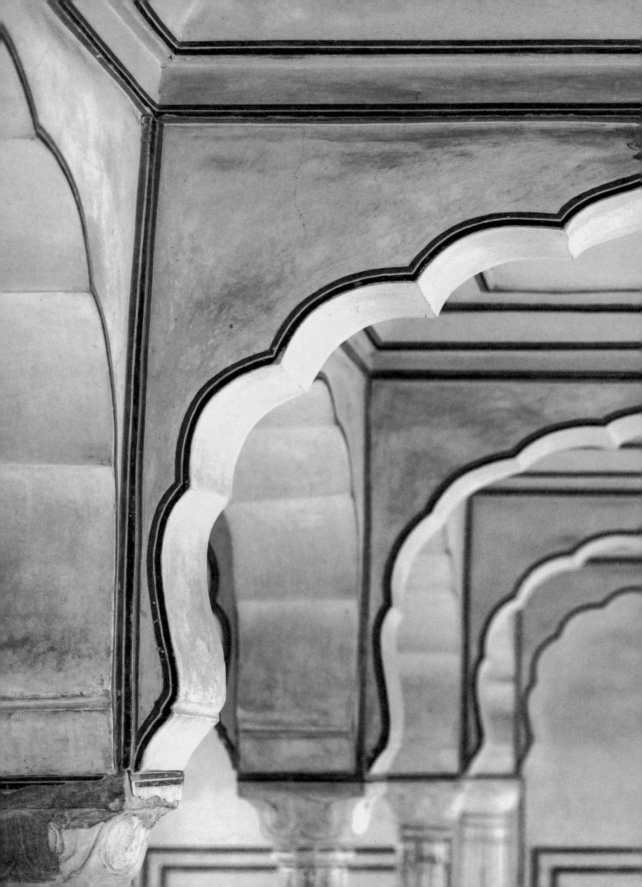

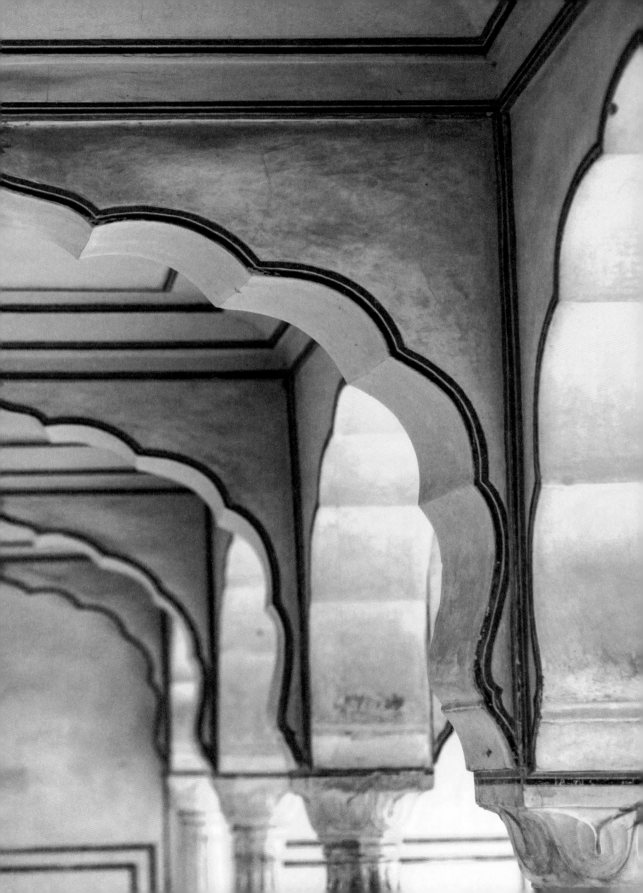

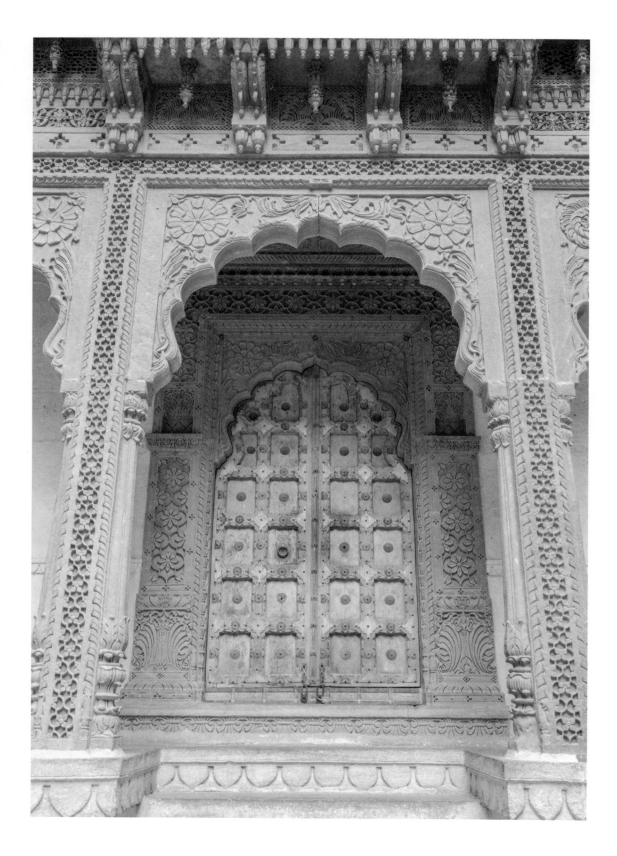

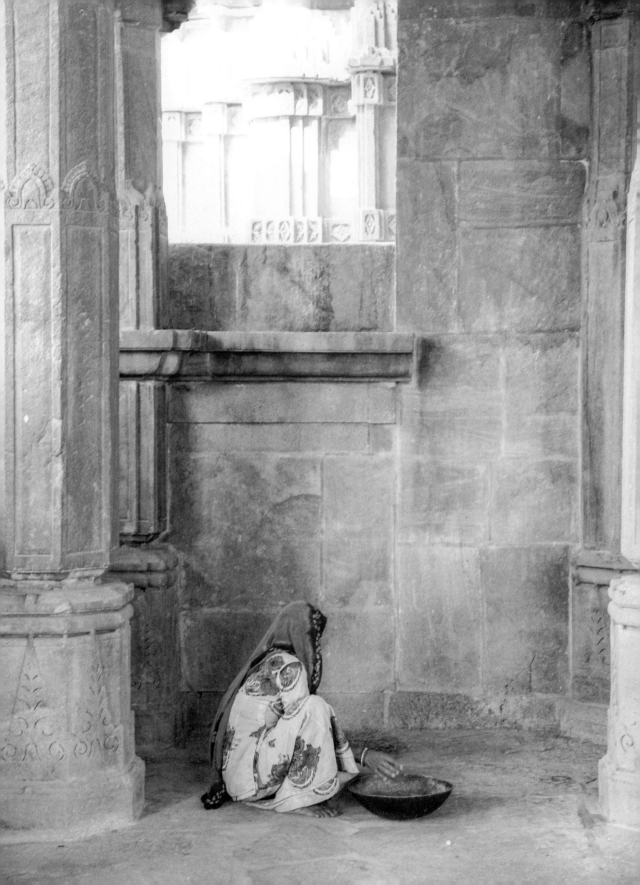

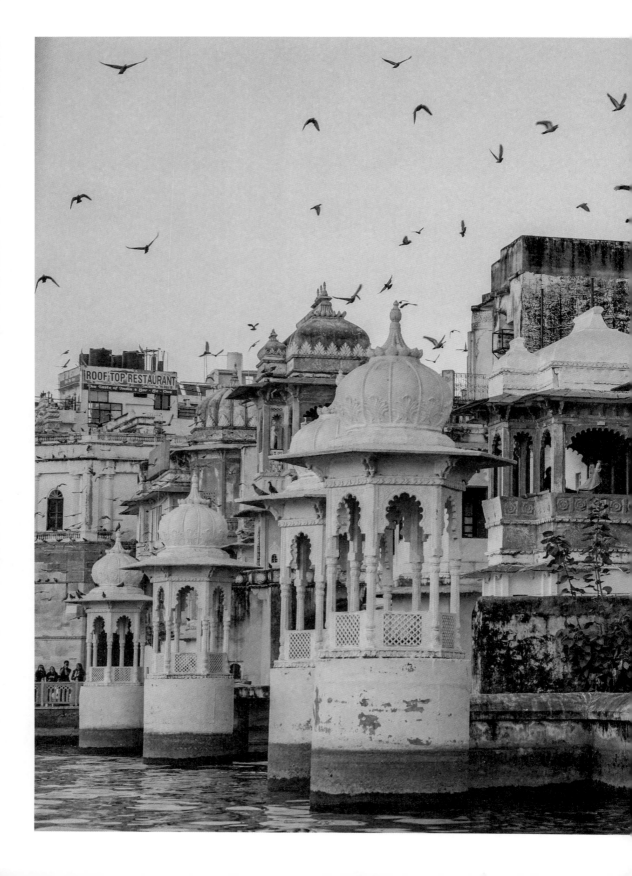

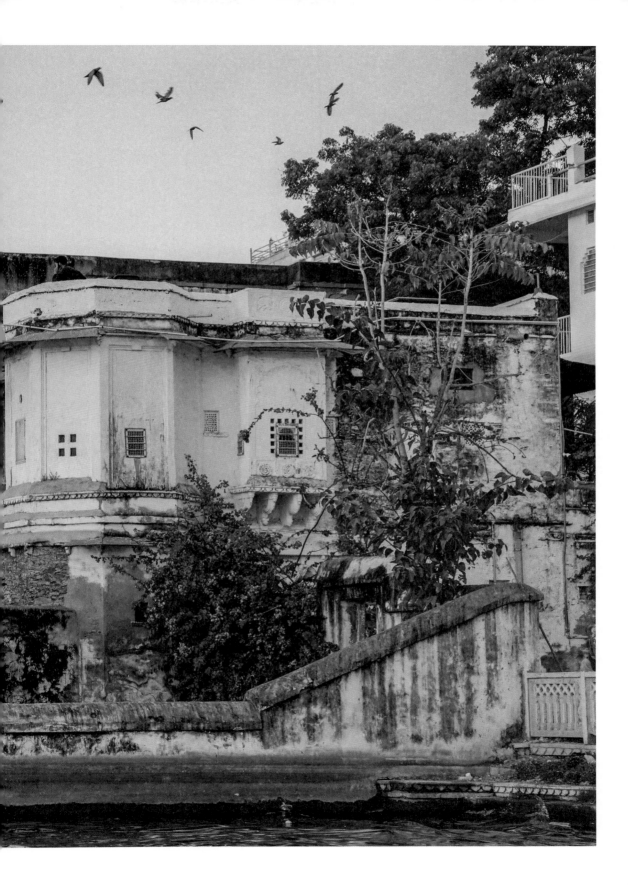

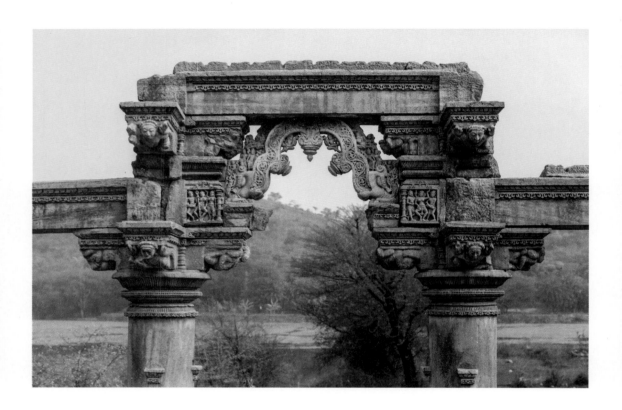

p. 30 An ornately carved red sandstone doorway at the Mehrangarh Fort.

p. 31 A woman sweeps the grounds at Mandore Gardens, a lush park in the ancient, now-abandoned town of Mandore, a few miles from Jodhpur.

⟵ The sandstone-toned shores of Udaipur, which is known as the City of Lakes, rise from the waters of Lake Pichola.

↑ → Located a short drive from Udaipur, the remains of the Sahasra Bahu temples, which were built in the early tenth century AD, are a testament to the artistry of that time period, despite their current state of ruin.

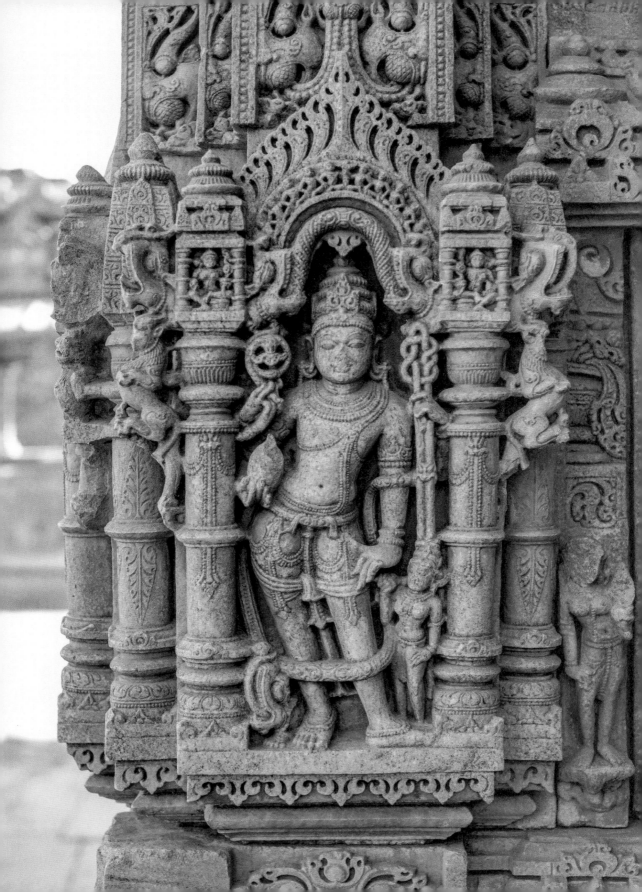

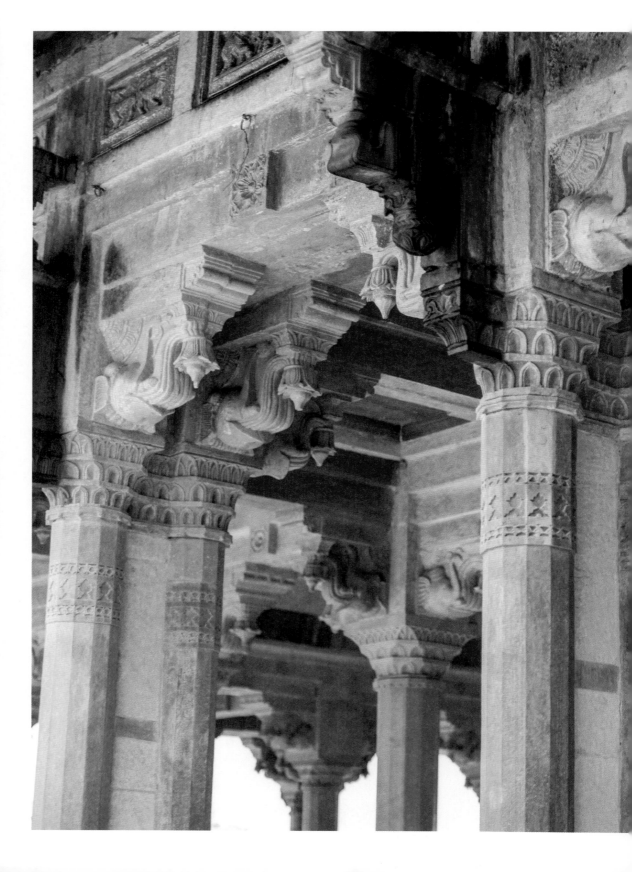

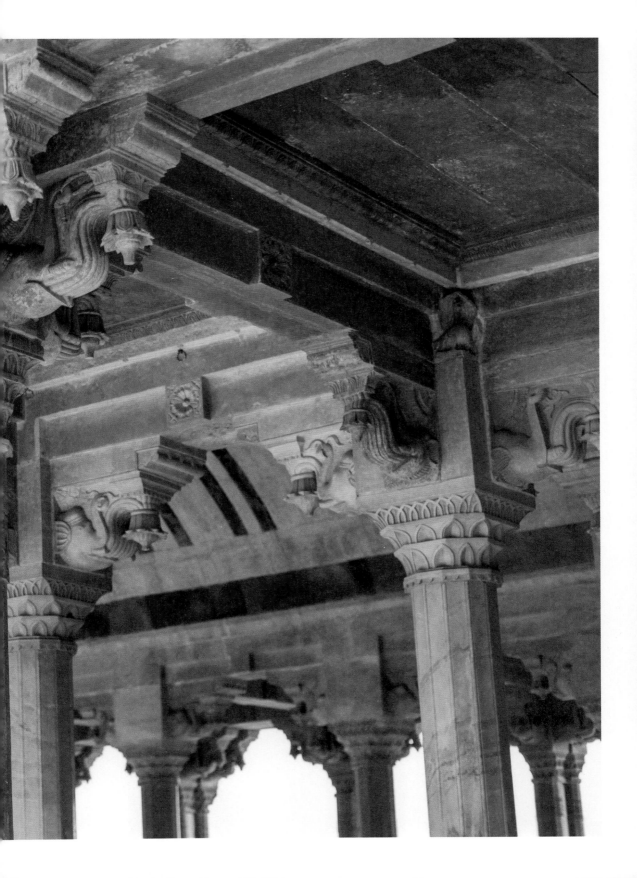

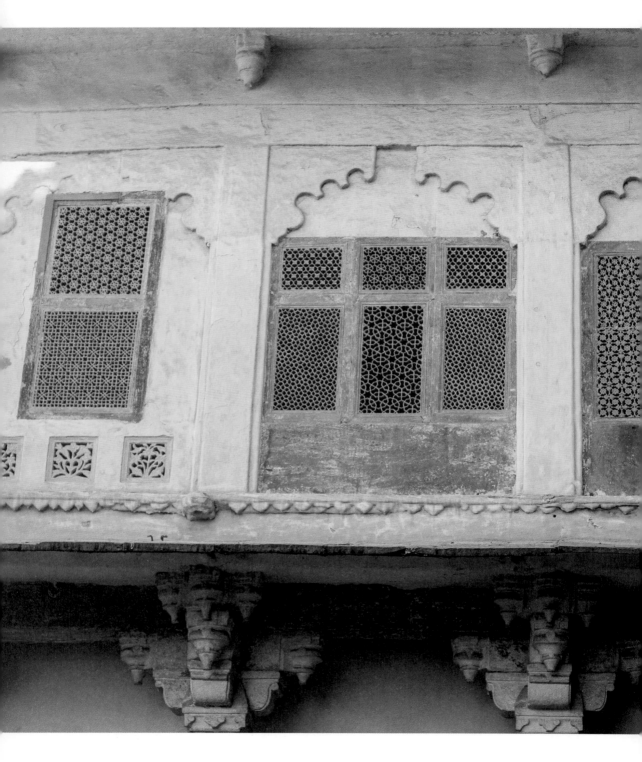

←—— In the Diwan-i-Aam (Hall of Public Audience) carved marble and sandstone pillars draw the eye upward to repeating ornamental elephant heads.

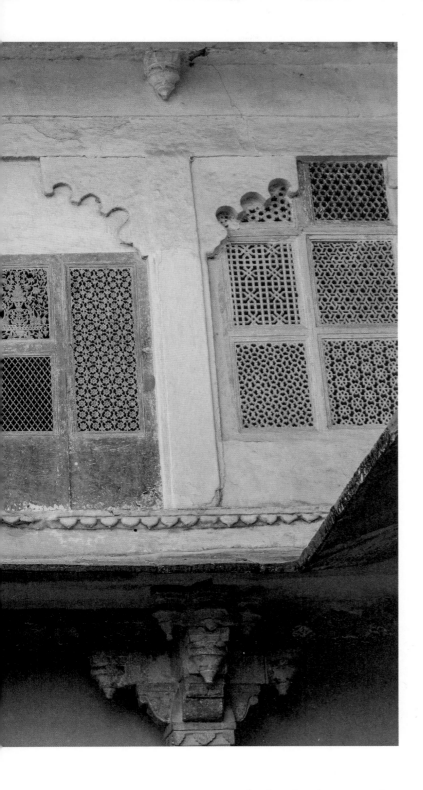

↑ *Jalis* at the Udaipur City Palace.

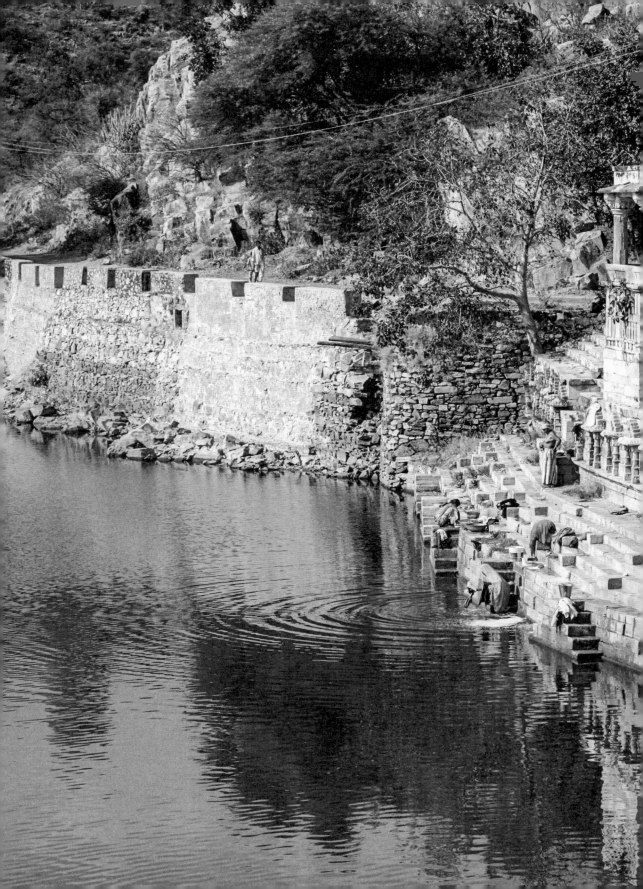

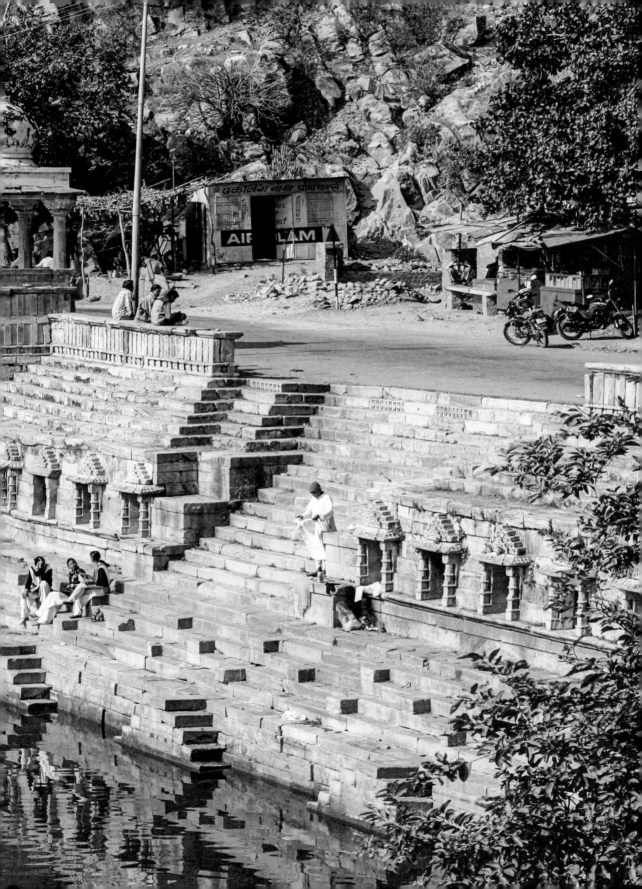

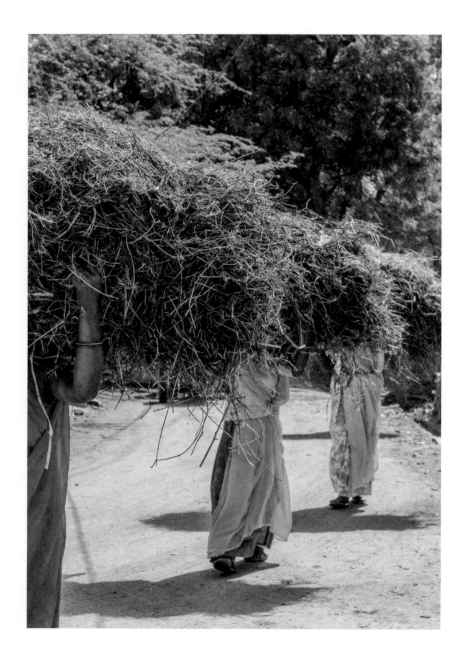

←——— A ghat, or flight of stairs leading to water, allows local
villagers easy access to the lake.

↑ → Scenes from rural Rajasthan: women carry large bundles
of hay atop their heads; a sacred cow with painted horns.

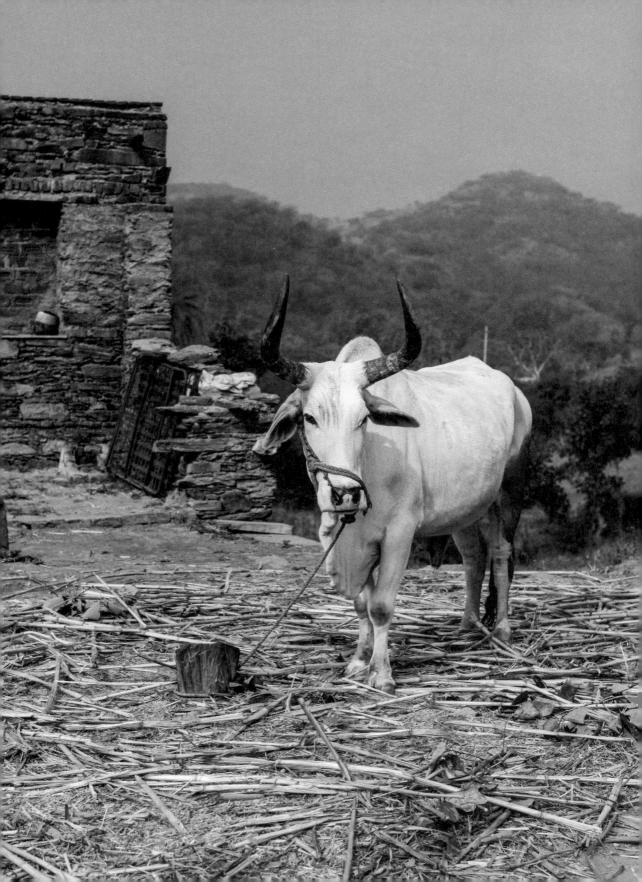

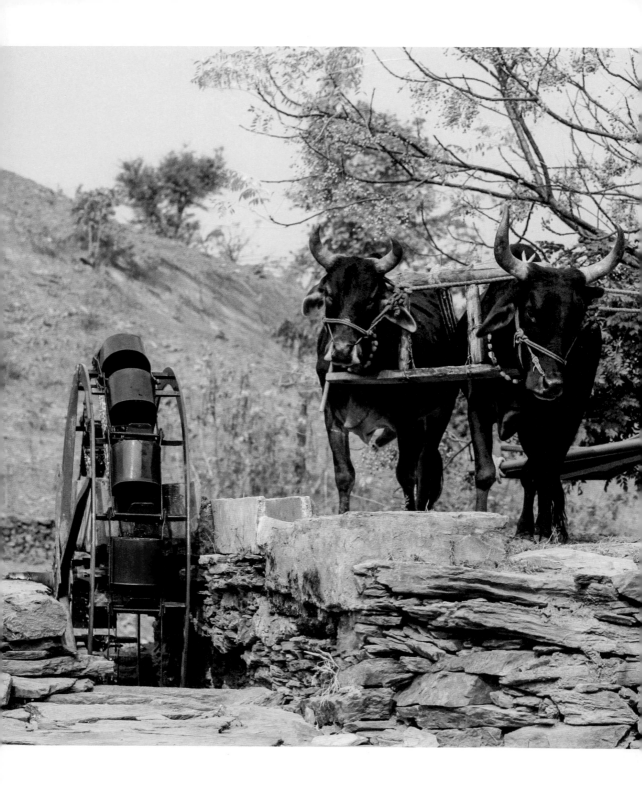

↑ A cattle-powered irrigation system in rural Rajasthan.

→ The streets of Jaipur bustle with activity as vendors
haul their dry goods to market and set up shop.

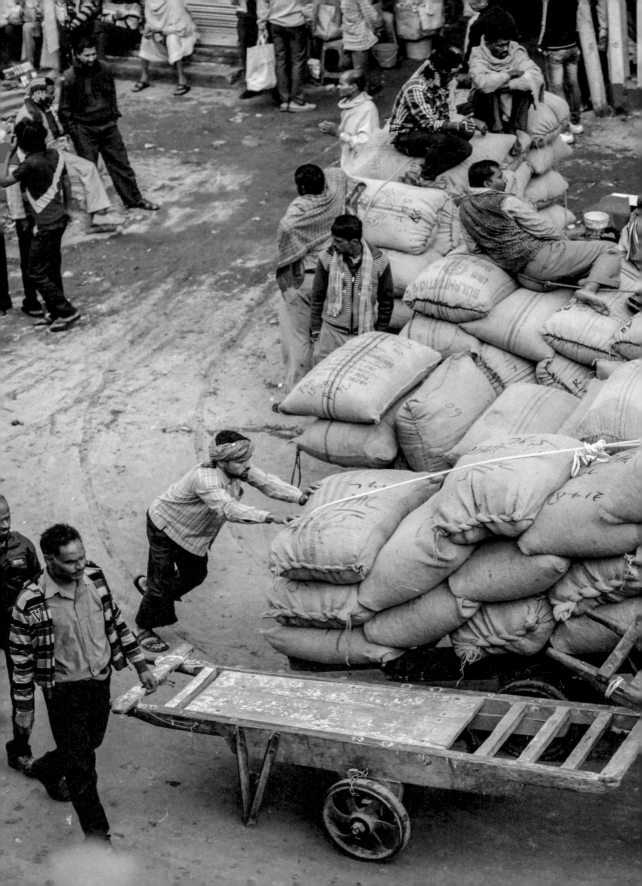

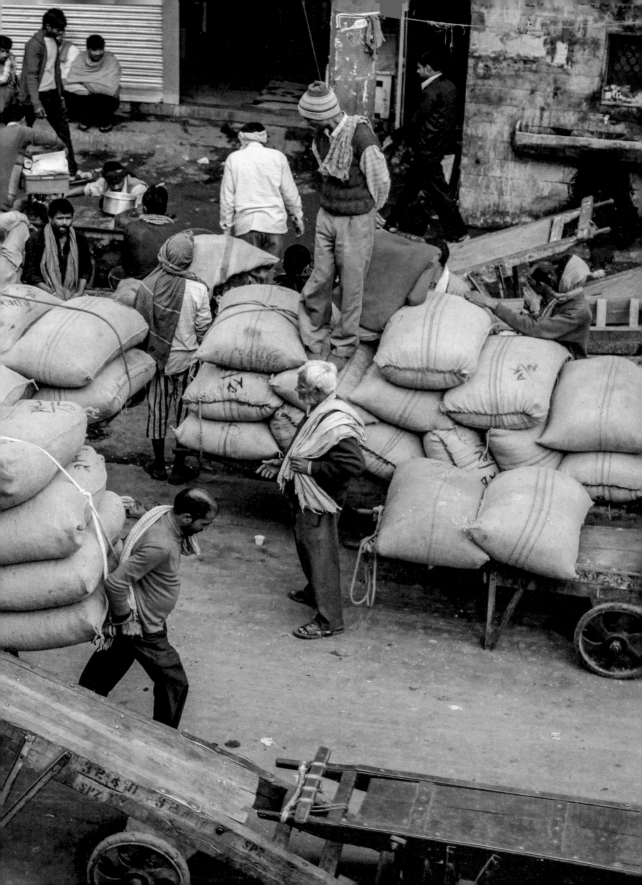

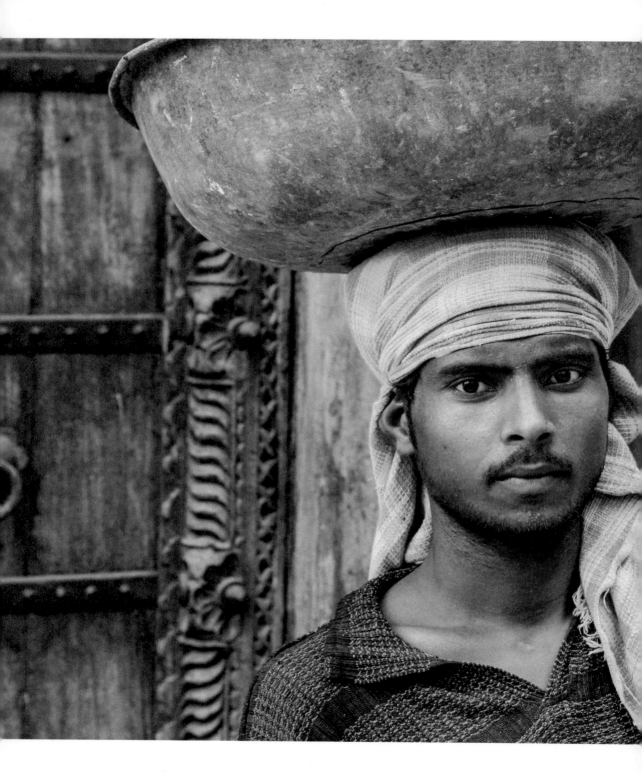

↑ Using a large bowl atop his head, a laborer hauls away dust and debris from a work site where an old *haveli* (mansion) is being restored.

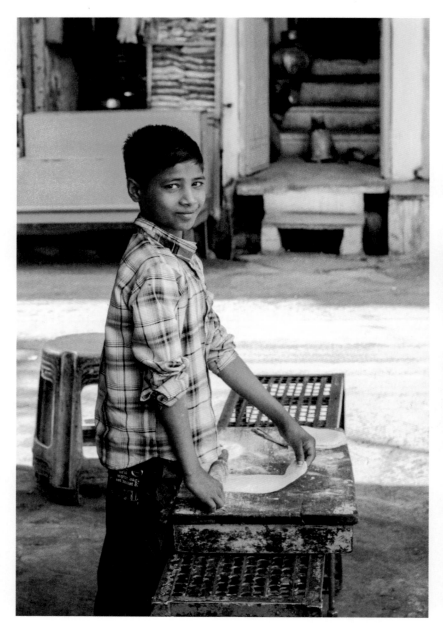

↑ A young boy rolls out fresh roti, a traditional Indian flatbread.

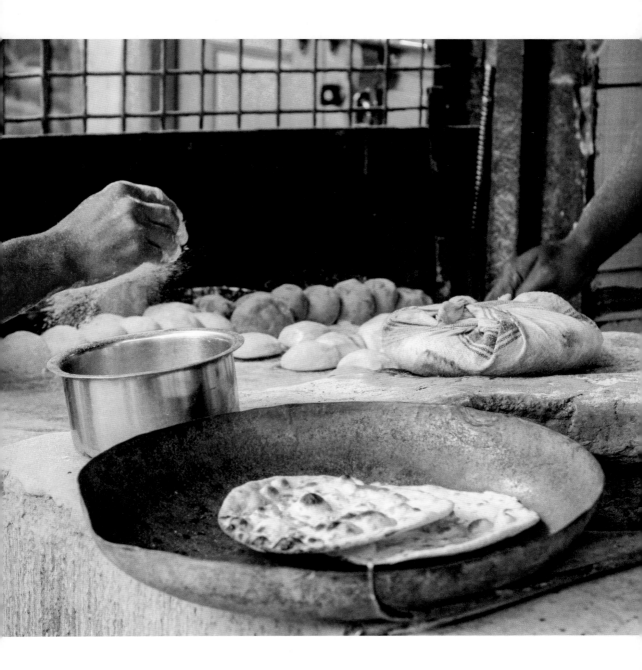

↑ Naan, a leavened flatbread, is cooked in a tandoor,
a cylindrical clay oven.

⟶ Bougainvillea spills out of an abandoned *haveli* on the
shore of Lake Pichola.

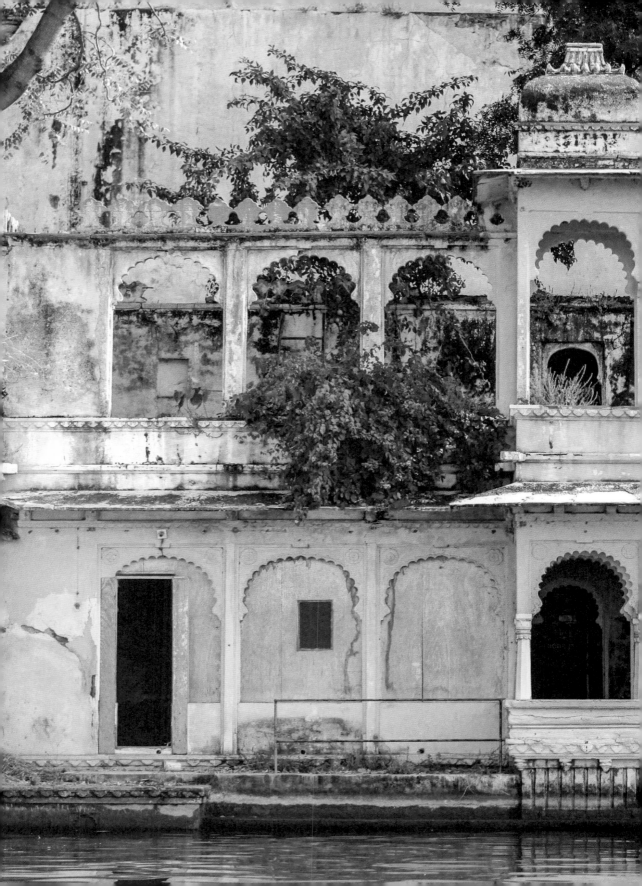

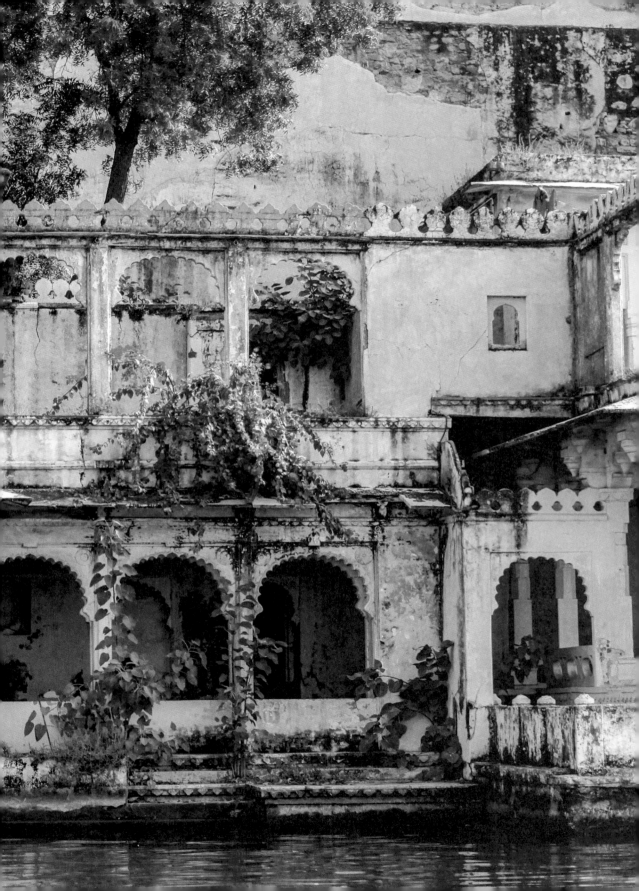

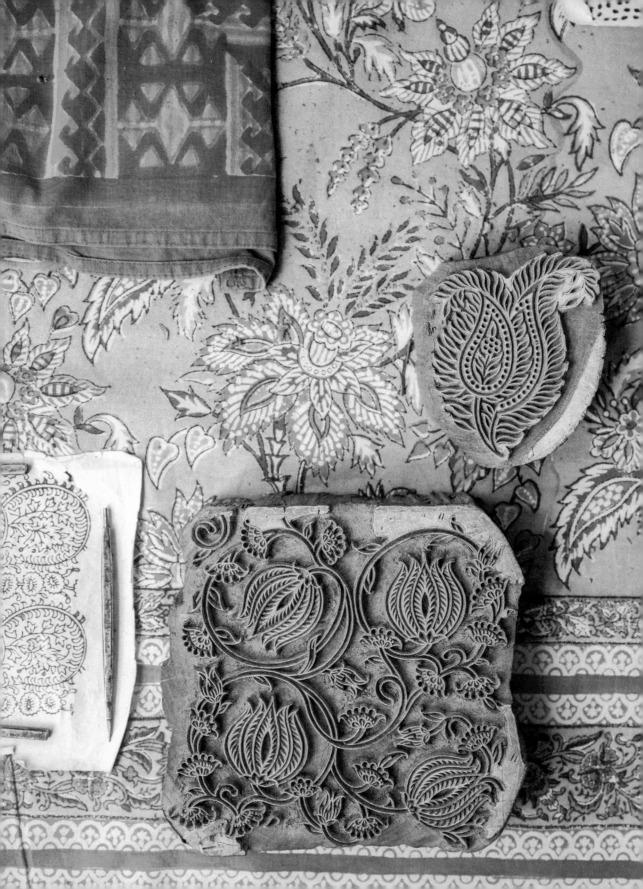

BLOCK PRINTING *in* RAJASTHAN

Rajasthan has a rich history of block printing—the making of hand-printed textiles characterized by the use of carved wooden blocks dipped in dye and pressed onto fabric. Maharaja Jai Singh II, who founded Jaipur in 1727, was an enlightened patron of the arts. During his rule, skilled craftsmen were invited to settle in Jaipur and were ensured a secure livelihood. Artisans eventually moved to surrounding villages as the city became overcrowded and the water sources needed for dyeing became scarce. Two nearby villages renowned for block printing, Bagru and Sanganer, remain vital contributors to India's textile industry. A few persevering artisans there have been instrumental in preserving the inherited knowledge of natural dye techniques, hand printing, and block carving by continuing to pass it down from generation to generation.

A rapid transformation took place in the mid-nineteenth century with the Industrial Revolution, the invention of chemical dye, and the eventual loss of the courtly patronage system after World War II. With these changes, many Indian handicrafts fell by the wayside as machinery took their place. These craft traditions face serious challenges in the modern, industrialized world, and many skills are at risk of being lost forever. It remains imperative to support the work of the artisans committed to maintaining the craft, though it is just as important to note that many artisans come to craft through obligation and tradition. Nowadays it is exciting to witness younger members of the *chhipa* (printer) community experimenting with contemporary patterns, pushing hand block printing in new directions, and claiming their own creativity and individuality in the process.

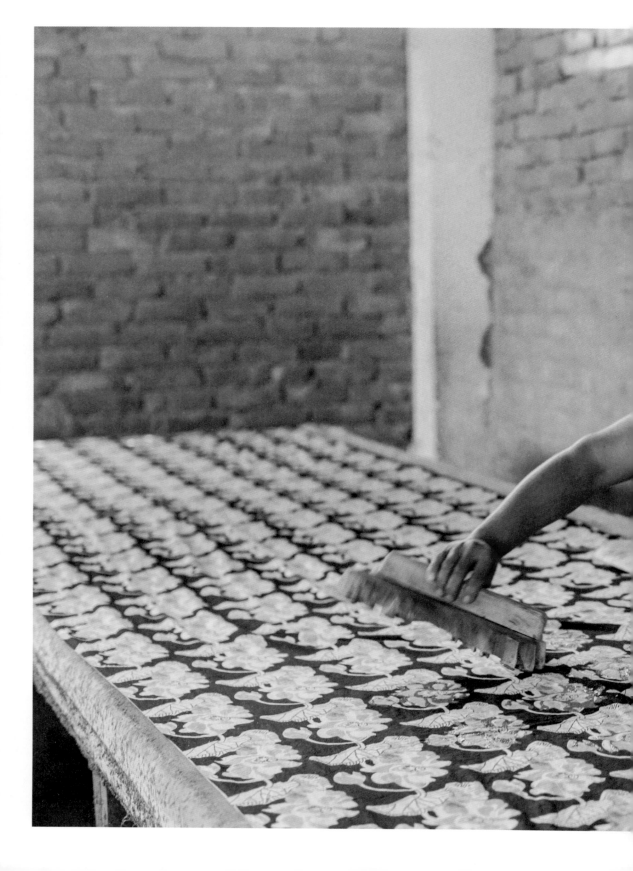

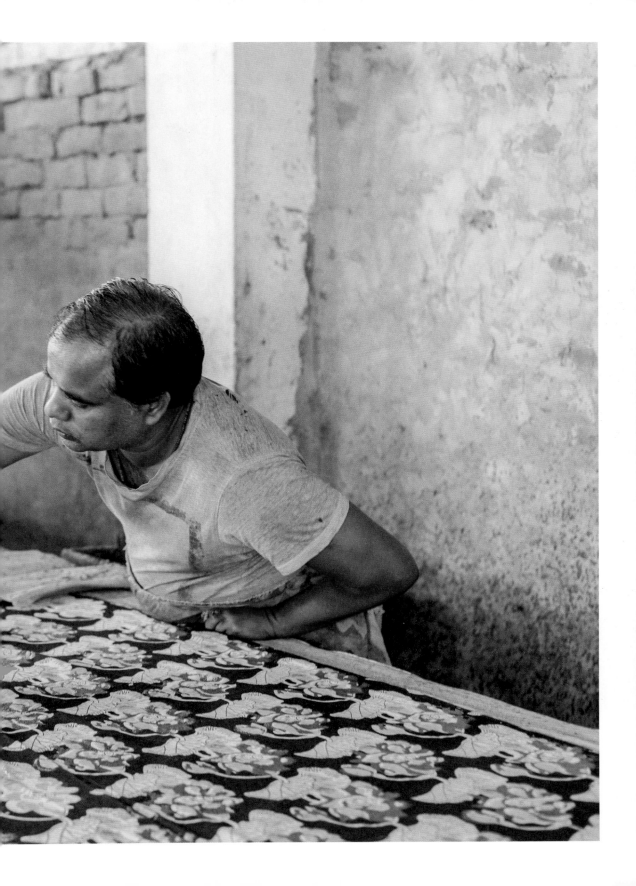

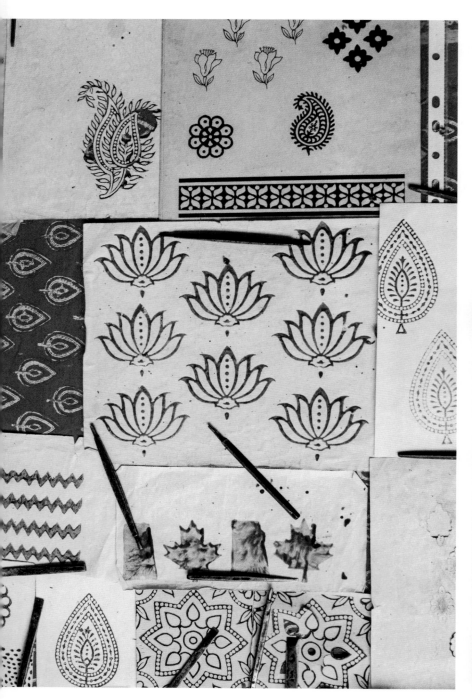

←— At his workshop in Bagru, Ganesh Chhipa adds a *dabu* layer to
a length of cloth already printed with *siyahi,* a black iron dye.

↑ Examples of block-print patterns seen here include lotus flowers,
geometric patterns, and paisley motifs.

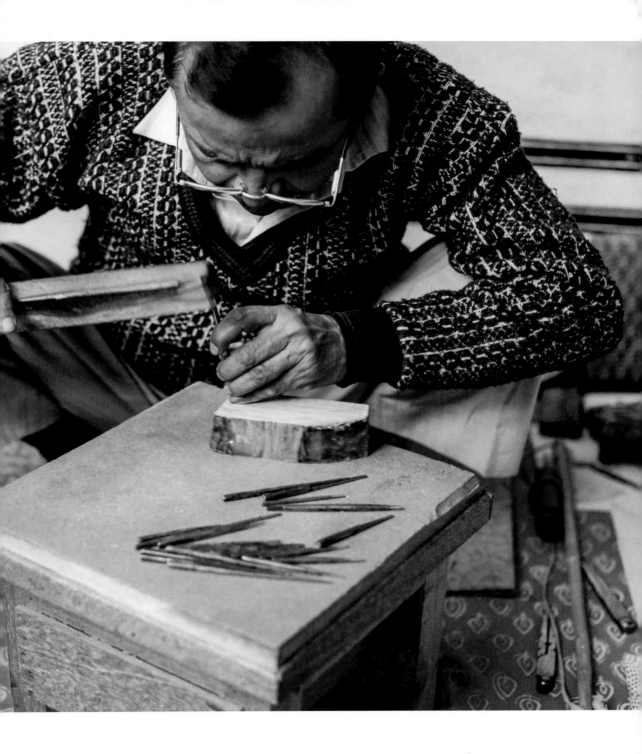

↑ At the Anokhi Museum of Hand Printing, Mujeebullah Khan, a master carver, uses traditional hand tools to chisel wooden blocks.

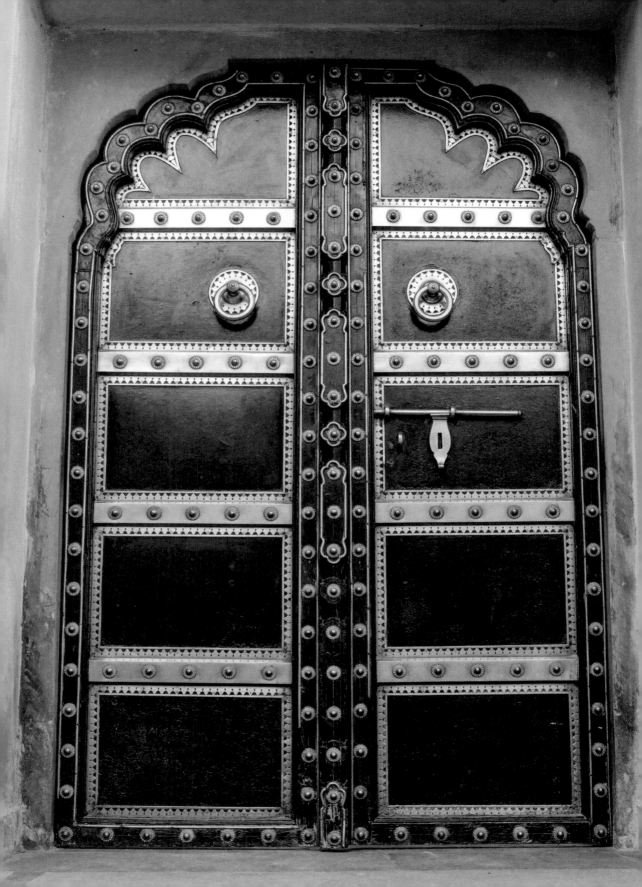

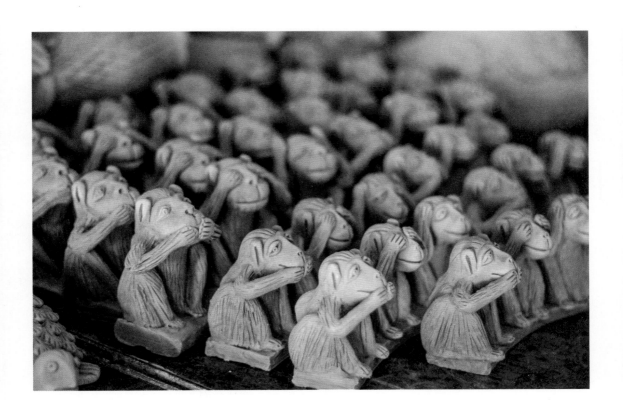

↑ Carved clay monkeys at a roadside craft stand depict the
proverb "See no evil, hear no evil, speak no evil."

← The entrance to Baradari, a restaurant housed within
the Jaipur City Palace.

⟶ Red sandstone cenotaphs commemorate many
of Jodhpur's maharajas in the Mandore Gardens.

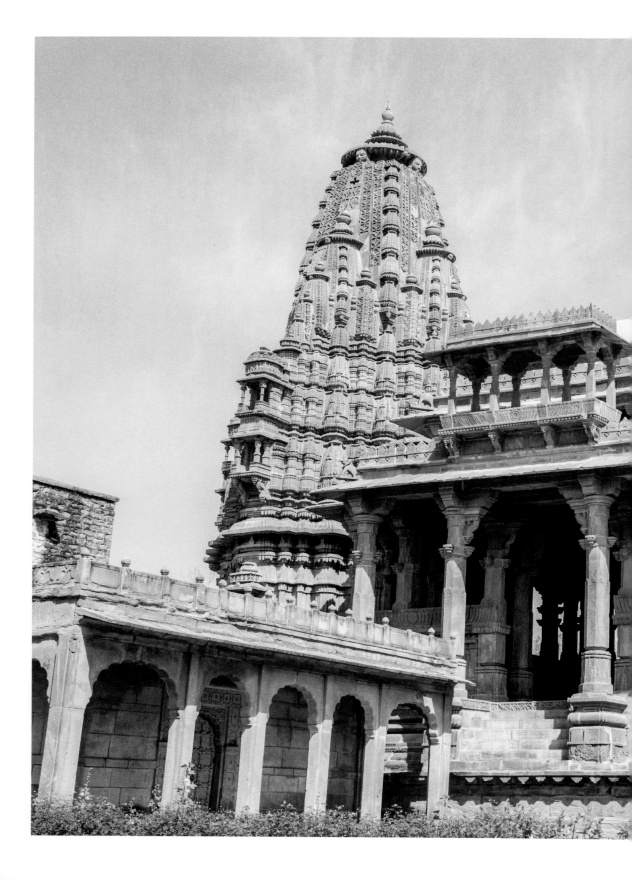

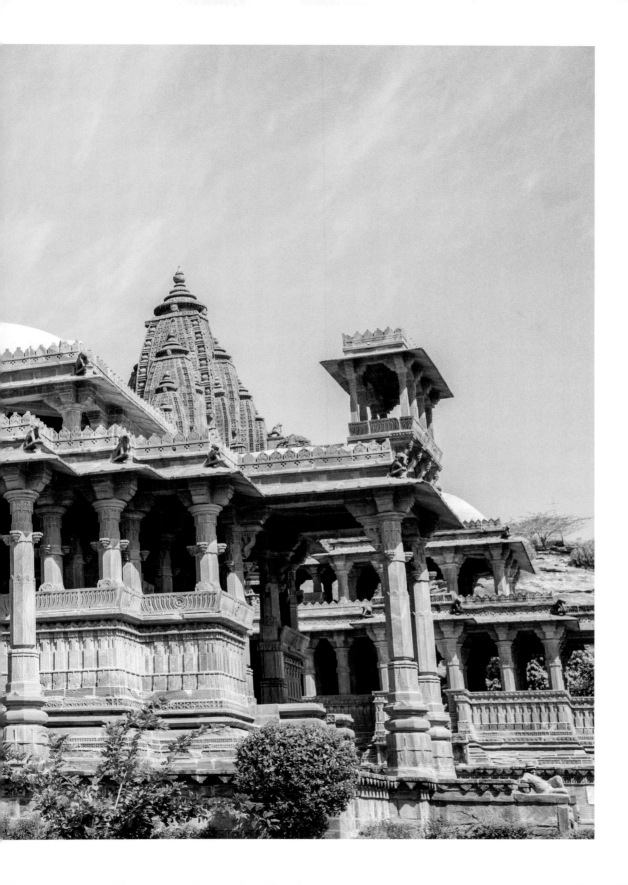

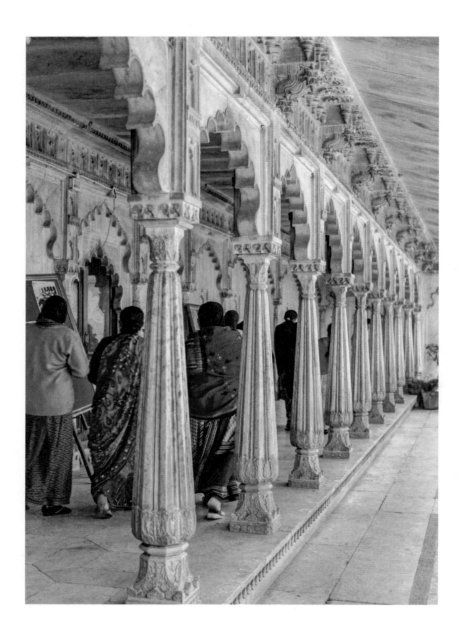

↑ Visitors stream through the Badi Mahal, or Garden Palace, one of several residences housed within the Udaipur City Palace complex.

⟶ In the courtyard of the women's quarters at the Mehrangarh Fort, floral carvings, including lotus flowers in each corner, frame the doorways.

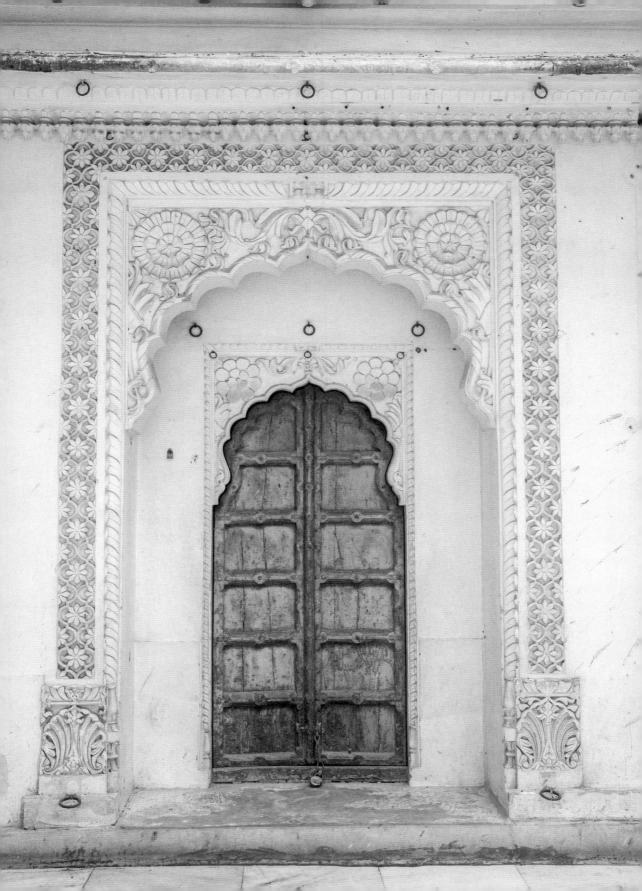

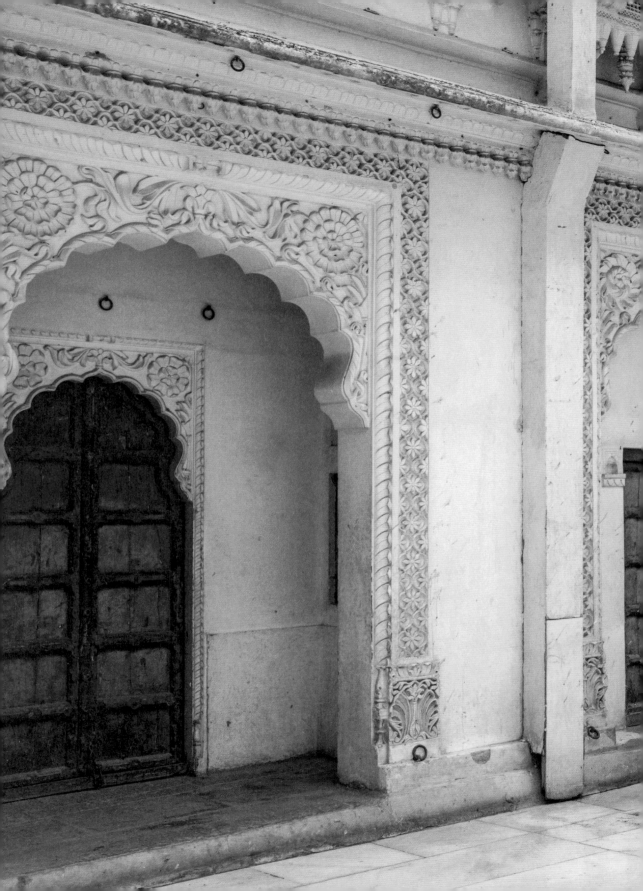

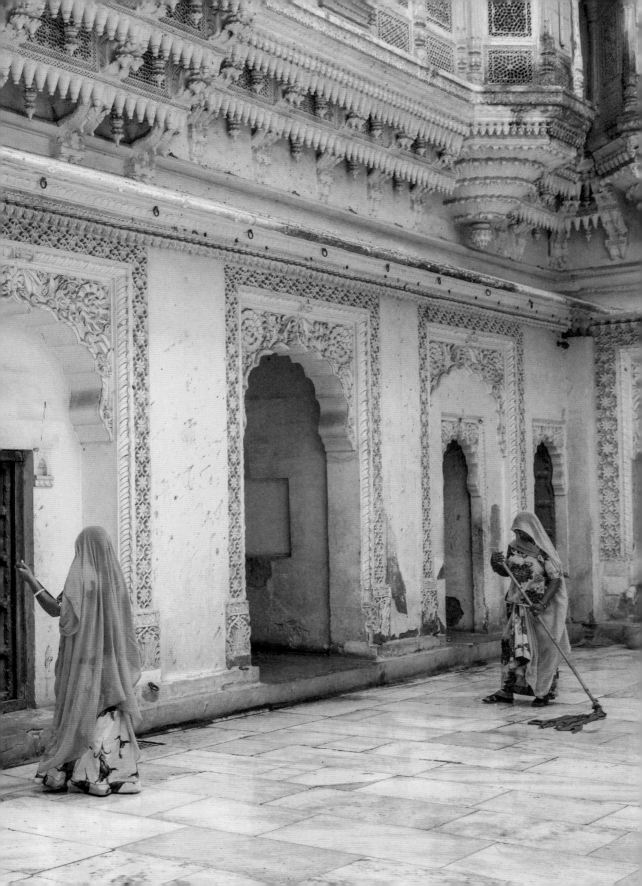

MARI-GOLD

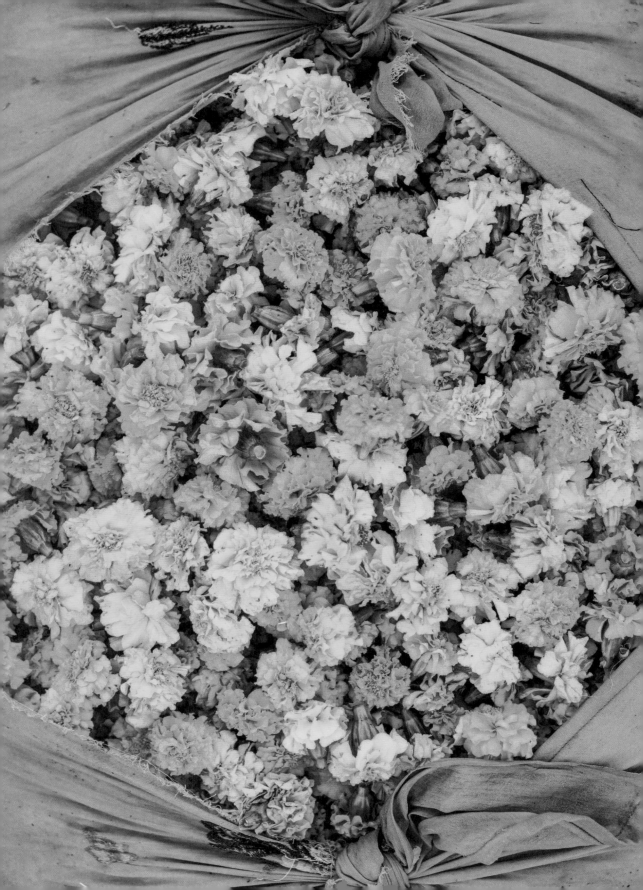

The benefit of traveling to India from the East Coast of the United States is that my jetlag always ensures I am up before the sun. Capturing the golden light of sunrise is a photographer's dream, so after a steaming cup of chai, I often head out while it is still pre-dawn. My favorite destination is the flower market, especially in Jaipur.

As Jaipur awakens, its flower vendors rise to greet the dawn, their overflowing sacks of marigold blooms spilling out onto the quiet streets. Even before the sun fully rises and burns off the haze of night, their stalls are meticulously arranged. Some sell individual blooms and simple strands, while others work with nimble fingers to string together elaborate garlands. The bustle of activity begins early and doesn't relent until close. Once the rest of the city wakes there is not a moment of quiet to be found amid the auto rickshaws roaring by, the constant stream of cars, motorcycles, and trucks weaving through the narrow streets, and the shouts of vendors hustling their goods to the crowds that make their way through the markets.

The marigold flower, used in worship and devotion, has spiritual significance in Hinduism. It is offered to God as an auspicious symbol of trust in the divine. Grown in almost every state in India, marigolds, known as the "herb of the sun," are incorporated into all festivals, celebrations, and ceremonies. Garlands are strung daily over doorways of homes and businesses as a sign of devotion, and laid at the feet and around the necks of deities being worshipped in the *mandir*. Marigolds are a traditional favorite at Hindu weddings, which are elaborate, colorful multiday affairs.

The marigold family encompasses many hues including gold, saffron, ocher, copper, cinnamon, rust, turmeric, and sienna. It can be seen in stacks of cheery yellow lemons piled high and bright fields of flowering mustard plants. Yellow signifies spring; it is the color of young mango blossoms and the sun warming the desert earth. Even in the darkened hush of an empty *mandir*, tea lights cast an orange glow onto the altar, calling to mind this color family and its bright beauty, as well as the religious importance of fire.

← Sacks of marigolds for sale at the Phool Mandi,
Jaipur's wholesale flower market.

Saffron, the most sacred color for Hindus, represents fire, which burns away darkness and symbolizes light. Sadhus, Hindu holy men who have renounced the world, wear saffron robes to symbolize their quest for purity and knowledge. Saffron is also one of the three colors in the Indian flag, occupying the top of the three bands and signifying the country's strength and bravery.

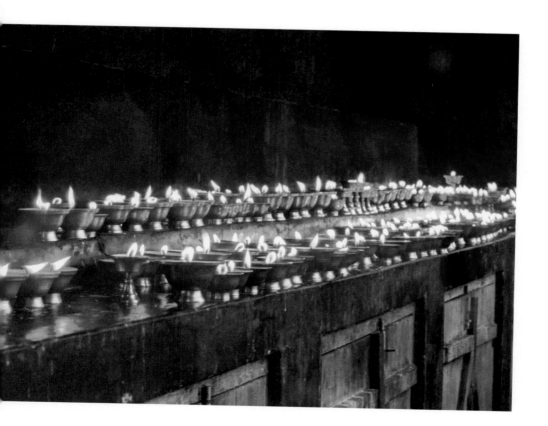

↑ An empty *mandir* illuminated by candlelight.
→ A roadside cart selling soda made with a fresh squeeze of lemon.
⟶ Mounds of spices on display at a spice shop in Jaipur's Bapu Bazaar.

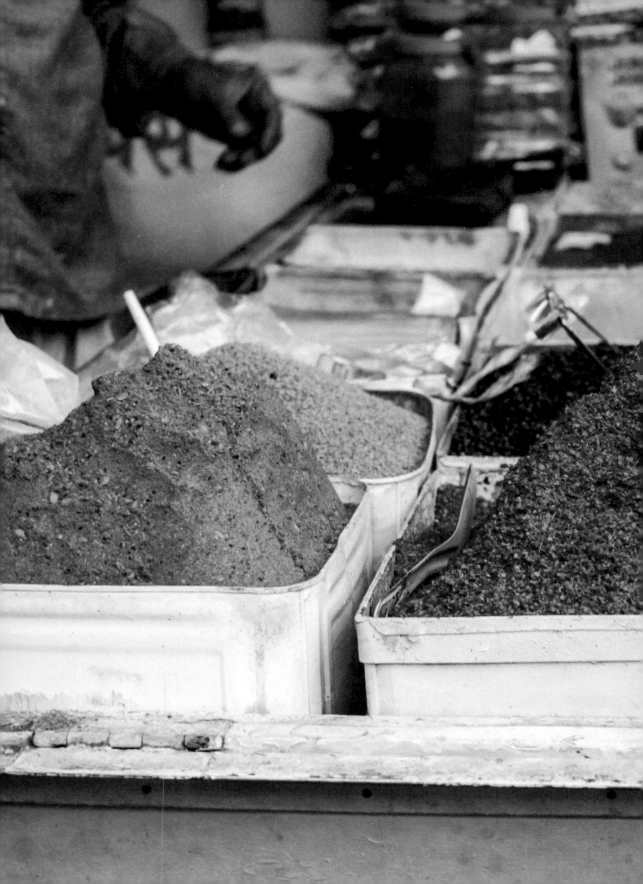

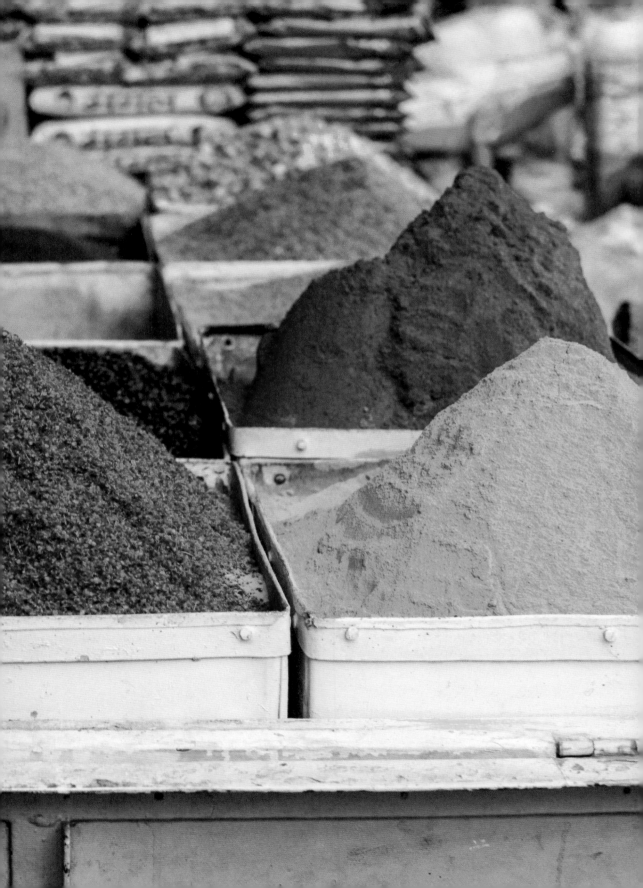

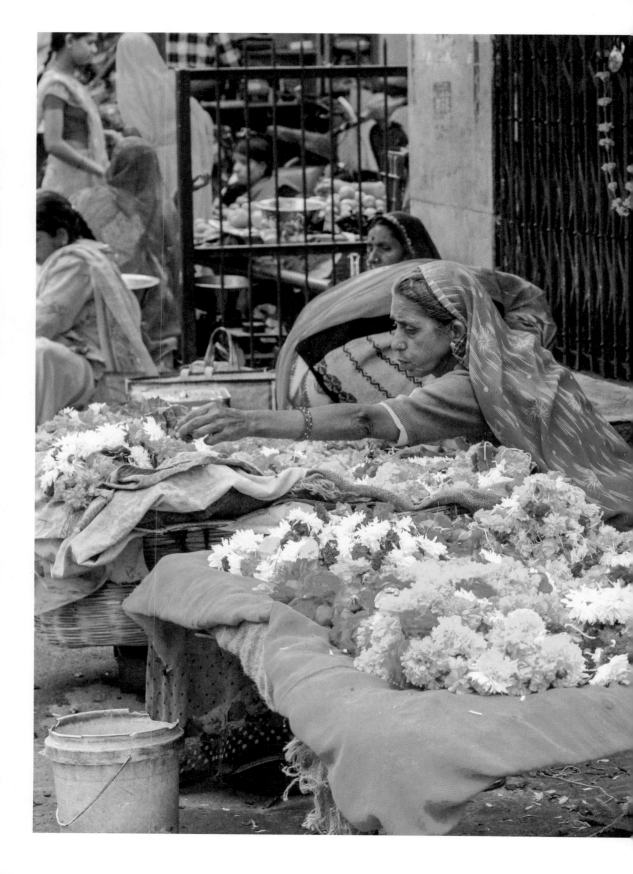

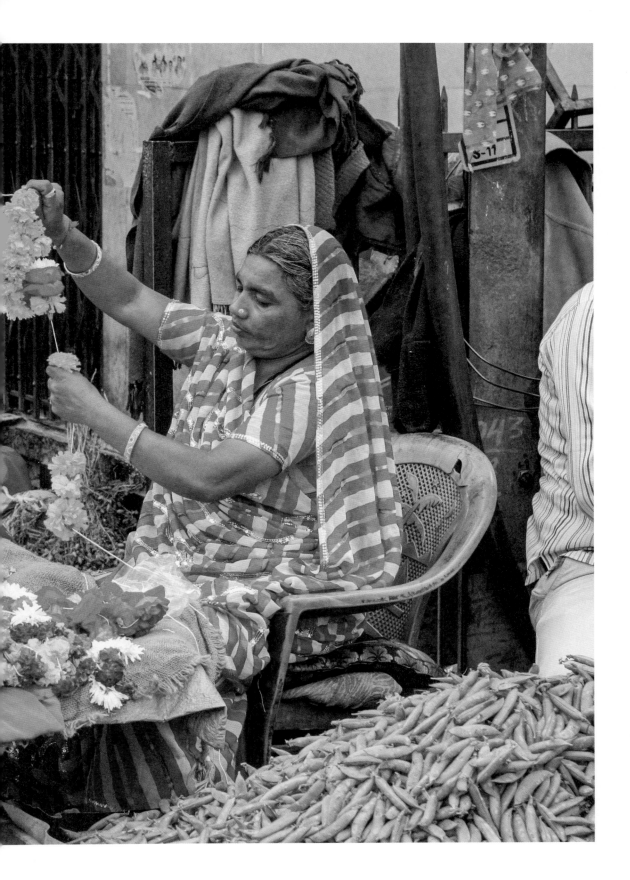

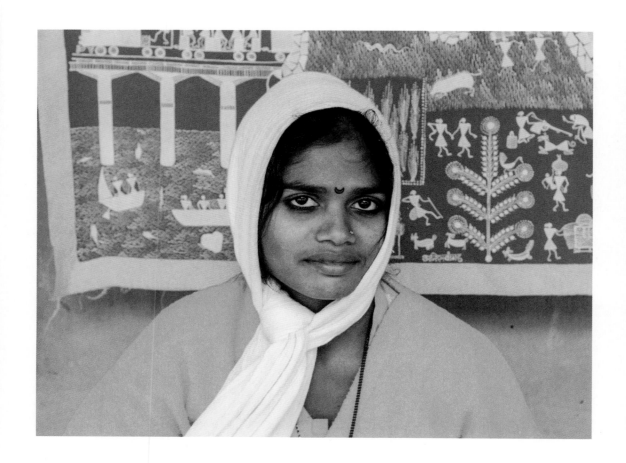

← Vendors string together flower garlands at the market in Udaipur.

↑ → Portraits at the Udaipur market.

→ A joint family breaks for lunch after working their farm in rural
Rajasthan. Lunch is brought from home in a tiffin carrier,
which is a steel, tiered lunch box. Tiffin refers to a midday meal.

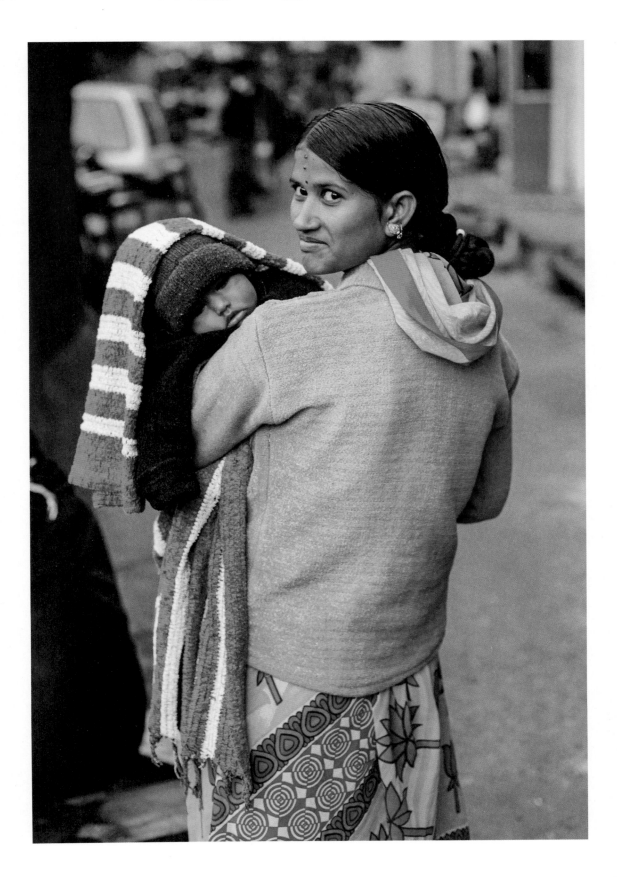

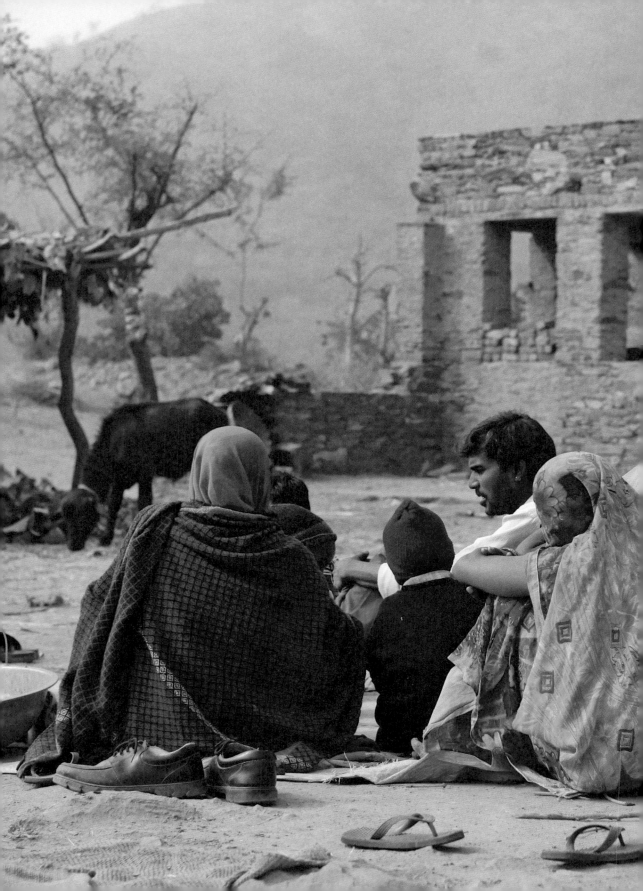

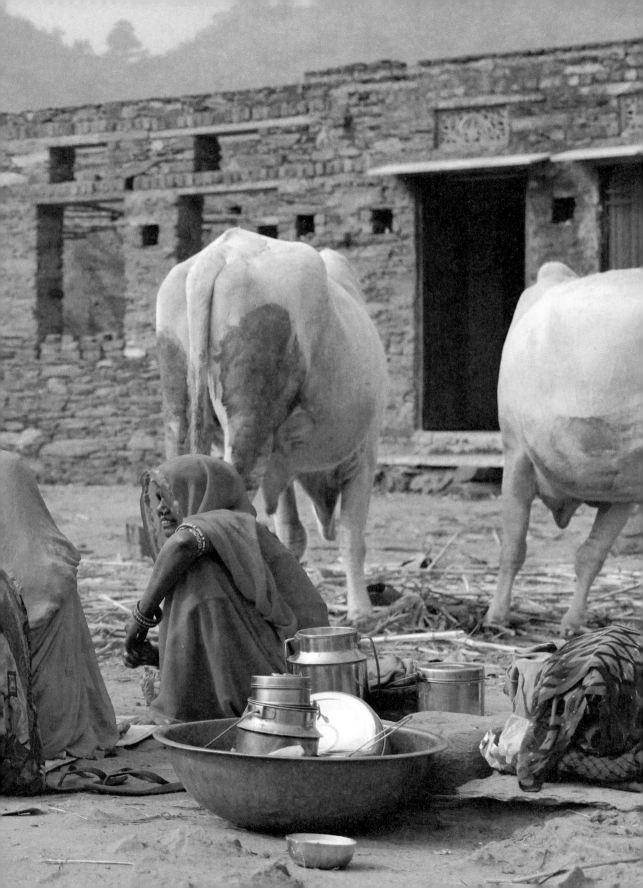

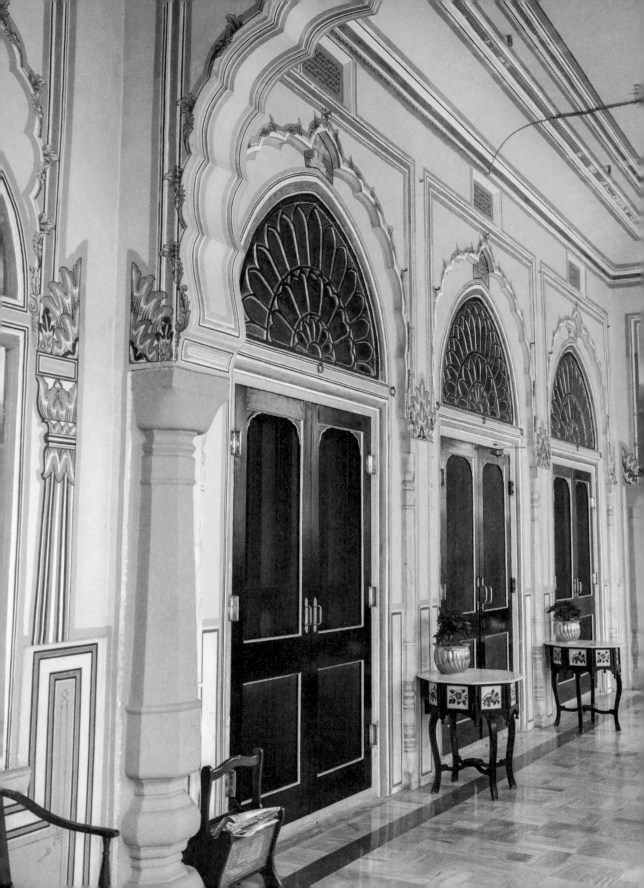

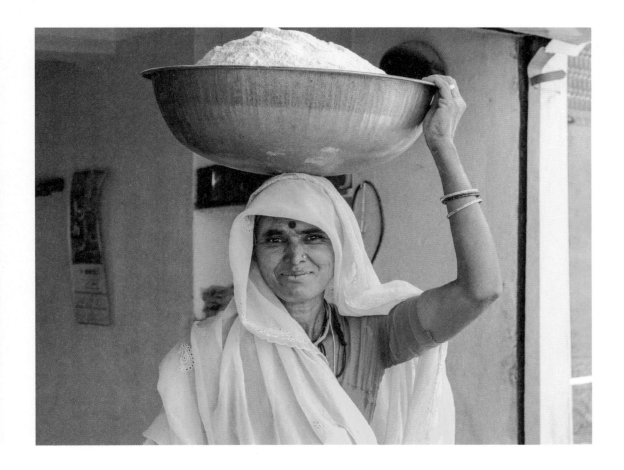

↑ Yellow clothing is often worn to celebrate the arrival of spring, as seen here
on a sunny March day in rural Rajasthan.

← Housed in havelis, palaces or forts built prior to 1950, heritage hotels
preserve the architecture and atmospheric integrity of the original structure.

A TRIP *to* MARKET

The daily markets in cities such as Udaipur and Jaipur are a rich experience for all the senses. Mounds of vibrantly colored spices, such as turmeric, saffron, cumin, and garam masala, perfume the air, along with overflowing sacks of dried chili peppers that make your eyes water as you pass by. Rajasthani cuisine relies on a layering of these spices to achieve the rich and flavorful dishes for which the region is known, so most home cooks make a daily trip to market to procure them, along with fresh vegetables and dry goods, as well as to socialize with fellow market-goers, neighbors, friends, and vendors.

The markets are roughly separated into sections, including vegetable and fruit sellers, spice and dry goods stalls, and snack vendors. The vegetable stalls are piled high with produce brought in daily from the countryside. Piles of rich purple eggplants are nestled alongside cherry-red tomatoes, stacks of lemons and limes, and baskets overflowing with gingerroot, okra, bitter melon, onions, and garlic. Dry goods stalls are meticulously arranged with cashews, dates, lentils, rice, flour, and tea, all displayed in sacks and large metal bowls with scoops for serving.

Market-goers frequently indulge in street food. Vendors selling savory snacks, such as samosas (fried pockets of dough filled with a mixture of potatoes, vegetables, and sometimes meat), *papdi chaat* (crunchy, spicy fried wafers topped with yogurt, chutney, potato, and chickpeas), and *panipuri* (hollow fried crisps stuffed with savory fillings and sauces) welcome a steady stream of customers. Sweetshops, wafting their enticing aromas through the market, offer *ladoos* (round dense balls made from flour, sugar, ghee, and additional flavorings), *kaju barfi* (rich, bite-sized sweets made from cashews, milk, and sugar), and deep-fried *jalebi* (fried batter soaked in syrup) to satisfy sugar cravings. No trip to market is complete without a cup of masala chai: a sweet black tea steeped with a mixture of spices, milk, and sugar that is an integral part of the daily rhythm of life in India. Each *chaiwala*, a person who prepares and serves chai from a roadside or market stall, is known for his or her particular blend.

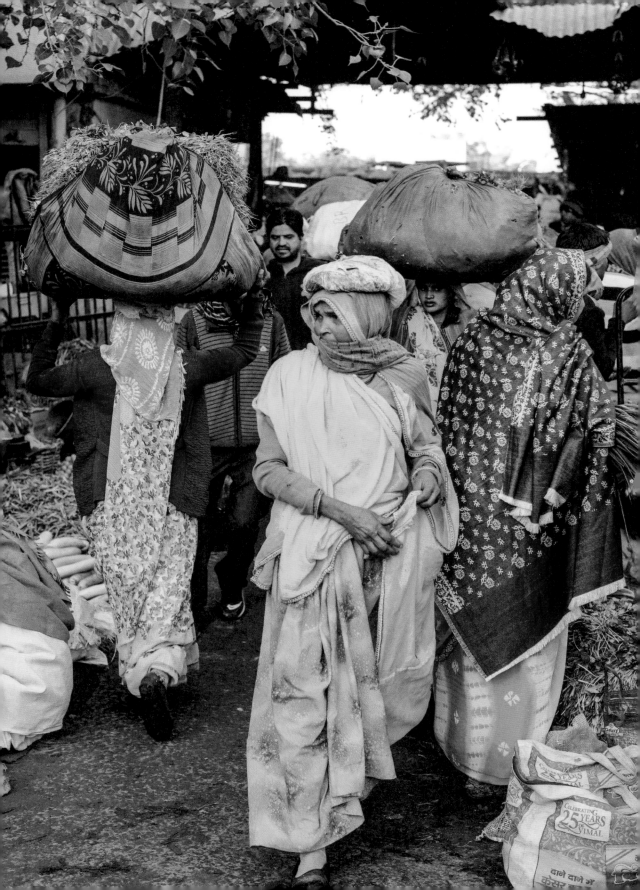

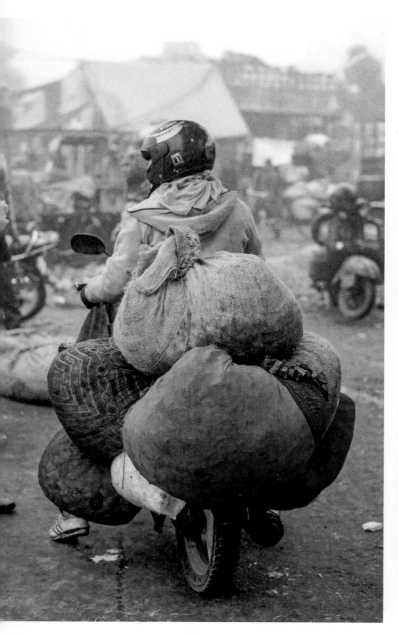

↑ Along with auto rickshaws, motorcycles dominate the roadways
and are often piled high with goods to bring to market.

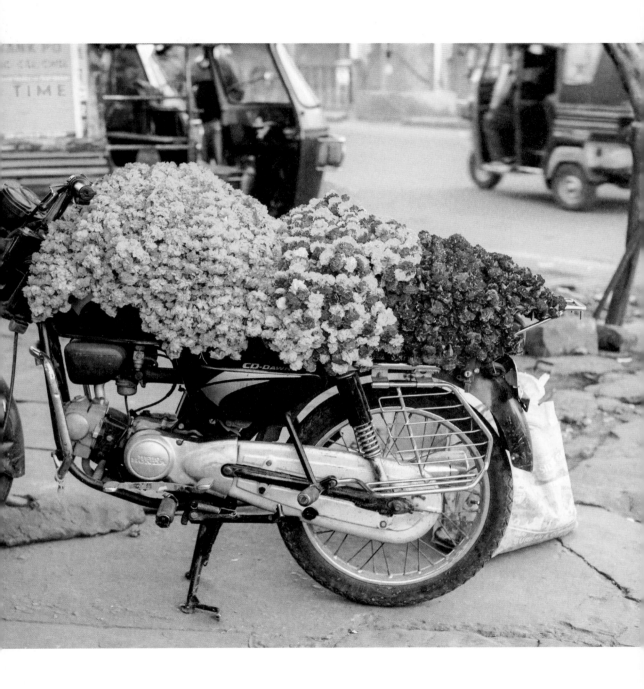

⟶ Tidy piles of spices and packaged snacks for sale at
a shop front in Jaipur's Bapu Bazaar.

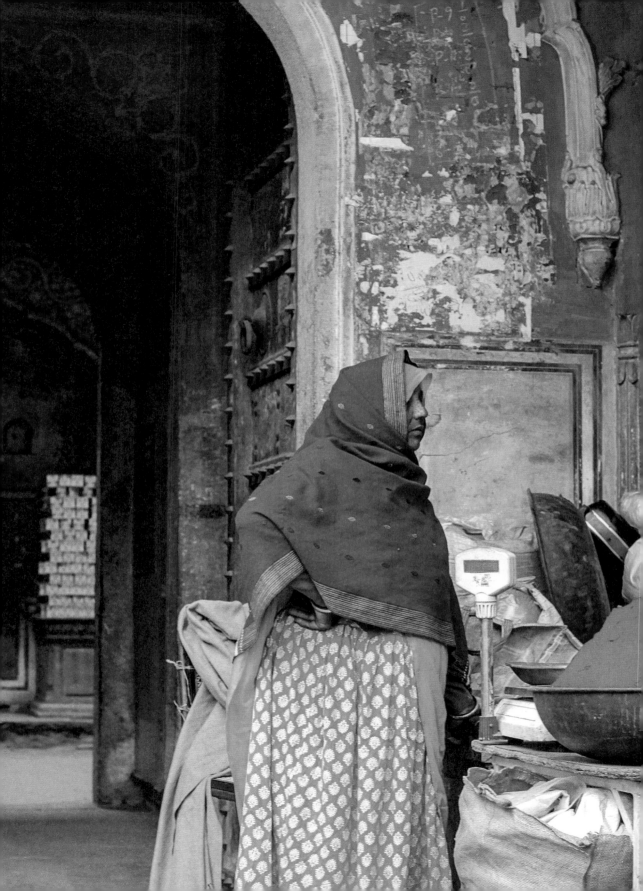

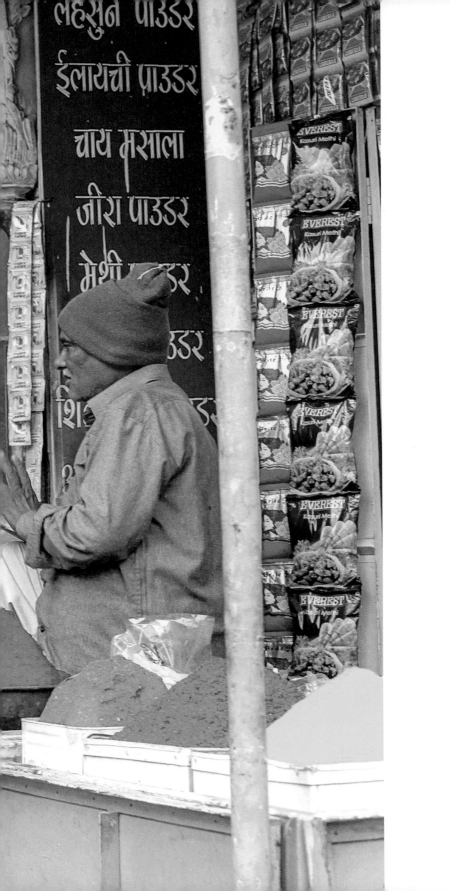

↑ Dried tumeric root being ground into powder at a spice stall in Jaipur.

→ Visible here are two of the five articles of faith worn by all baptized Sikhs: *Kesh*, uncut hair wrapped and tied in a turban, and *Kirpan*, a dagger.

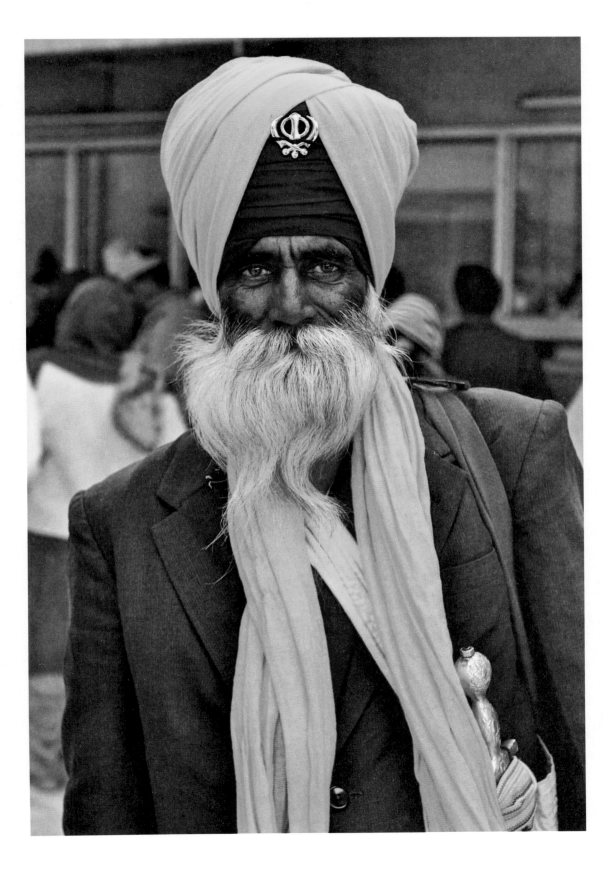

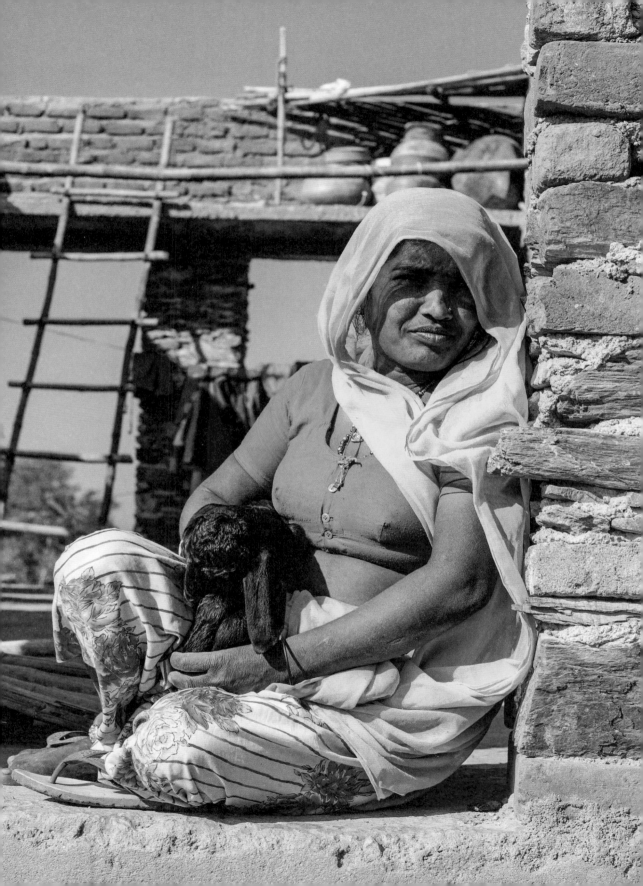

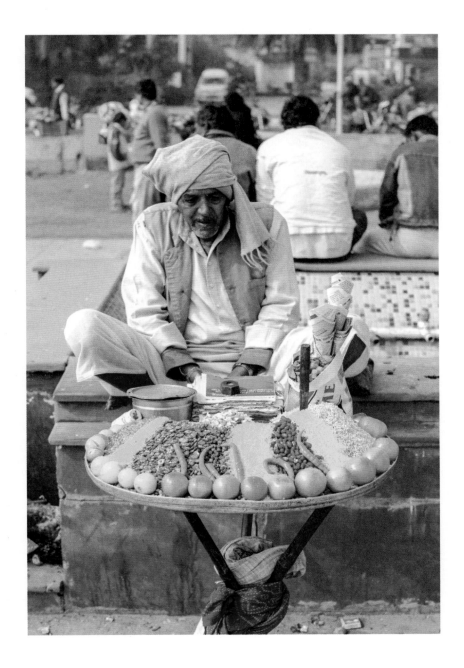

← A woman takes a break from goat herding to enjoy a
sunny spot with a newborn kid (baby goat).

↑ A street food vendor sells *bhel puri,* a popular spicy snack
made with puffed rice, onion, vegetables, and chutneys.

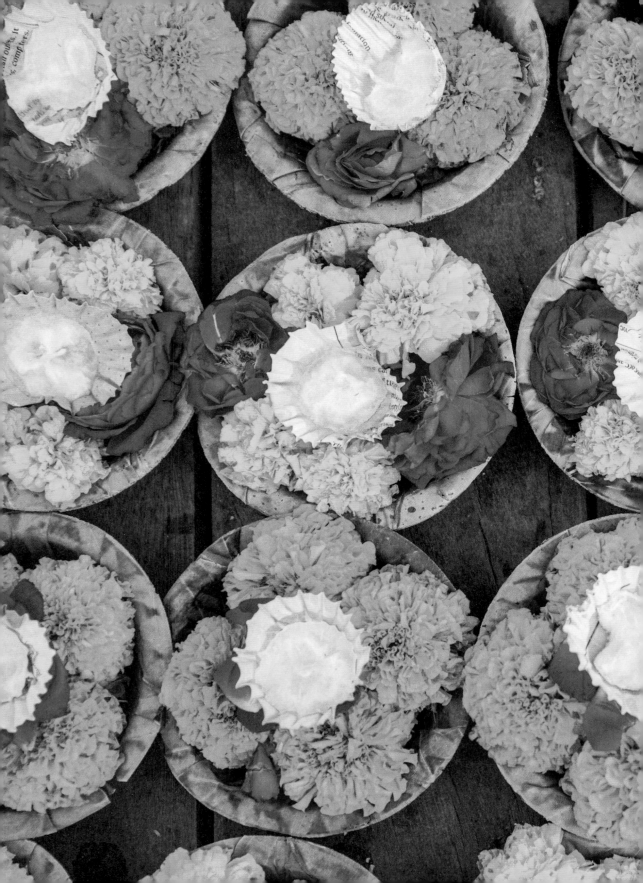

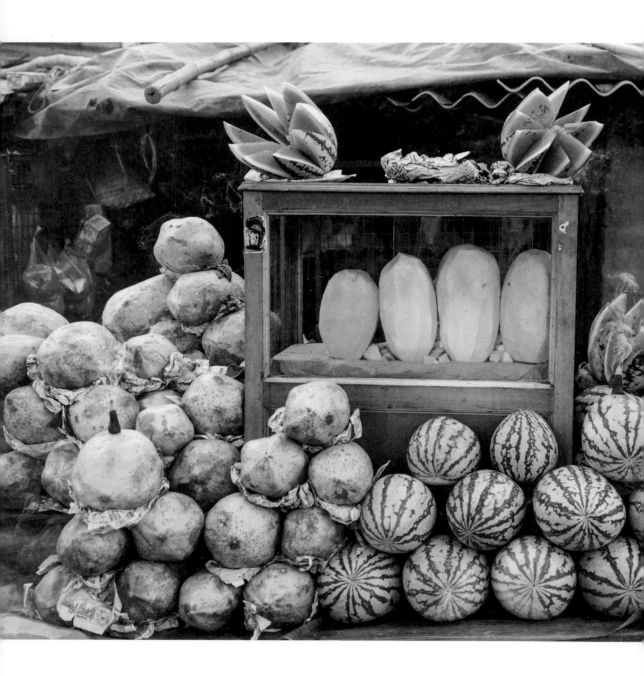

←— Offerings of flowers and candles for *puja* (Hindu devotional worship).

↑ Incense, burned to keep the insects at bay, fills the air around this
market stall offering fresh fruits.

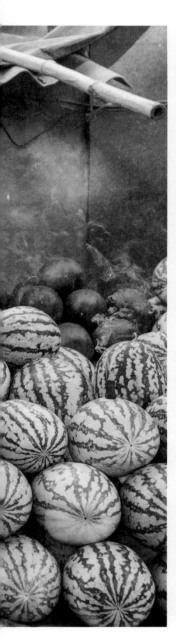

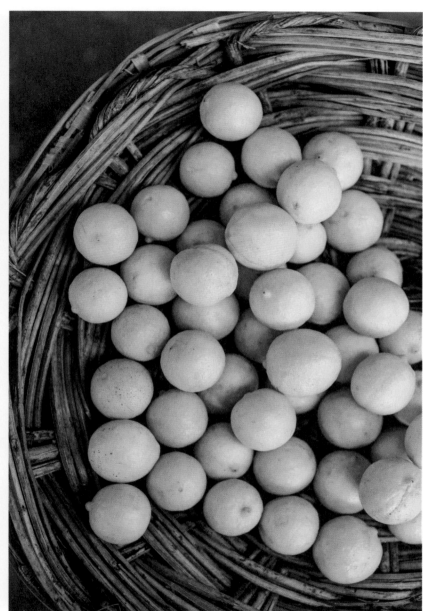

↑ A basket full of sunny yellow lemons for sale at Udaipur's market.

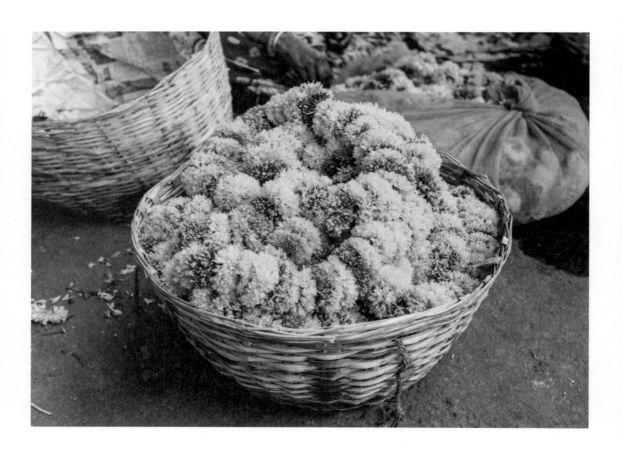

↑ Marigolds are the most widely cultivated flower crop in India.

→ Gingerroot, a staple in Rajasthani cuisine and a key ingredient in the preparation of masala chai, is sorted and stacked for sale at market.

⟶ Joint families are common in India; several generations often reside in the same household. This joint family lives and works together on their farm in rural Udaipur.

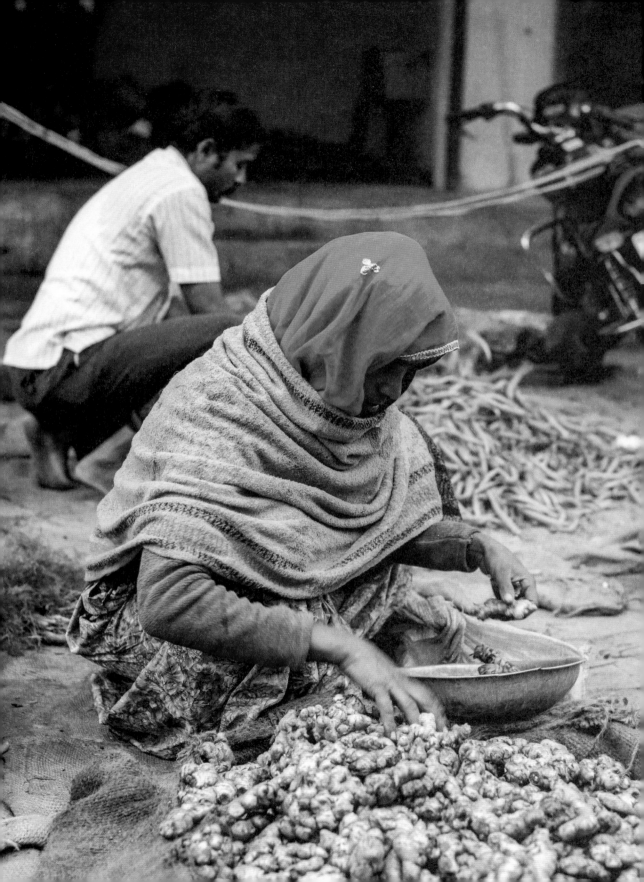

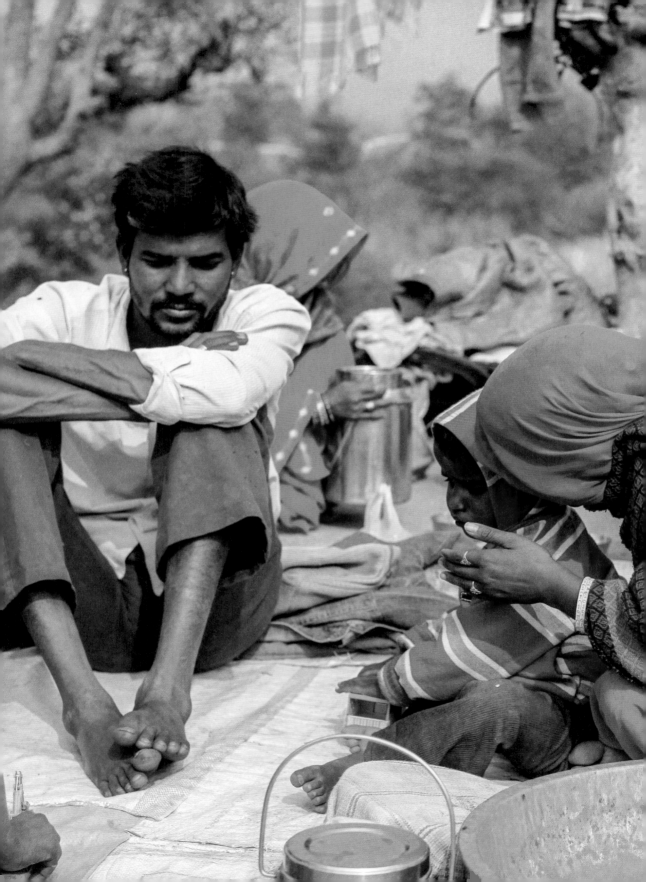

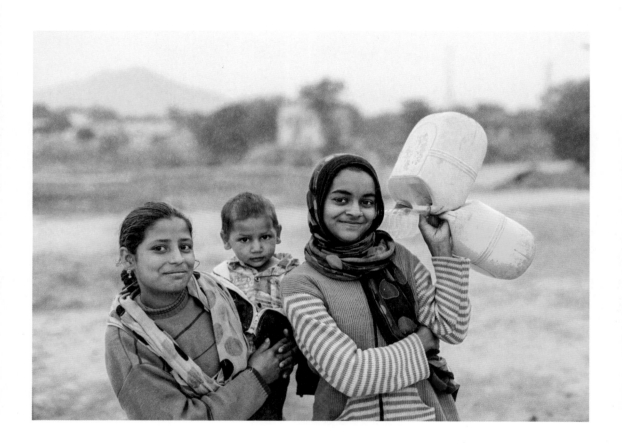

↑ Rural communities often have only one water source to serve an entire village,
which means multiple daily trips to haul water are necessary.

→ At many forts and palaces, women work throughout the day to sweep the ever-
accumulating desert dust and carry it away in bowls balanced on their heads.

——→ A new bride on her honeymoon shows off her fading *mehndi,* decorative
body art using henna paste to draw designs, which was applied to her hands and
feet at a ceremony prior to the wedding.

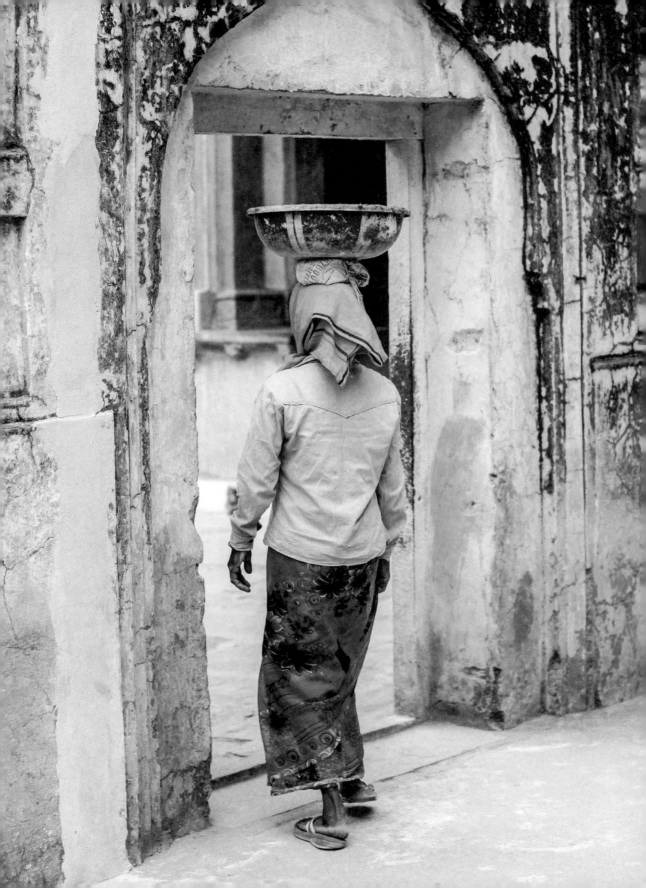

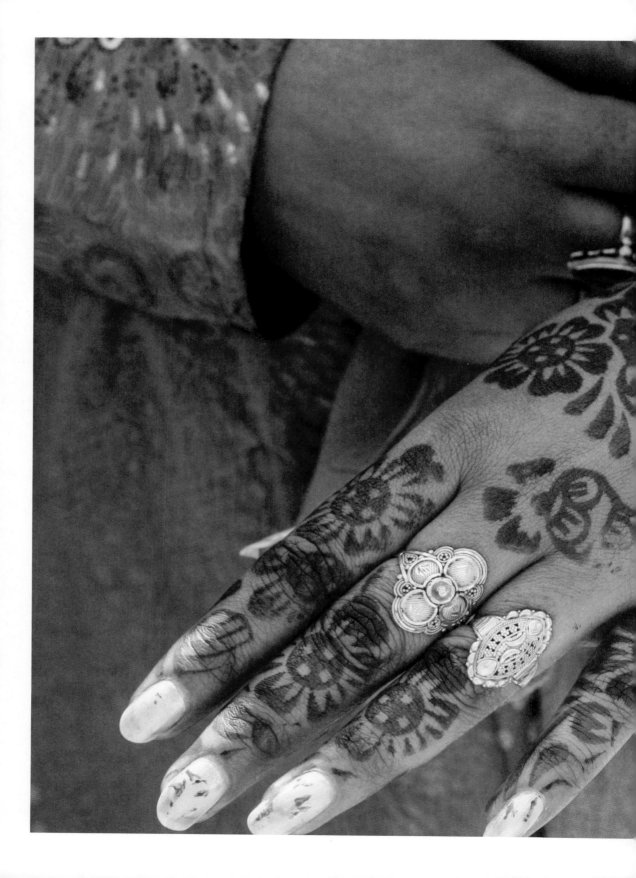

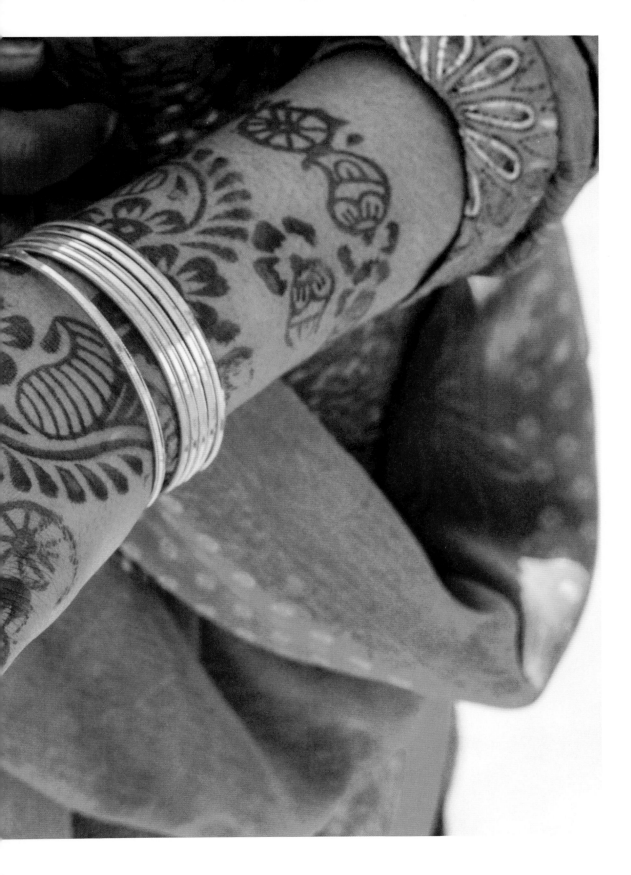

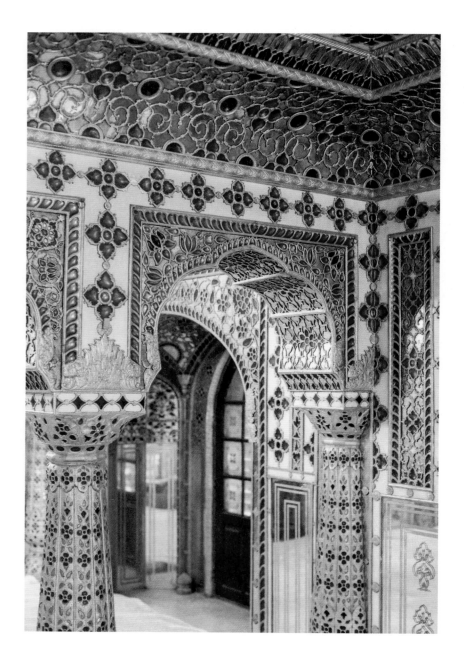

↑ The bejeweled Shobha Niwas (Hall of Beauty) is on the
fourth floor of the Chandra Mahal at the Jaipur City Palace.

→ The elaborately decorated doorway of Virendra Pol,
one of three entry gates to the Jaipur City Palace.

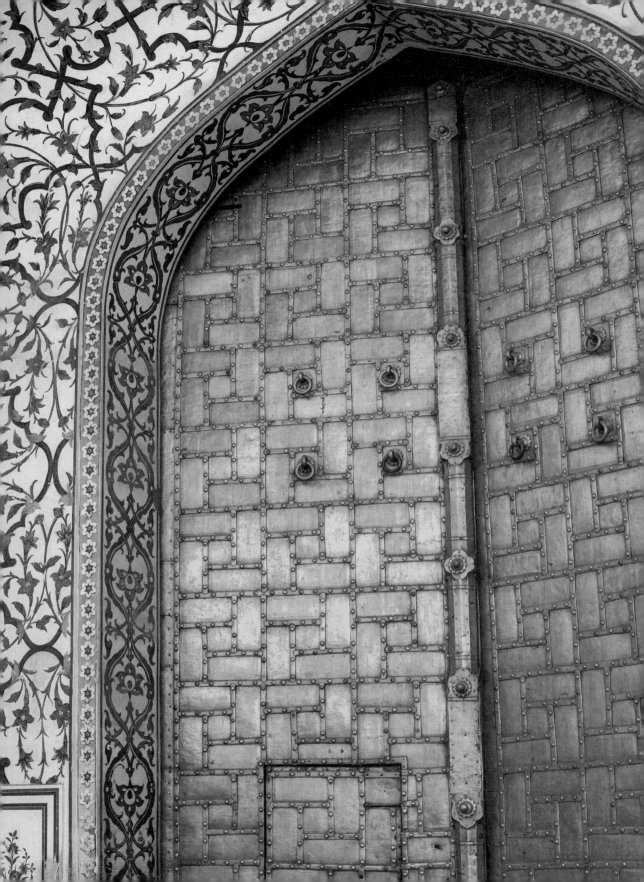

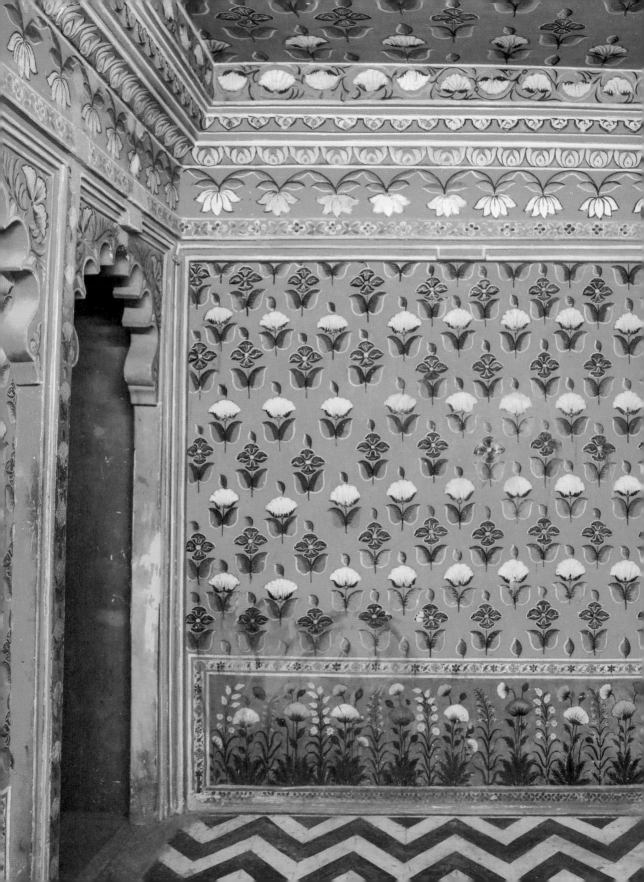

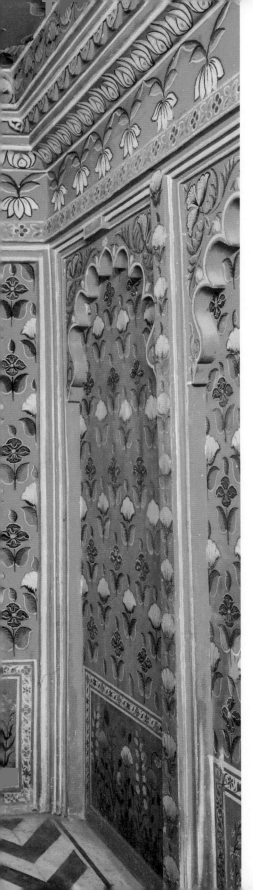

← Lotus flowers in a chevron-inspired pattern adorn the walls and ceiling of this vibrant room in the Udaipur City Palace.

⟶ The restored *haveli* that houses the Anokhi Museum of Hand Printing is filled with architectural details, such as these Mughal-inspired geometric *jalis*.

⟶ My husband and I, standing atop a *rangoli* of marigold and rose petals during our Hindu wedding ceremony.

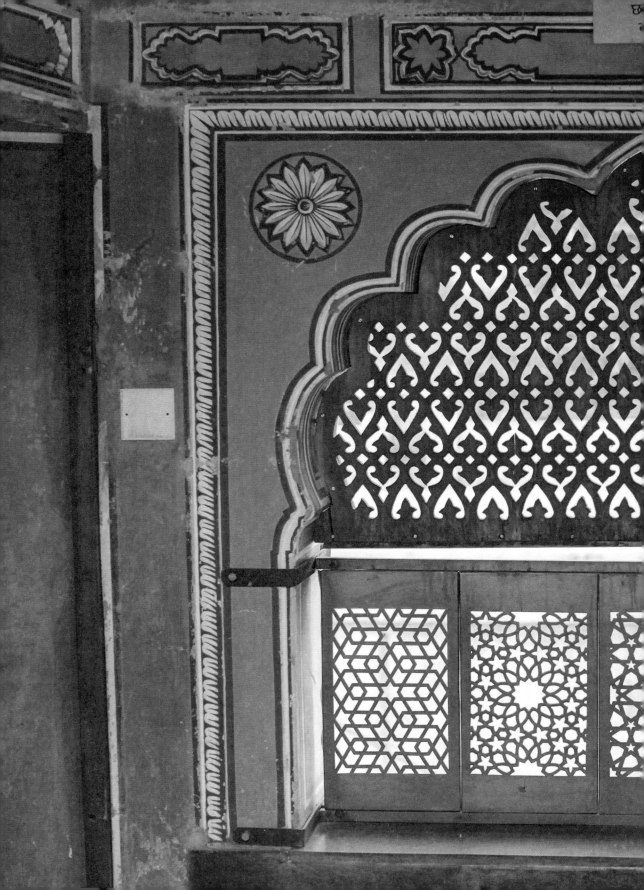

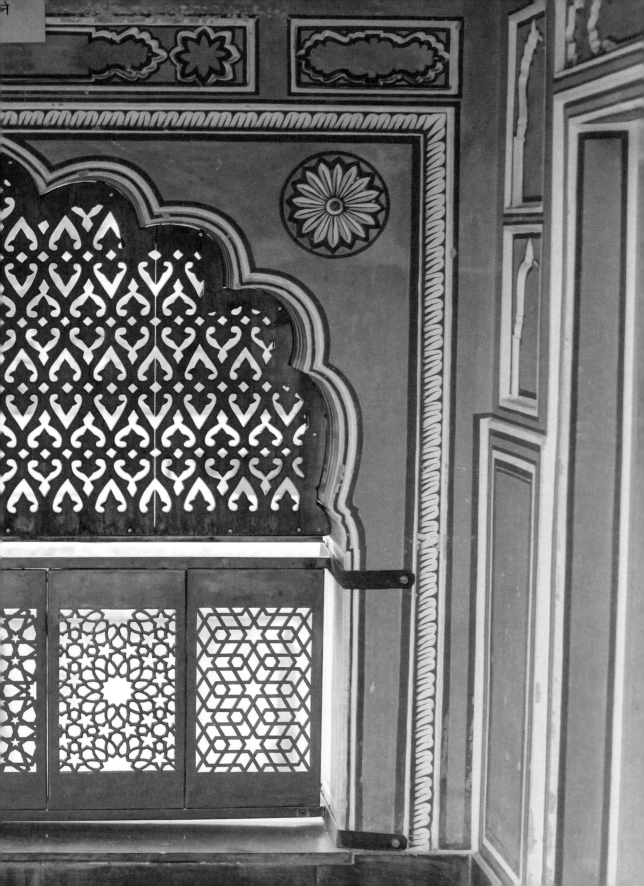

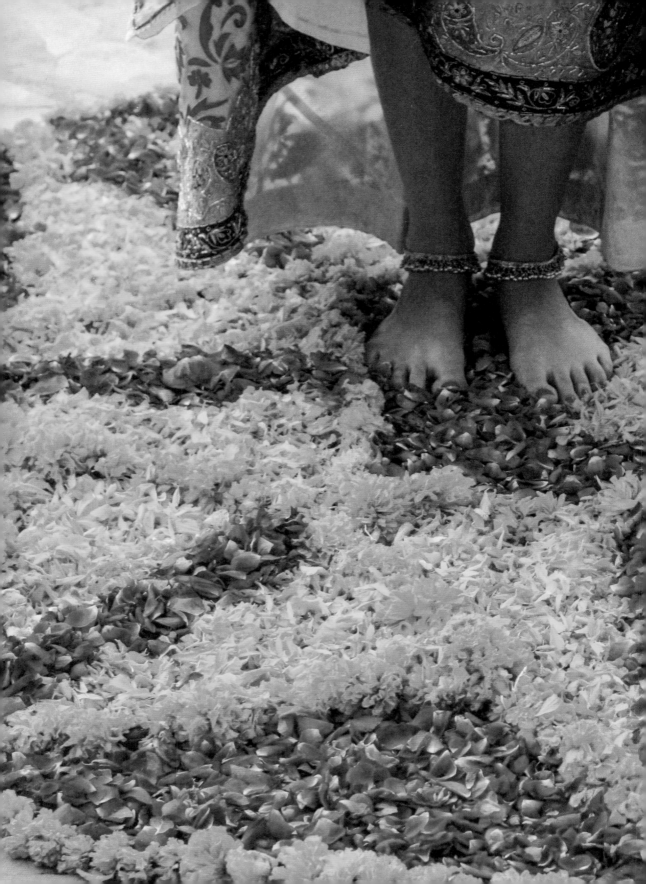

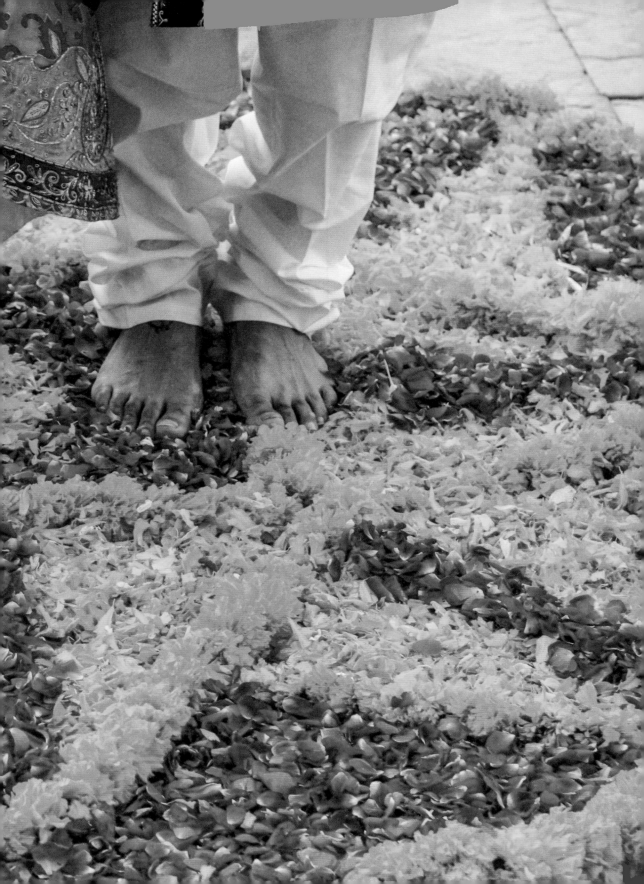

ROSE

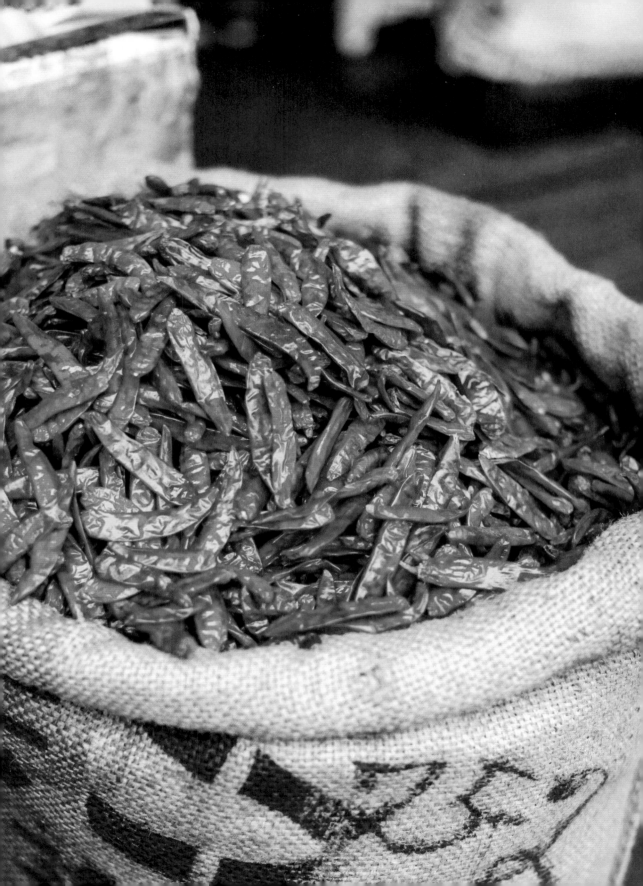

From the overflowing bushels of dried red chili peppers at the market to the soaring dusky-pink Hawa Mahal, Rajasthan basks in hues of rouge, blush, fuchsia, rosewood, coral, and magenta. The pink and red sandstone from the region's numerous quarries that was used to build Jaipur may have initially contributed to its reputation as the Pink City; then in 1876, awaiting a visit from Prince Albert of Wales and Queen Victoria, Maharaja Sawai Ram Singh II gave an order to paint the entire city pink, the color of hospitality. The maharaja's favorite wife fell in love with Jaipur Pink, and with her encouragement it became illegal for buildings to be painted any other color. The law remains in effect today, and though time has weathered many exteriors throughout the old city, it still holds its pink glow. The spirit of hospitality is alive and well in the city of Jaipur, whose residents warmly welcome throngs of tourists from across India and abroad. Visitors easily fall in love with it, which is why my husband and I chose it as the city in which to hold our Hindu wedding.

My husband and I recited our wedding vows in an intimate ceremony in Jaipur. We were draped in pink rose garlands and stood atop a magnificent *rangoli* of marigold and rose petals. Often seen at weddings, celebrations, and festivals, *rangoli* is an art form in which patterns are created on the ground using flower petals, colored sand, or rice. Our carpet of blooms added a rich flourish to our otherwise simple ceremony. Touches of red colored the day as is tradition, to bring prosperity, fertility, purity, and passion to our marriage. In a traditional Hindu wedding ceremony, a red turban is worn by the groom, a red *bindi* is affixed to the bride's forehead to signify her status as a married woman, and *sindoor*, a vermilion red powder, is applied to the bride's hairline by her husband to signify her married status. From that day forward, a married woman traditionally applies *sindoor* until she is widowed. Some brides choose to wear a *lehenga* or a *ghagra*, a full-length, embellished flared skirt, along with a *choli* bodice and an *odhani*, a head covering also used as a veil; however, most brides wear a red sari often adorned with gold accents to highlight elaborate bridal jewelry. The sari, unstitched and gracefully

← Sacks of dried chili pepper, an essential ingredient in Rajasthani cuisine.

draped, is perhaps India's most iconic article of clothing. Using a single piece of cloth to create elaborate garments—the turban, *lungi* (length of cloth worn around the waist), *dupatta* (scarf worn to cover the head), and *odhani*, to name just a few—is a distinct trait of Indian dress.

India is a land blessed with an abundance of materials for natural dyes, ranging from pomegranate and walnut to indigo and Himalayan rhubarb. Indian artisans were some of the first in the world to develop methods for not only extracting dyes from their surroundings but also using mordants to adhere dyes to cloth and maintain their vibrancy. The Indian craftsman's knowledge of mordants was vital to India's dominance in the textile market and remained a closely guarded secret for a long time. The pink and red color family is especially valued in the art of natural dyeing, and the root of the maddar plant, one of the most ancient dyes on record, is used to produce a vibrant range: Turkey red, mulberry, and terra-cotta. Derived from the resinous secretion of insects, lac is another brilliant red natural dyeing agent with a long history in India. Crimsoned-colored fabrics were reserved for royalty and wealthy courtiers because of the level of skill required to achieve such vibrant hues.

→ Details of the elaborate frescoes of Ganesh Pol, the entry to the private palaces of the maharajas at the Amer Fort.

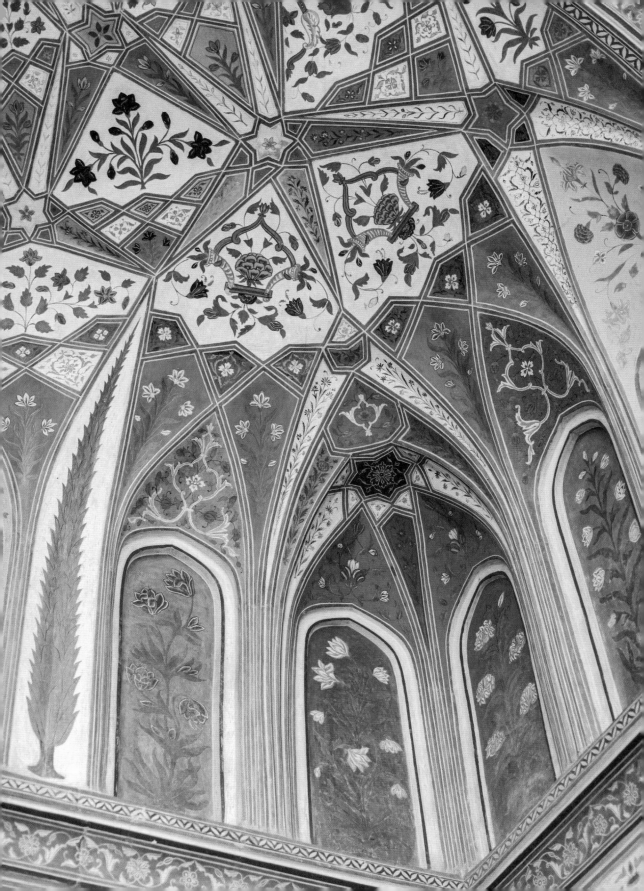

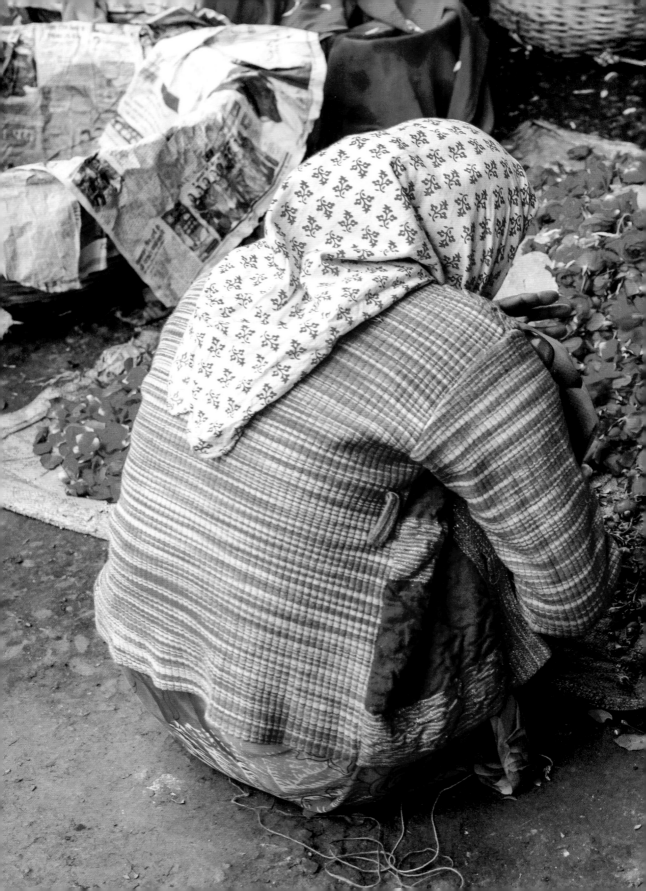

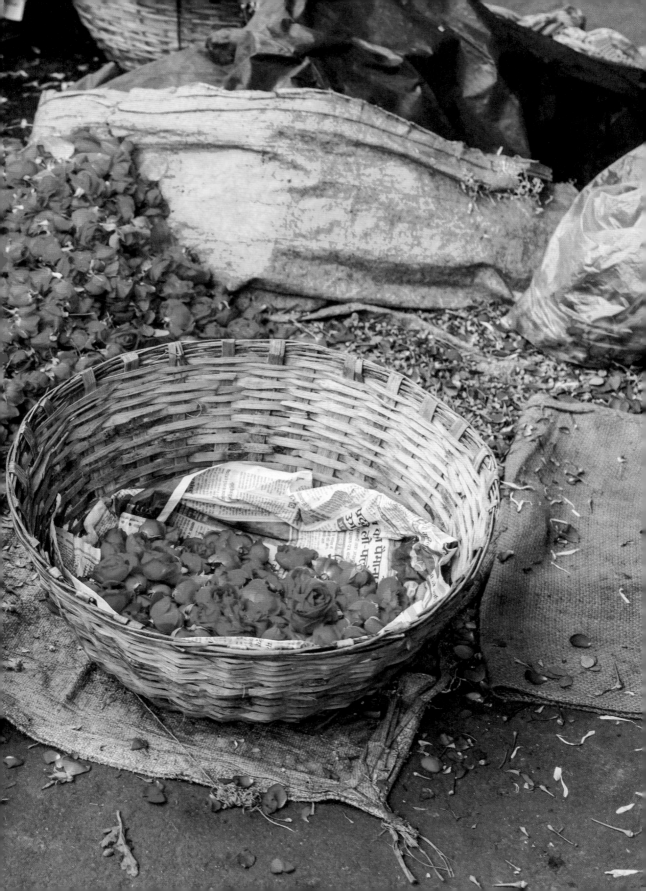

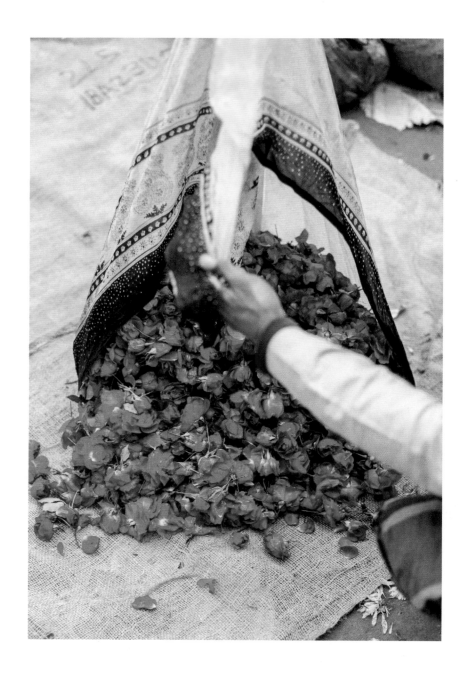

⟵ ↑ A vendor prepares a pile of rosebuds for garland making.
→ Portrait of a woman in rural Rajasthan.

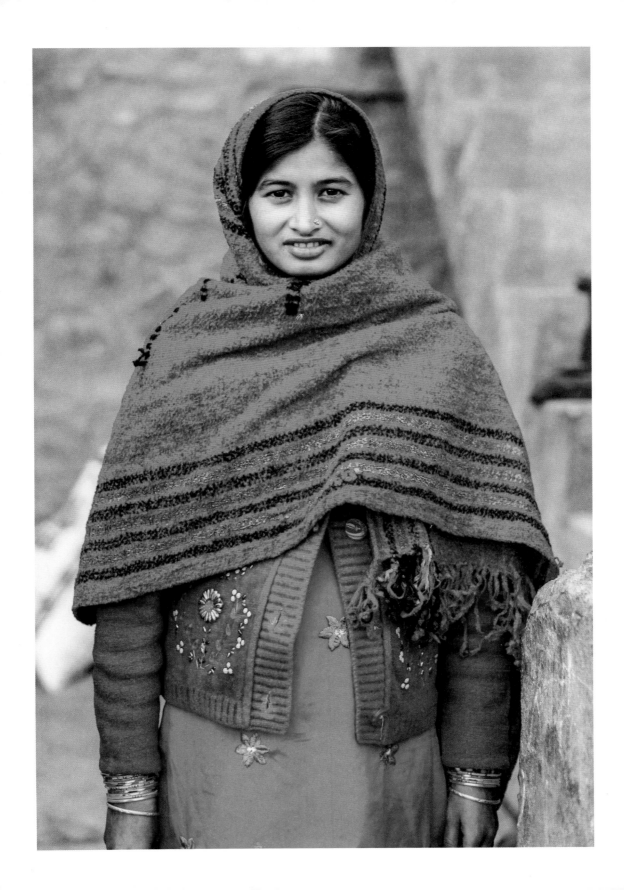

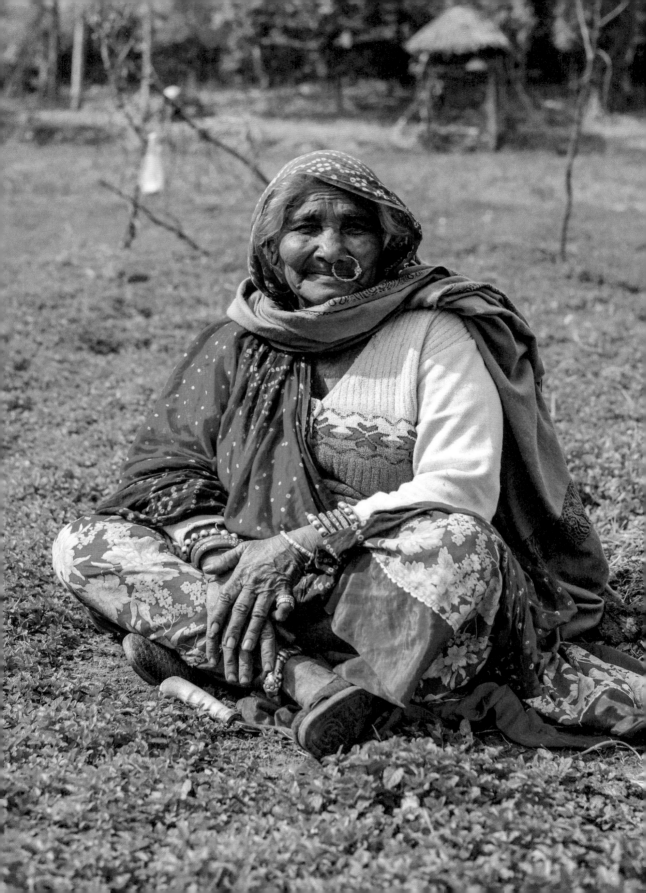

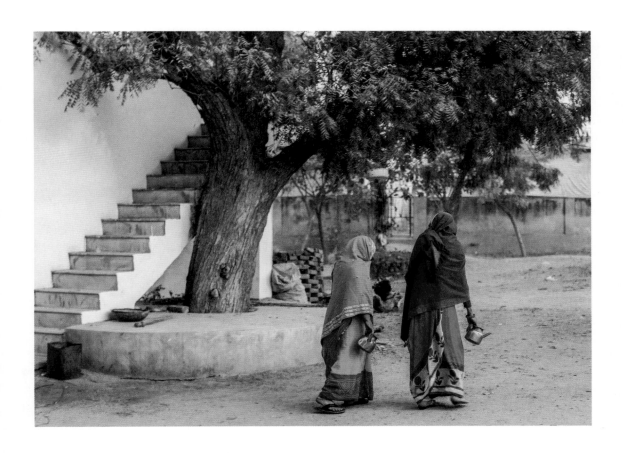

← Portrait of a farmer in a village near Udaipur.

↑ Women in Bagru collect water for their morning chai.

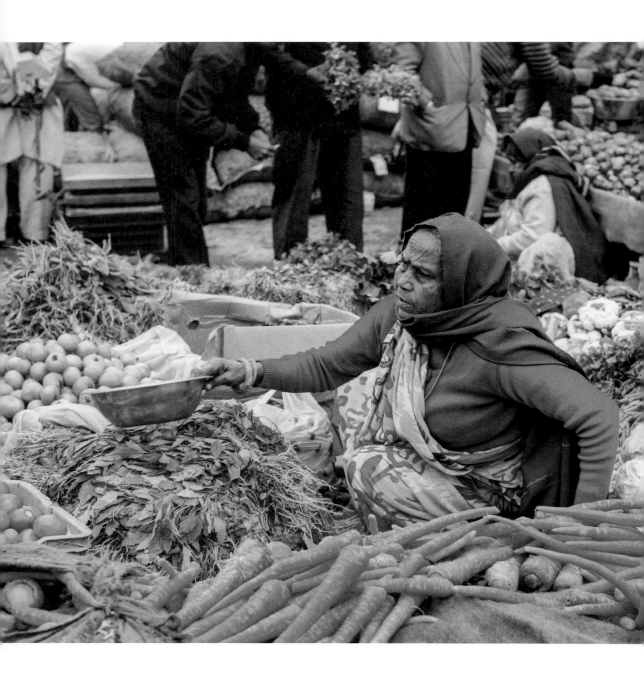

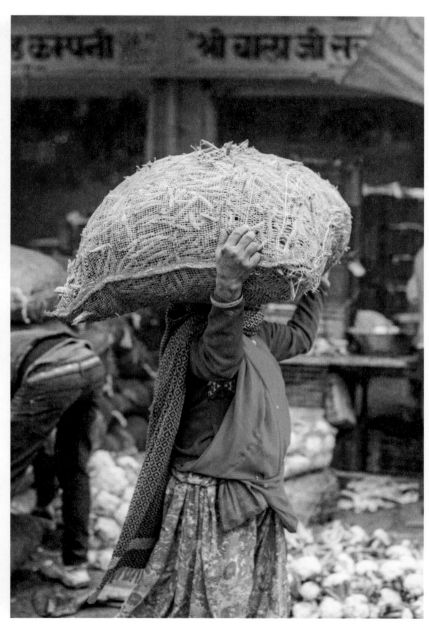

←↑ Women from the surrounding villages bring their
goods to the Jaipur vegetable market.

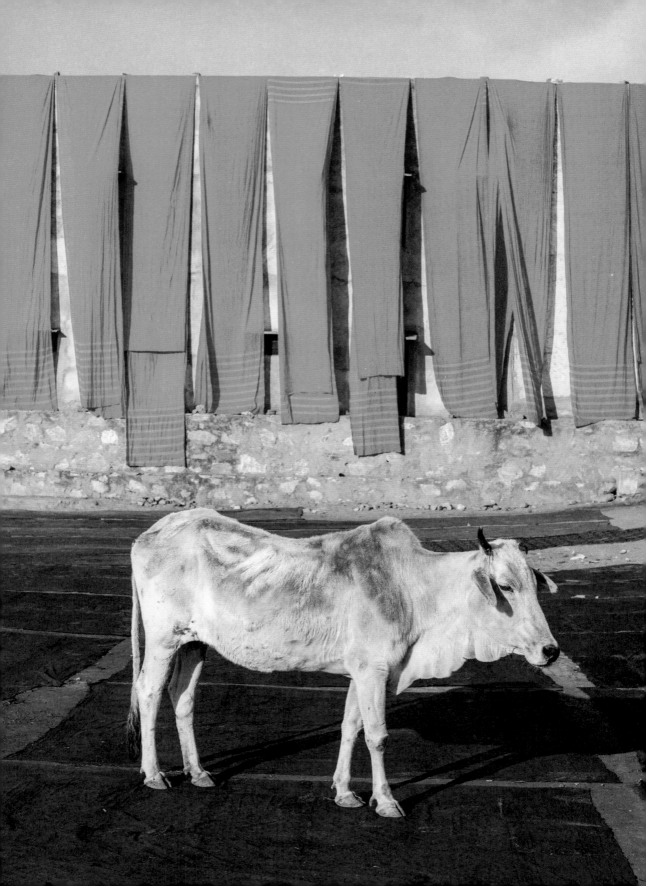

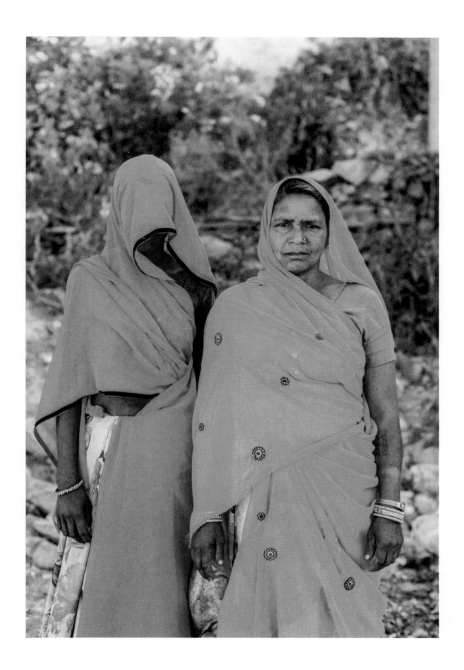

← Freshly dyed fabrics dry in the sun on rooftops in Bagru, where artisans have been printing and dyeing fabric for over 350 years.

↑ It is tradition for a married woman in rural Rajasthan to cover her head with a *ghoonghat* (a veil or a headscarf) as a sign of modesty.

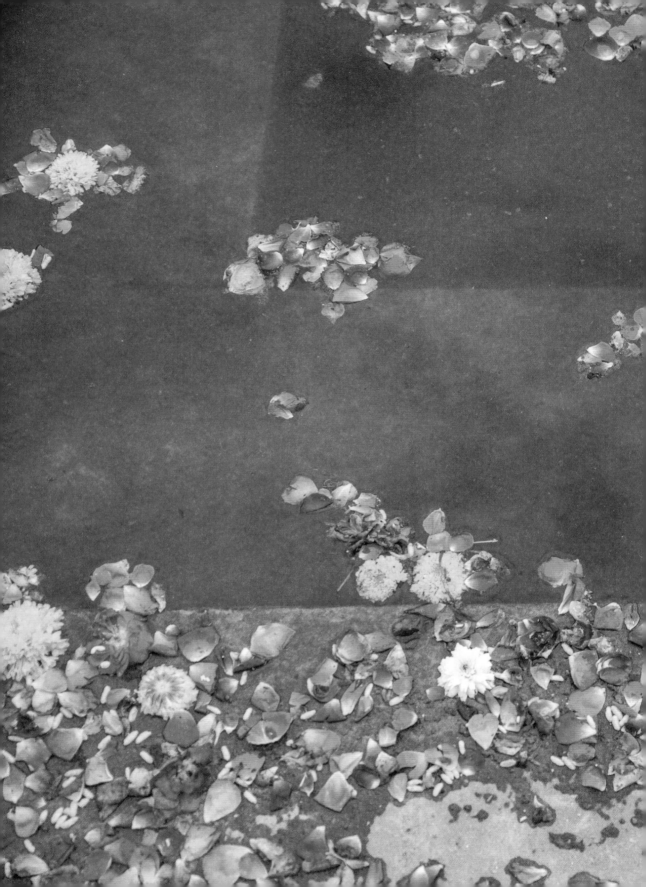

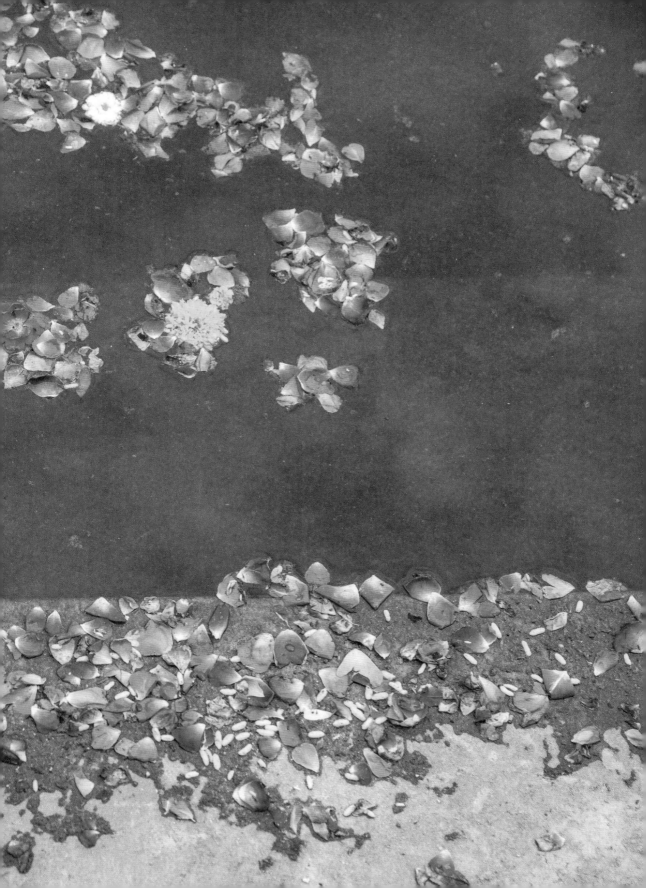

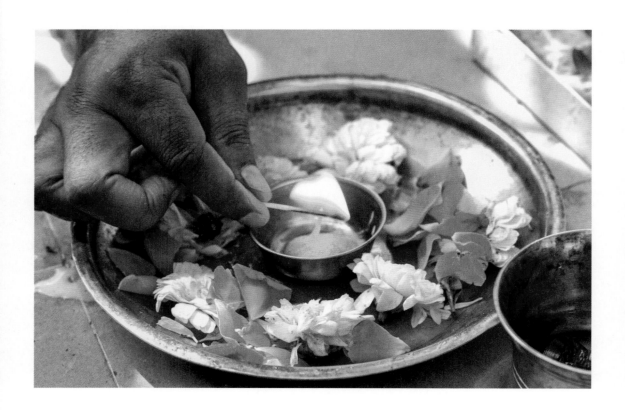

← Rose petals and marigold blooms, the remnants
of offerings, float on the surface of Pushkar Sarovar, one
of the holiest lakes in India.

↑ A *pujari* (Hindu priest) lights an offering during a *puja*.

→ The Rajput style of painting evolved in the
royal courts of Rajasthan and can be found on the walls
of palaces, forts, and havelis.

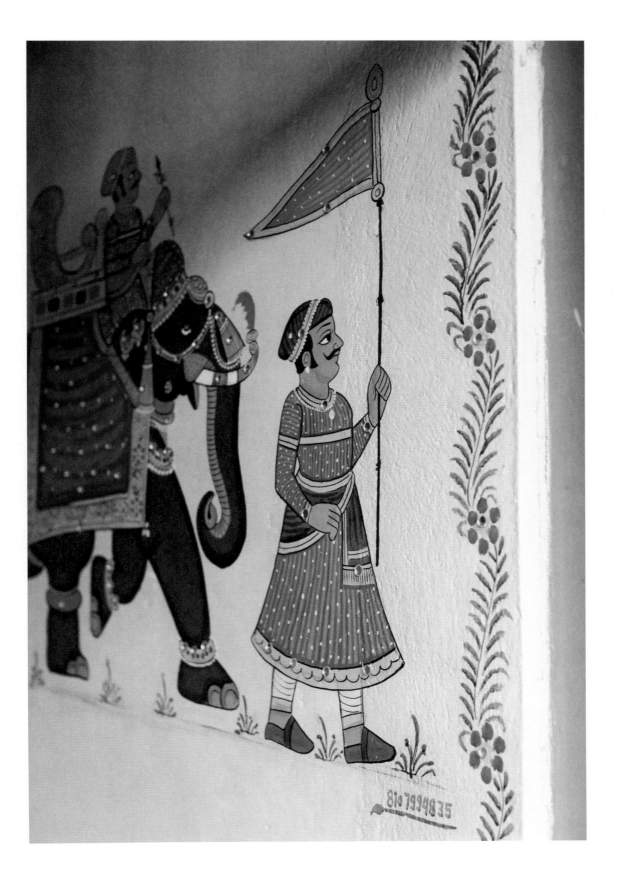

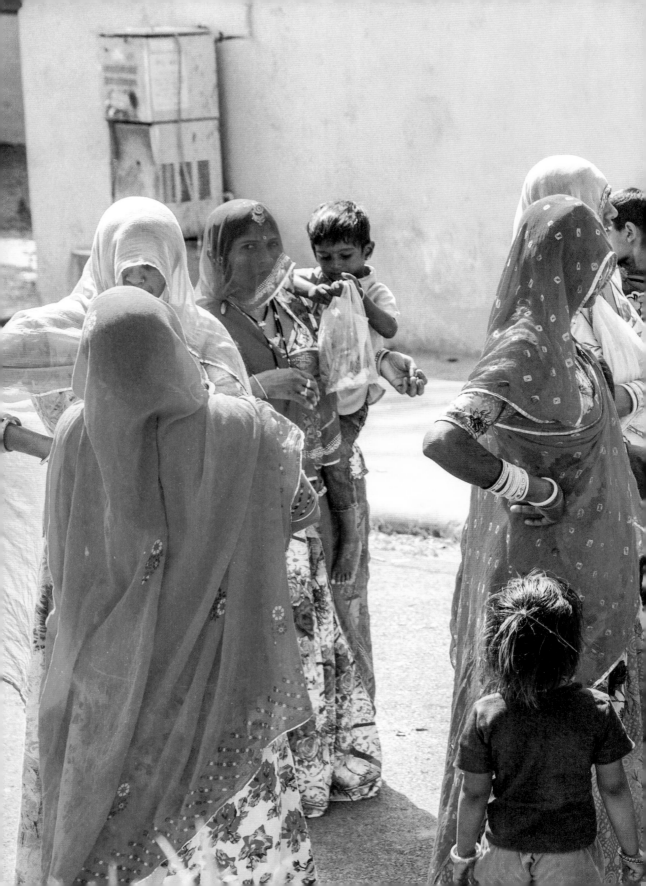

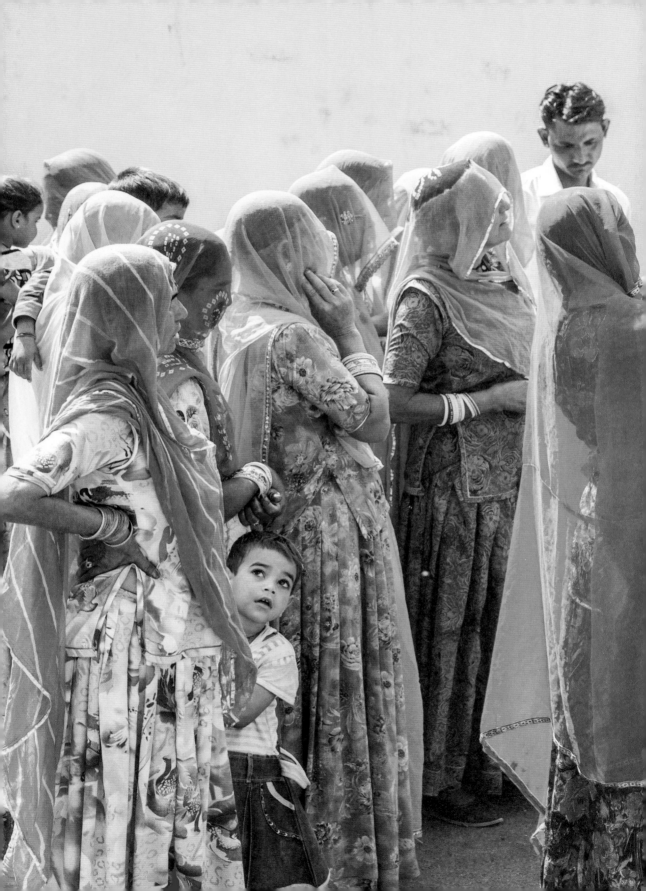

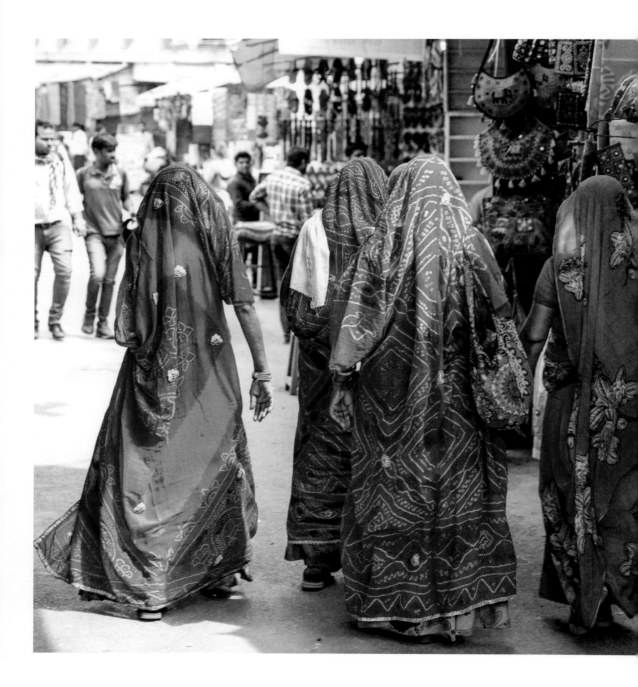

⟵ Women wearing colorful silk *ghoonghats* gather for
a celebration in Jodhpur.

↑ Women on a pilgrimage to Jagatpita Brahma Mandir in Pushkar.

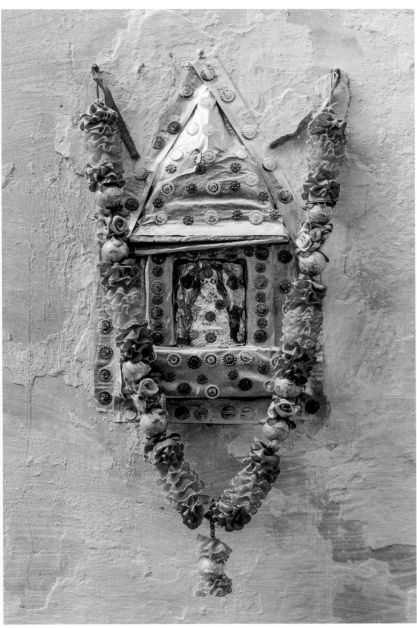

↑ Most Hindus have a small shrine like this one in their homes and workplaces where they can worship daily and receive the blessings of the deities.

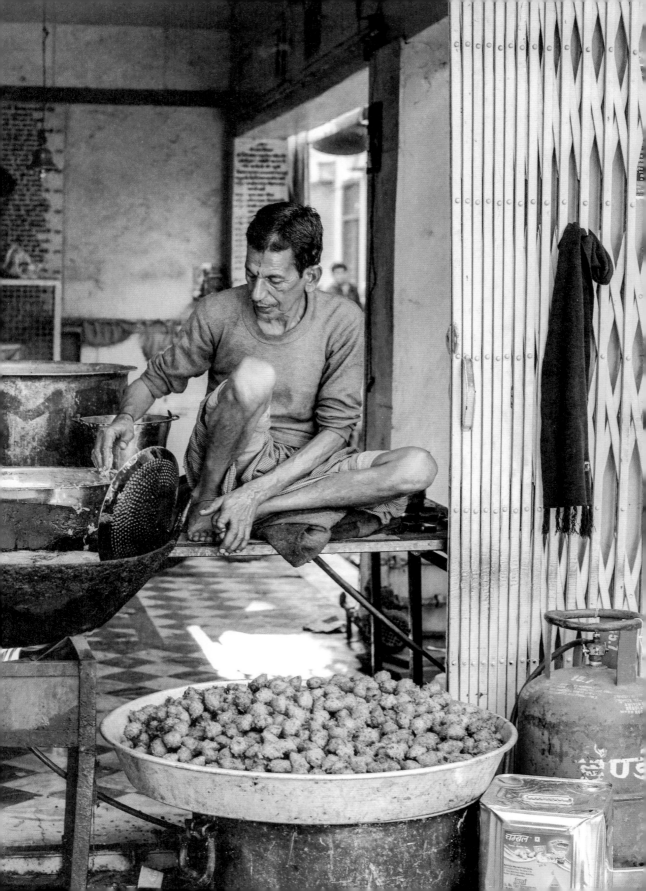

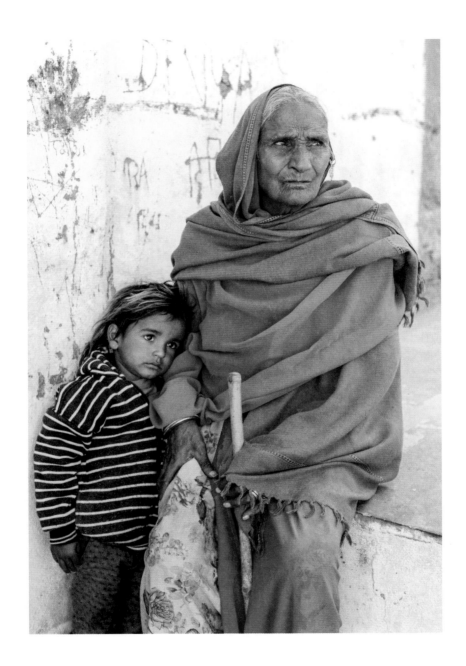

← A food vendor tends to a vat of boiling oil, in which he stirs
and strains fried snacks.

↑ A great-grandmother and her great-grandson pass the afternoon on
the porch of their joint family home in a village outside Udaipur.

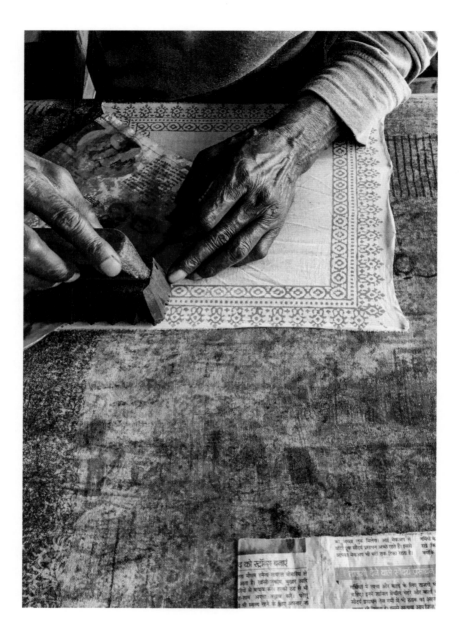

↑ To apply the dye evenly, the printer lines up the block with his fingers and then hits it firmly with the heel of his hand.

→ The number of blocks needed for a design depends on how many colors are in the print. These four blocks are used together to make a print featuring four colors.

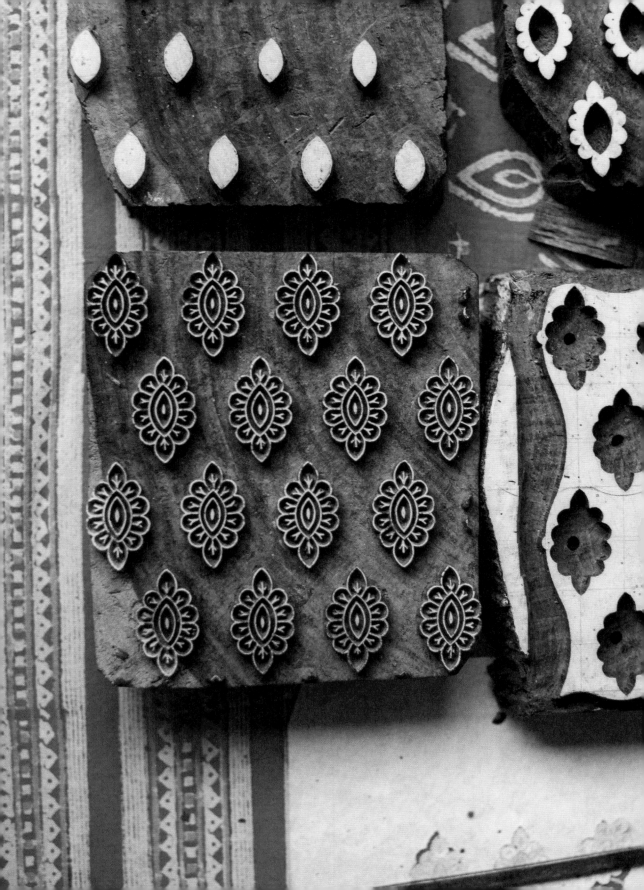

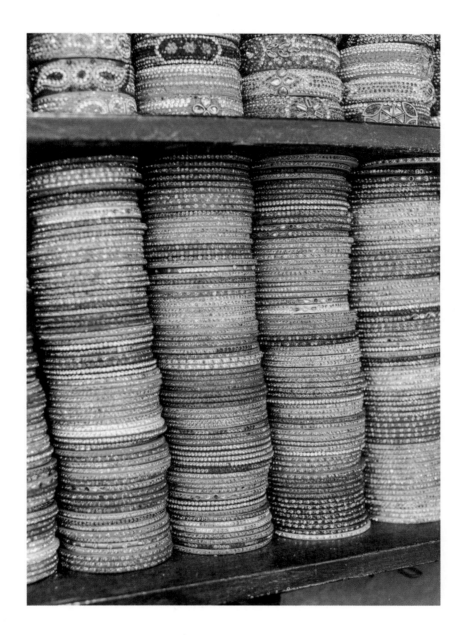

← The aptly named 51 Shades of Pink dining room in the Suján Rajmahal Palace features custom wallpaper.

↑ Stacks of bangles for sale at a market stall.

⟶ Block-print fabric samples on display at Bagru Textiles, a workshop founded by fifth-generation dyer and master printer Vijendra Chhipa.

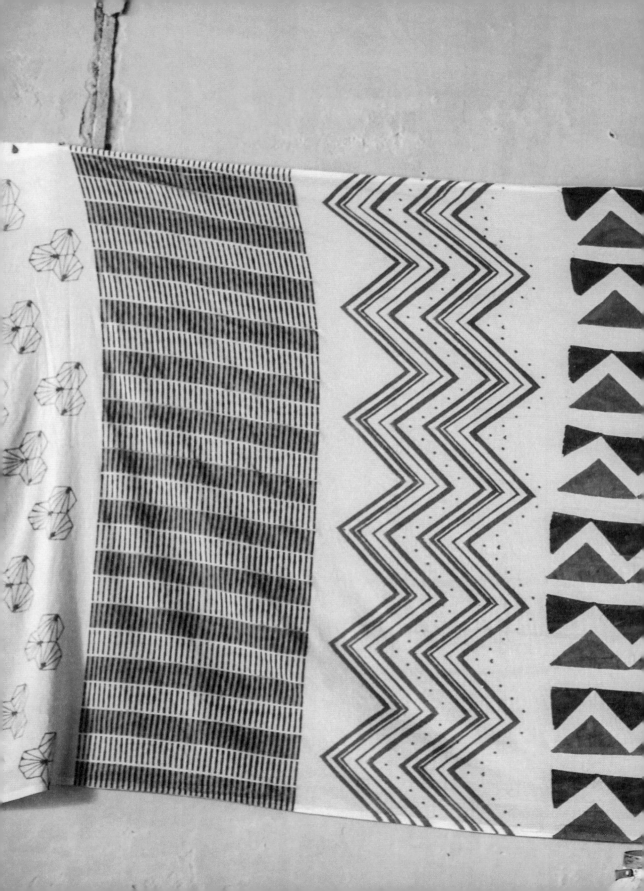

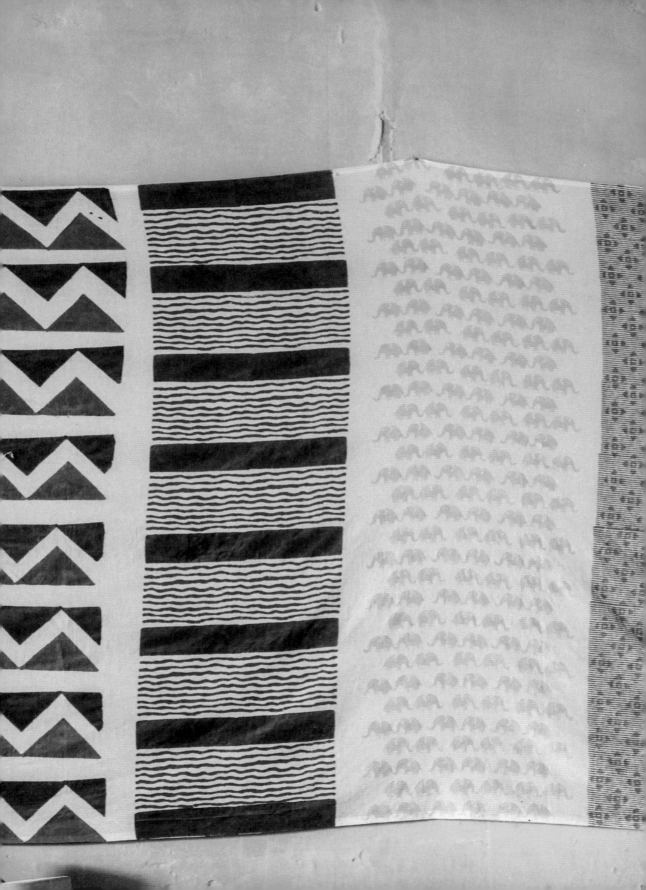

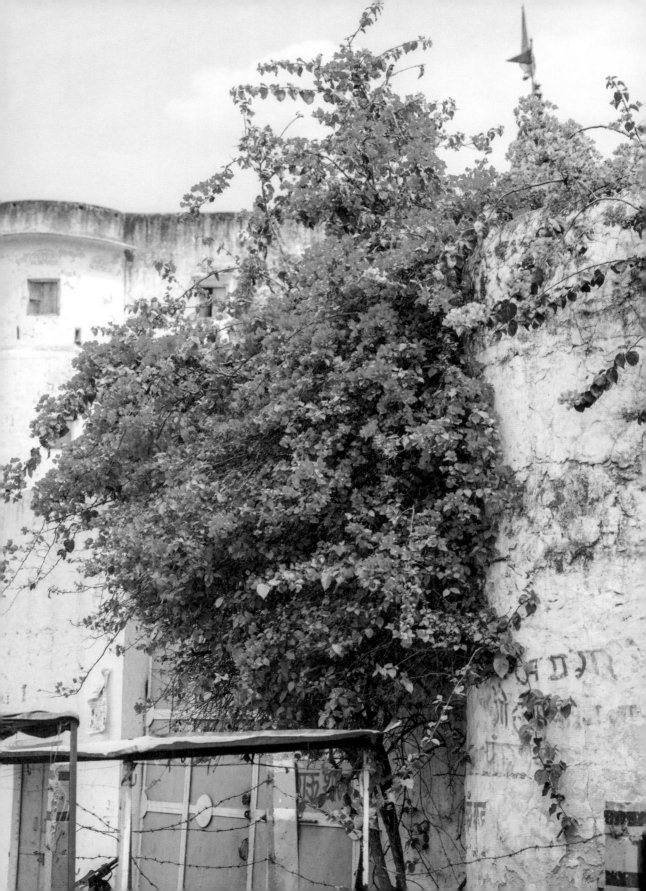

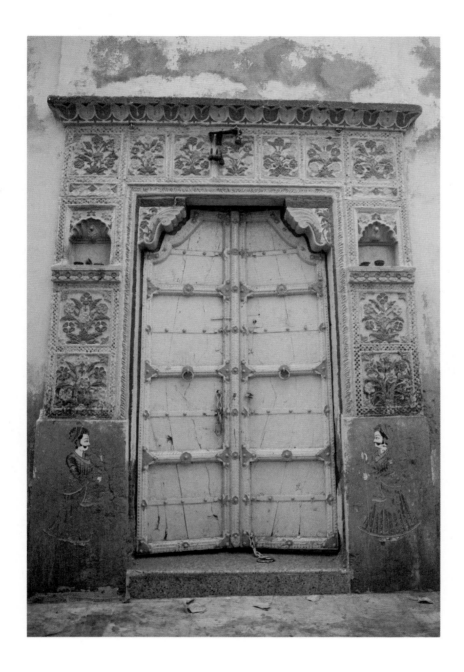

← Bougainvillea spills over the doorway of a home in Pushkar.

↑ Standing out from the sea of blue, this pink door in Jodhpur features
intricately carved floral flourishes.

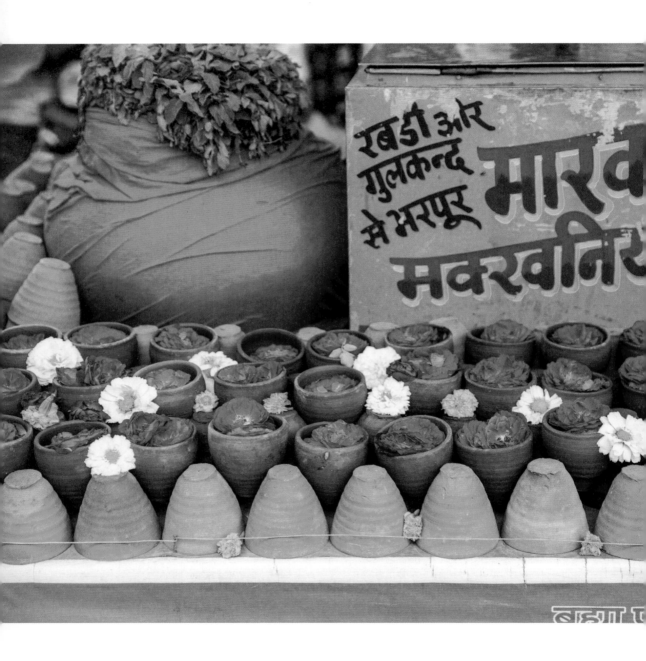

रबडी़ और
गुलकन्द
से भरपूर मारव
मक्खनि

↑ Chai is traditionally served in unglazed, single-use clay cups
called *kulhars* that are smashed on the ground when drained.

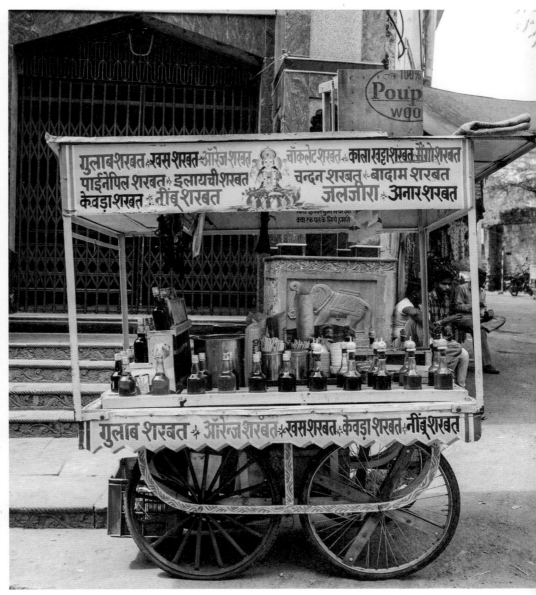

↑ A festively painted food cart serving shaved ice.

⟶ A school in rural Rajasthan featuring a mural of
a world map alongside a mural of Saraswati, the Hindu
goddess of knowledge and wisdom.

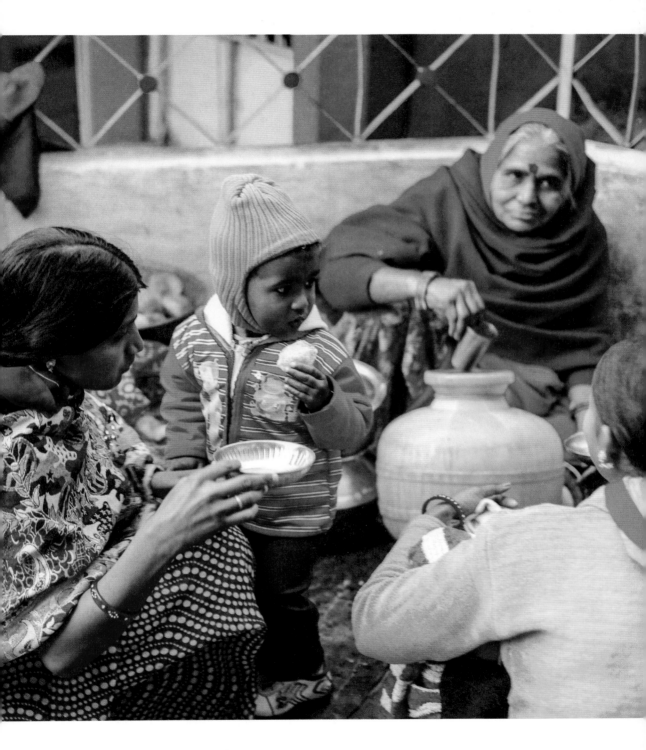

↑ A family gathers for lunch at the Udaipur market.

→ Following inked sketches, a seamstress carefully stitches
an embroidery pattern onto a length of silk.

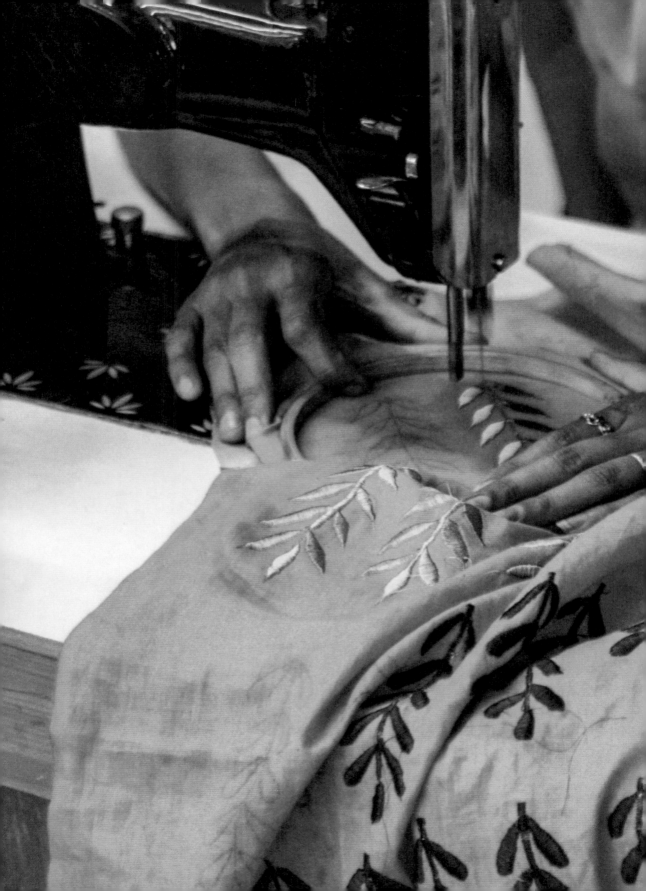

PATTERN & COLOR *in* DRESS

Steeped in customs and rituals, clothing is a complex and storied subject in India, and one of the great characteristics of Indian dress is that style is often imbued with symbolism. Every color, printed pattern, necklace, nose piercing, and bangle holds personal meanings, and what one wears often tells the story of one's homeland, religion, marital status, and occupation. The colors of clothing convey their own meanings: changing seasons, particular celebrations, and even human emotions. A sadhu in a saffron robe, a widow clothed in white, and a Hindu bride dressed in red are immediately discernible by the colors they wear.

Women in Rajasthan traditionally wear a *ghagra*, along with a *choli* and an *odhani*. These garments maintain modesty while still allowing ease of movement for women's work. In the past, specific patterns signaled profession or social standing and made certain groups instantly recognizable; for example, the Mali, a community of gardeners who grew fruits, vegetables, and flowers, wore *ghagras* patterned with vegetation such as marigolds or flower chains. Women in the ironworking community wore *ghagras* bearing a bold repeated pattern of large arrowheads. When social events like fairs, pilgrimages, and festivals brought together different communities, tribes, and religions, these distinctive patterns visually distinguished one group from another through the language of cloth.

India's weavers and dyers have elevated clothing from a fundamental need into an art form and an expression of identity. In many cultures ornate dress is reserved for royalty, yet both rich and poor Indians take pride in wearing fine textiles and elaborate jewelry, even though wealth and social standing dictate the quality of the materials.

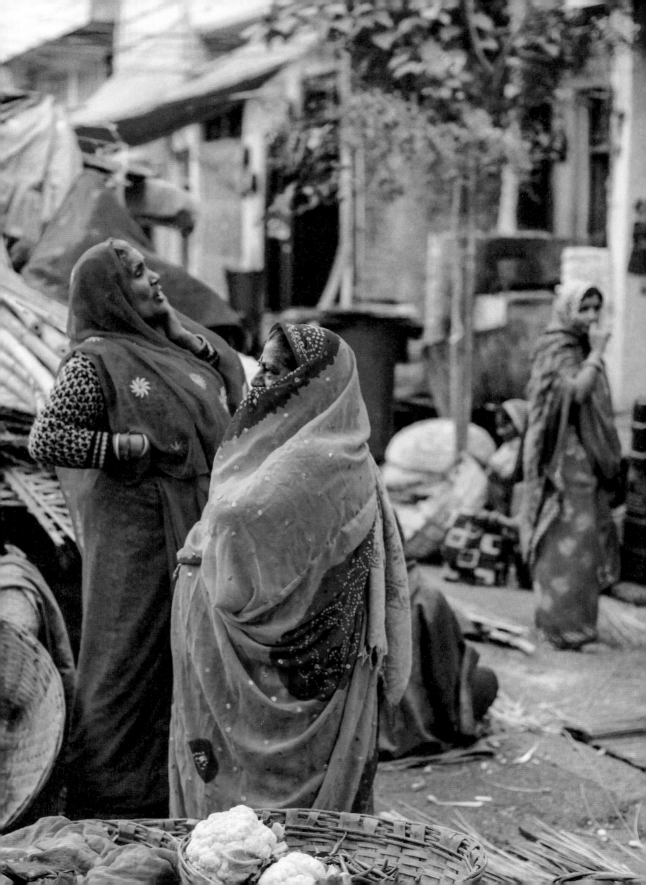

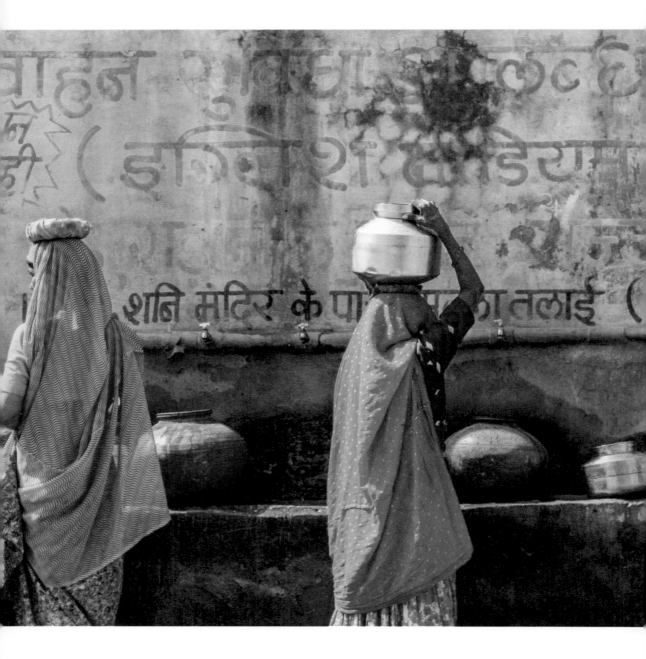

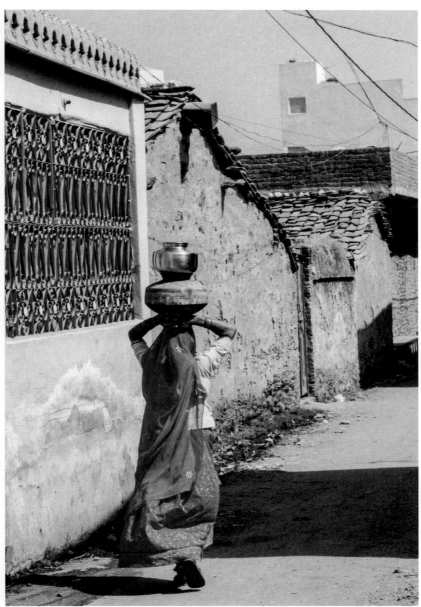

←↑ Women in rural Rajasthan often have to make multiple trips to a
local well or other source for a day's supply of water needed for drinking,
cooking, bathing, and doing laundry.

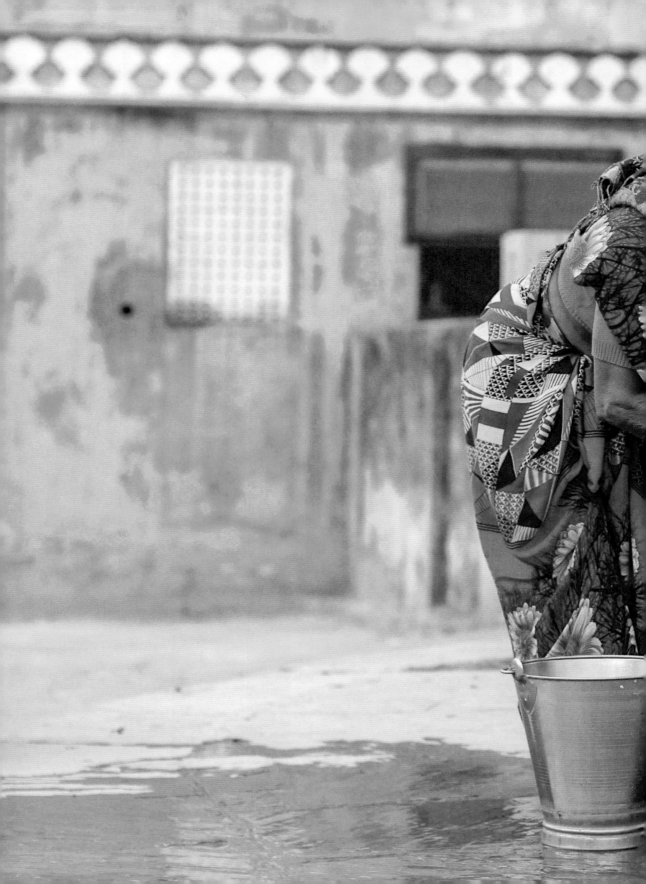

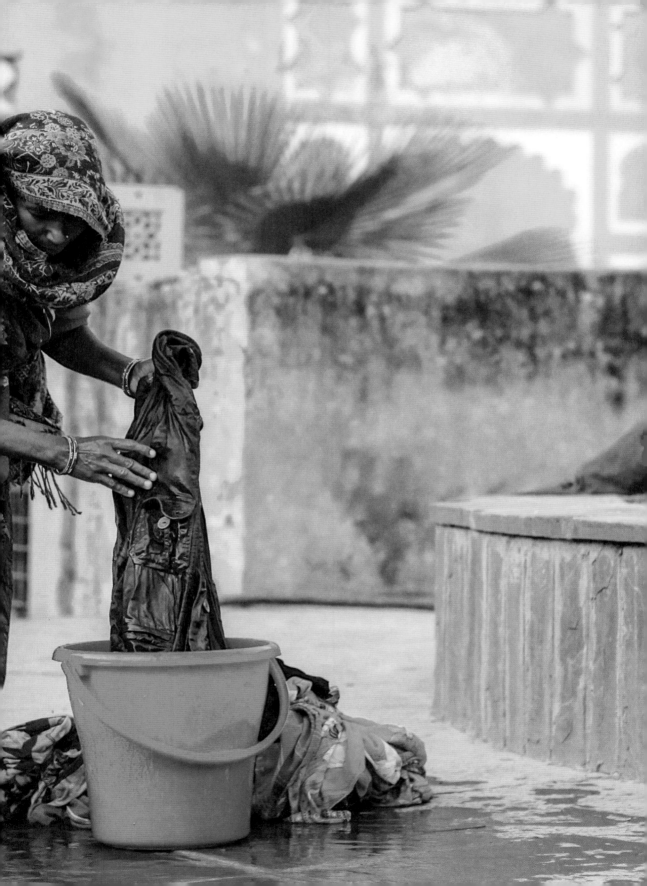

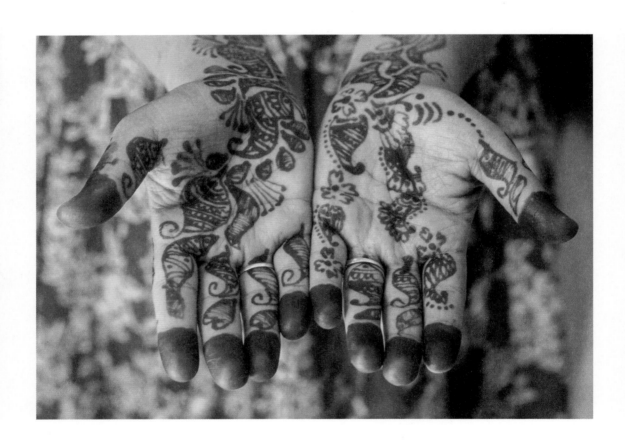

↑ *Mehndi* is typically applied during Hindu
wedding celebrations and festivals.

→ Sacks of red chili pepper fill the market air with their
spicy, eye-watering fragrance.

↑ Rice, grains, and other dry goods for sale at market.

→ A royal elephant painted in a doorway of a home in Jaipur.

⟶ The Diwan-i-Khas (Hall of Private Audience) at the Jaipur City Palace is
an open pavilion with marble floors and ceilings decorated in floral scrollwork.

शुभ
रिद्धि

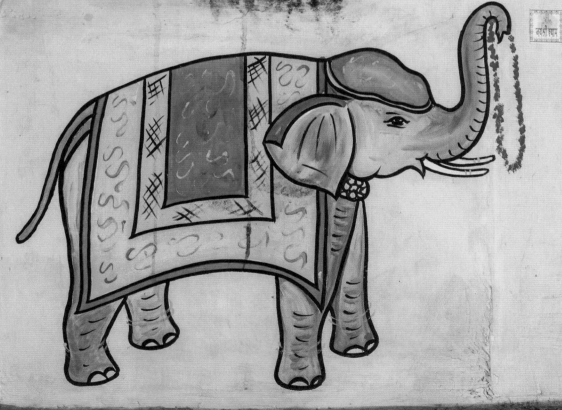

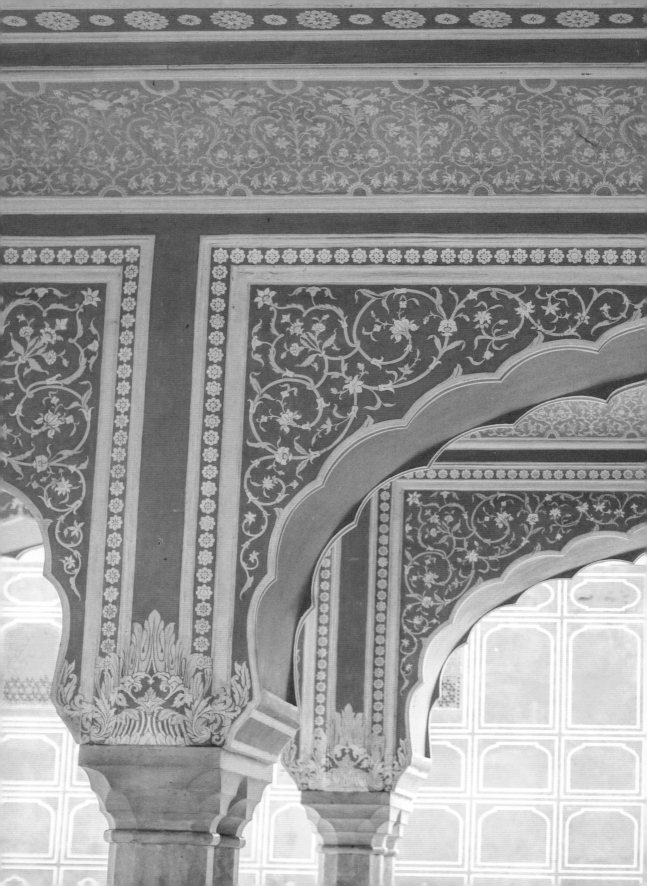

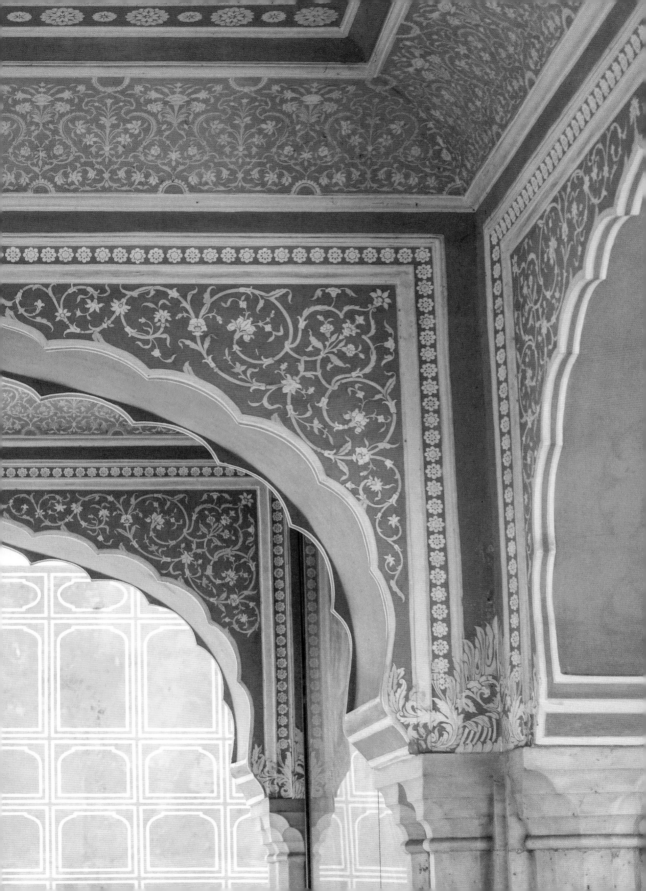

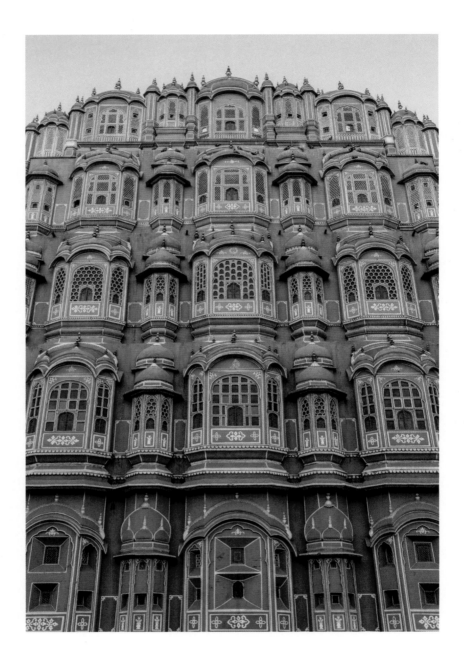

↑ Built from red and pink sandstone, the Hawa Mahal contains 953
jharokhas, a type of latticed window with an enclosed balcony that
projects from the face of the building.

→ Although portions of the Jaipur City Palace are open to the public, most
of the palace is home to the descendants of the former Jaipur rulers.

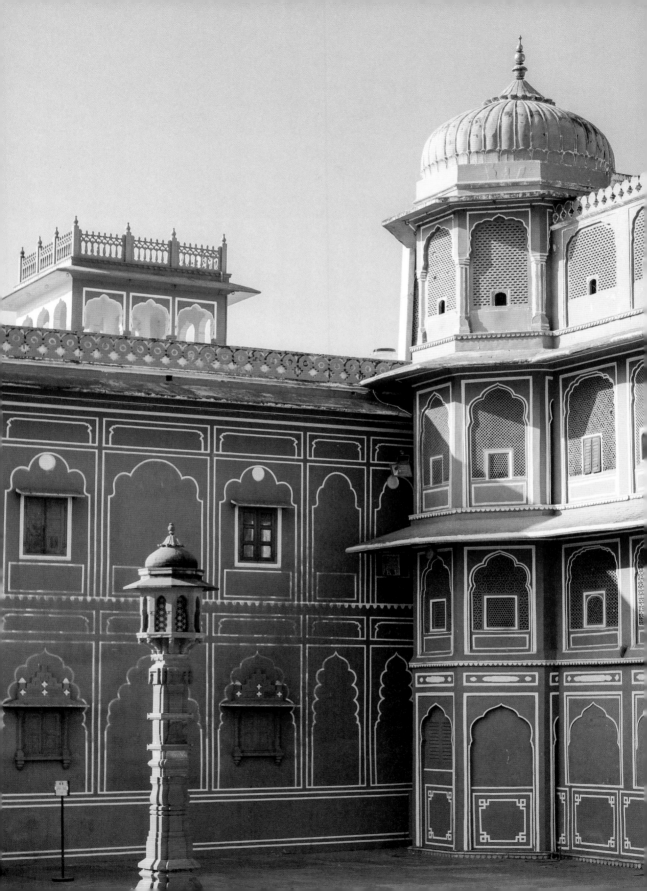

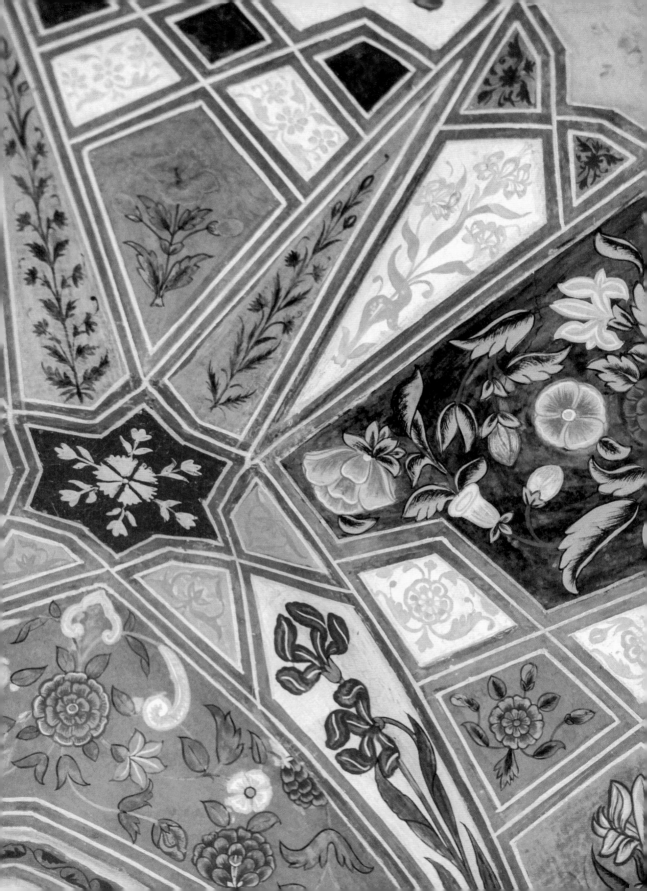

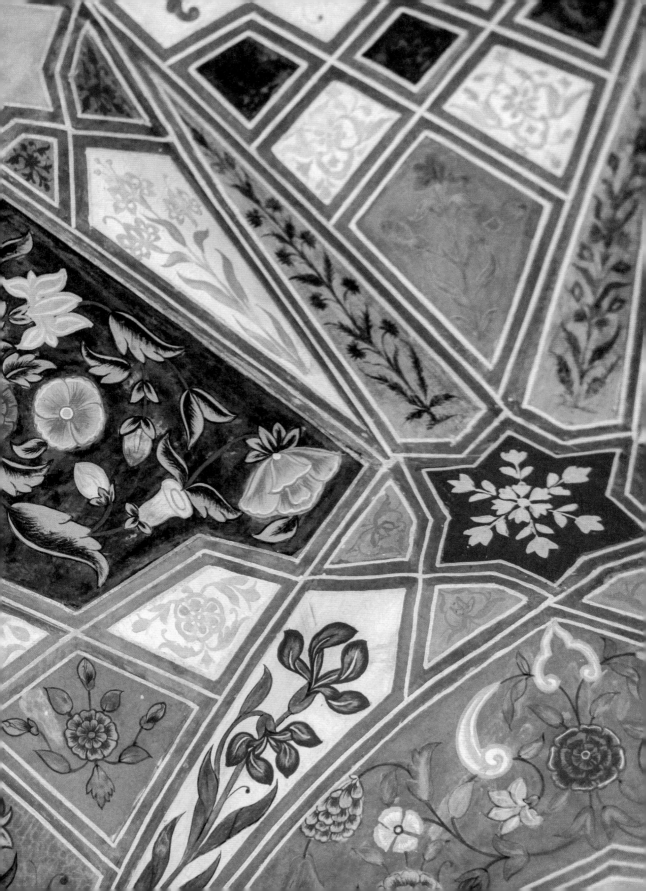

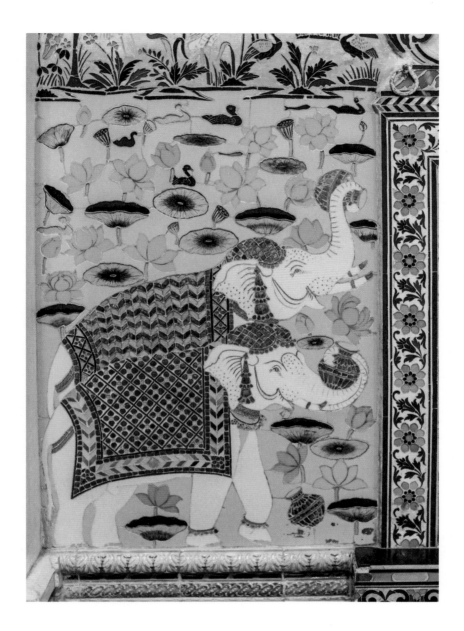

← Caffé Palladio's exquisitely painted murals feature orange blossoms, colorful songbirds, and lush gardens.

↑ Royal elephants are depicted in a mirror-and-stone-inlay mural seen at the Udaipur City Palace.

⟶ Stunning architecture and frescoes make the Ganesh Pol the most magnificent of the Amer Fort's seven gates.

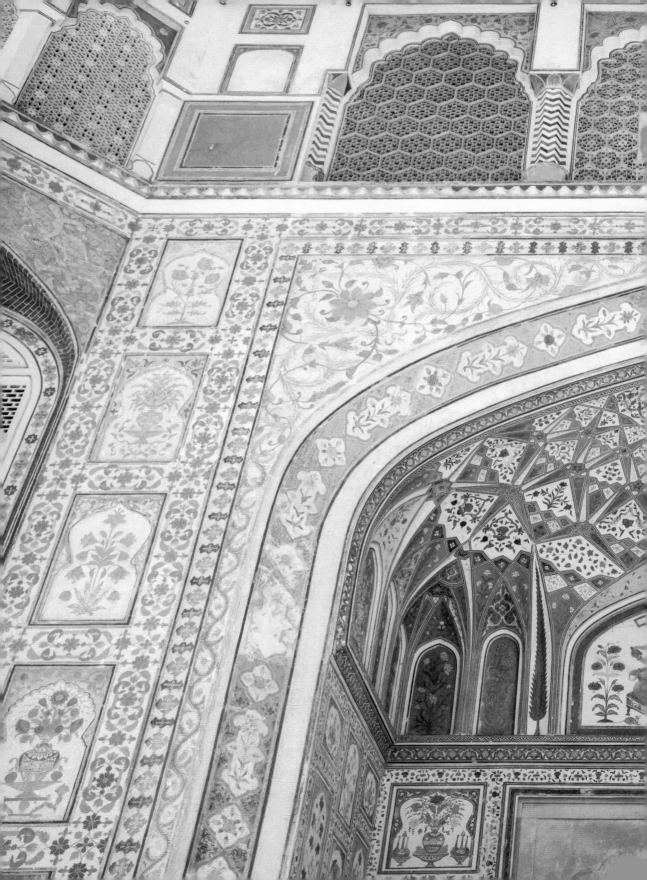

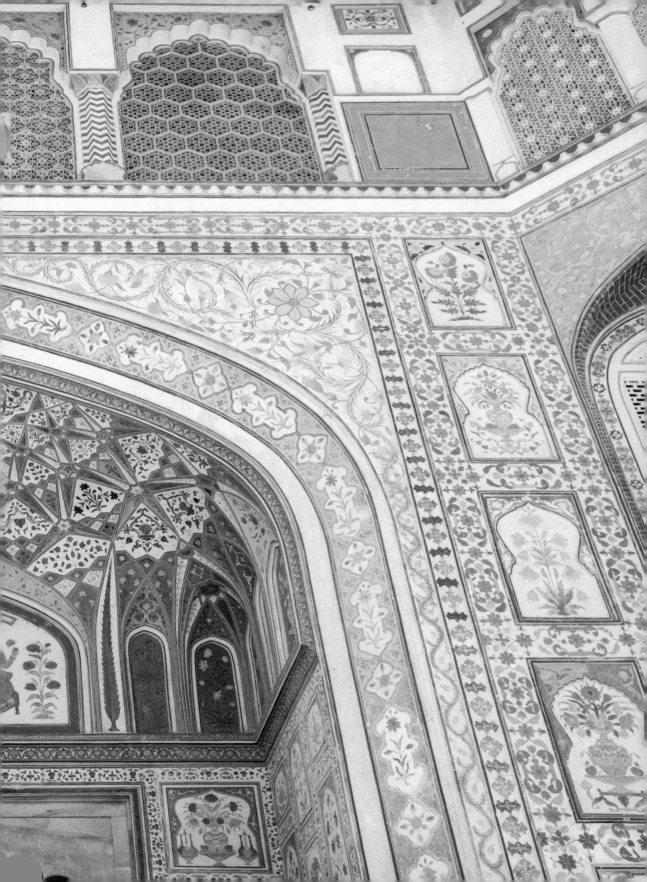

IVORY

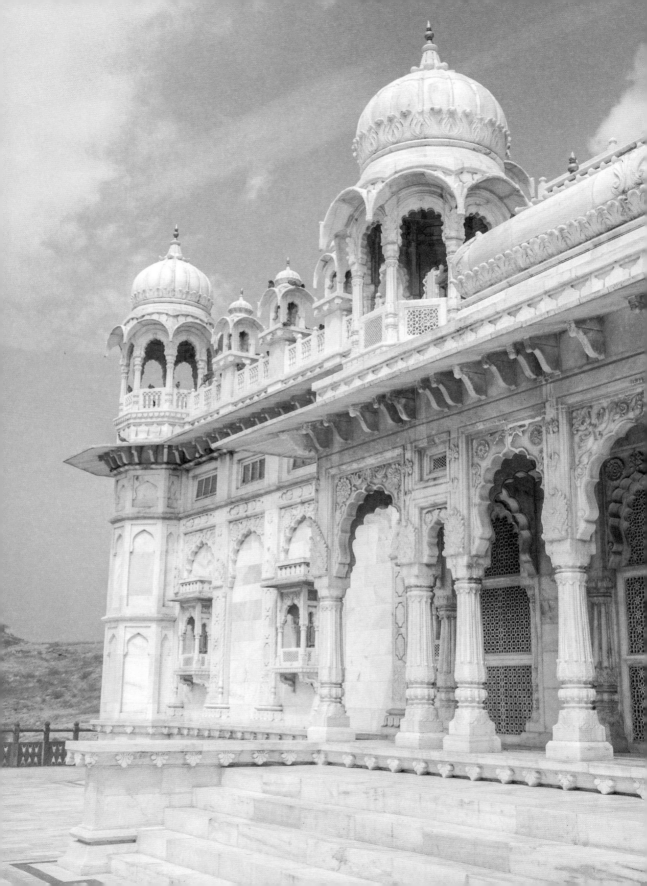

For Hindus, white is the color of mourning, yet its beauty is undeniable. Many of India's most iconic and breathtaking structures are in fact mausoleums, most notably the Taj Mahal, which was built entirely from white marble mined from Rajasthan's famed quarries. Commissioned by the Mughal emperor Shah Jahan for his beloved wife, Mumtaz Mahal, the Taj Mahal stands as a universal testament to the ingenuity of Indian artistry and architecture, and yet, simply put, it is a monument to grief conceived of by a husband in mourning. The mausoleum, completed in 1643, is home to the queen's tomb. Similarly the Jaswant Thada in Jodhpur was built by Maharaja Sardar Singh in memory of his father. The similarities between the Taj Mahal and Jaswant Thada are striking, most noticeably the pristine white marble exteriors. Having visited both in the early morning with the first rays of dawn illuminating the monuments, I was struck by the way in which the sun seemed to set them aglow, warmly igniting the white marble from within. If you manage to beat the throngs of tourists that flock to both, you'll find that the gardens and grounds surrounding the monuments offer quiet spaces for reflection.

Death, grief, and mourning are made visible in India, whether through the building of monuments or the wearing of white cloth by widows. Many Hindus wish to be cremated in Varanasi, a holy city that rises from the banks of the Ganges River. Pilgrims and mourners alike journey to this spiritual capital of India either to bathe in the holy waters of the Ganges or to cremate their dead.

The color white also represents purity, innocence, rebirth, and new beginnings. White textiles represent a blank slate on which to create. The first time I arrived in Bagru, I was excited to experience a community keeping the art of block printing alive. The sun was just rising over the village and my host was pinning a pristine length of cotton cloth to her worktable. The morning was crisp and cool and the latticework windows of the rooftop studio let in only a small stream of sunlight. Throughout the course of the day, I watched as that pristine length of cotton passed

← Jaswant Thada, a striking mausoleum, features marble
latticework, fluted domes, and carved floral patterns in a stunning
blend of Mughal and Hindu architectural styles.

through the hands of the *chhipas, rangrez* (dyers), and *dhobis* (washers).

Between every stage of the dyeing process, each piece of cloth was left to dry in the sun on a vast field in the center of the village, subject to the weather conditions of the day. Cows lazily meandered across the field, oblivious to the fabric drying under their hooves. The variability of the finished product only enhanced its beauty. What started as a pure length of white cotton cloth became something entirely unique and timeless, a testament to the beauty of the handmade.

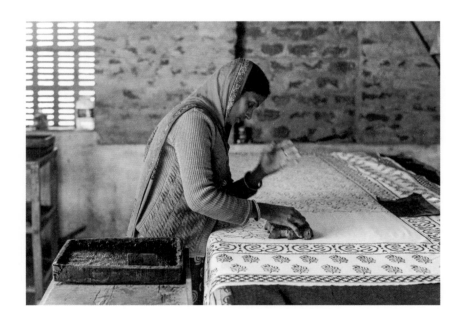

↑ After dipping a wooden block in the dye tray, Sushila Chhipa expertly aligns the block and firmly pounds it with her hand.

→ Block-printed fabric samples at Ridhi Sidhi Textiles.

⟶ The intricately sculpted marble facade of Jaswant Thada is a testament to the skills of the artisans who built the tomb in 1899.

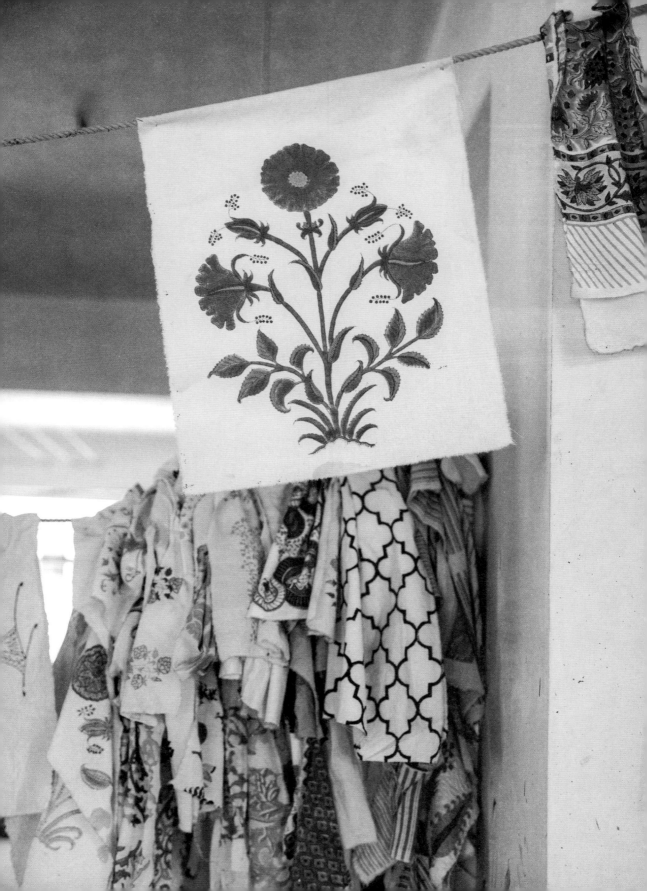

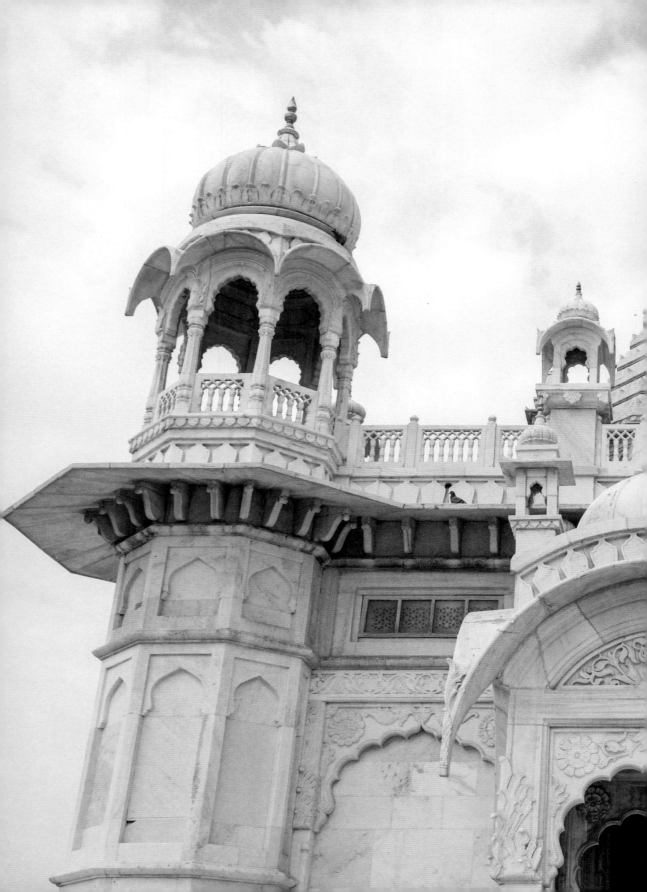

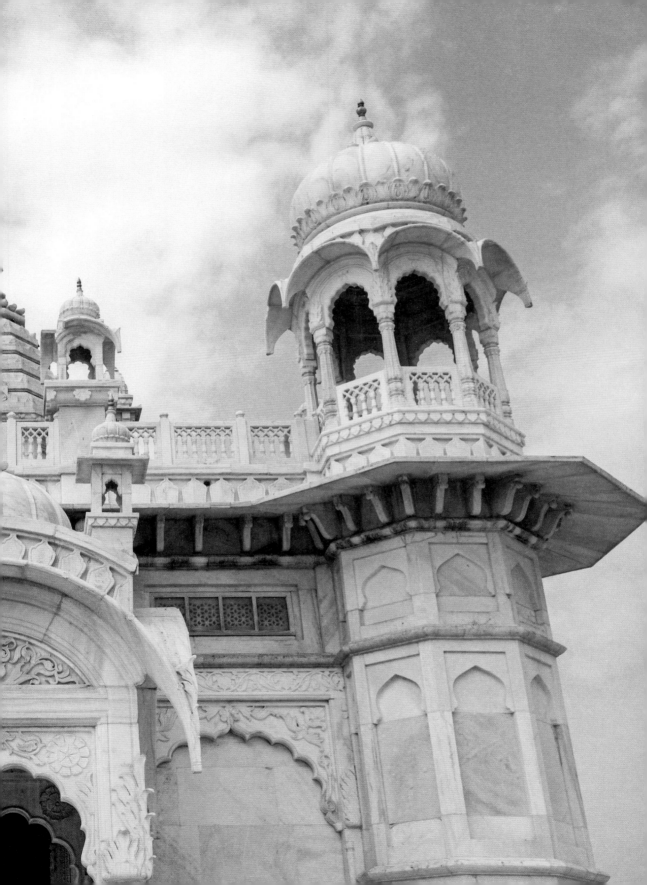

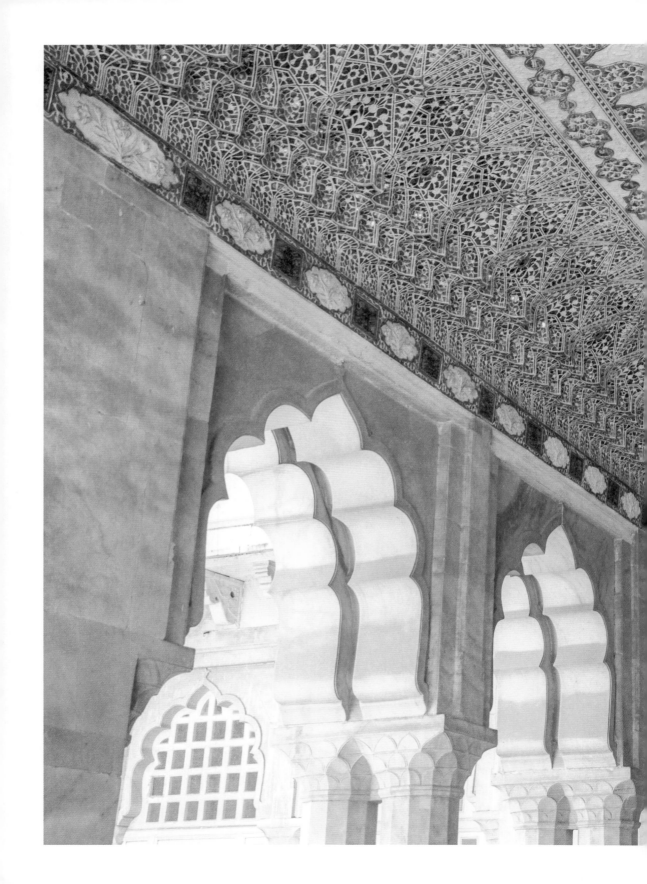

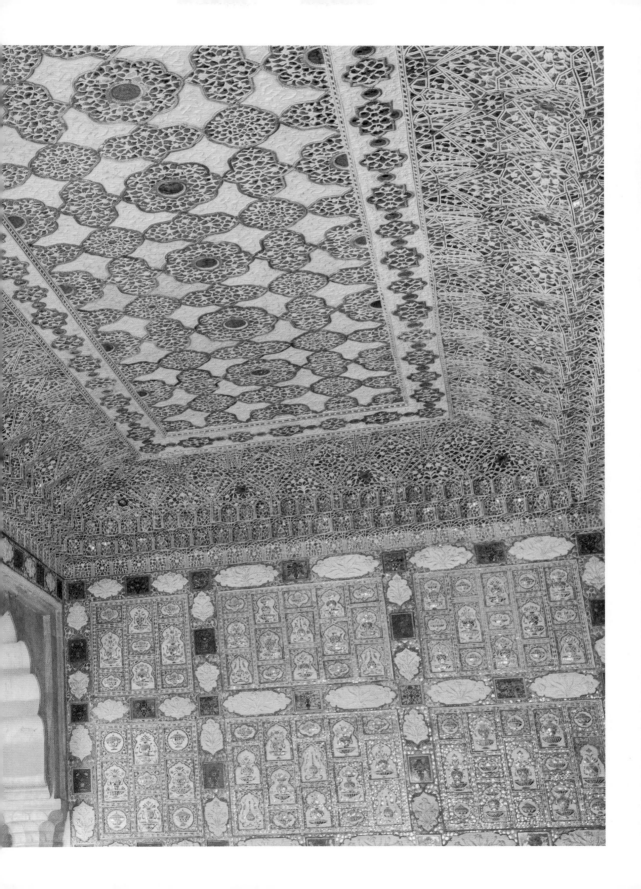

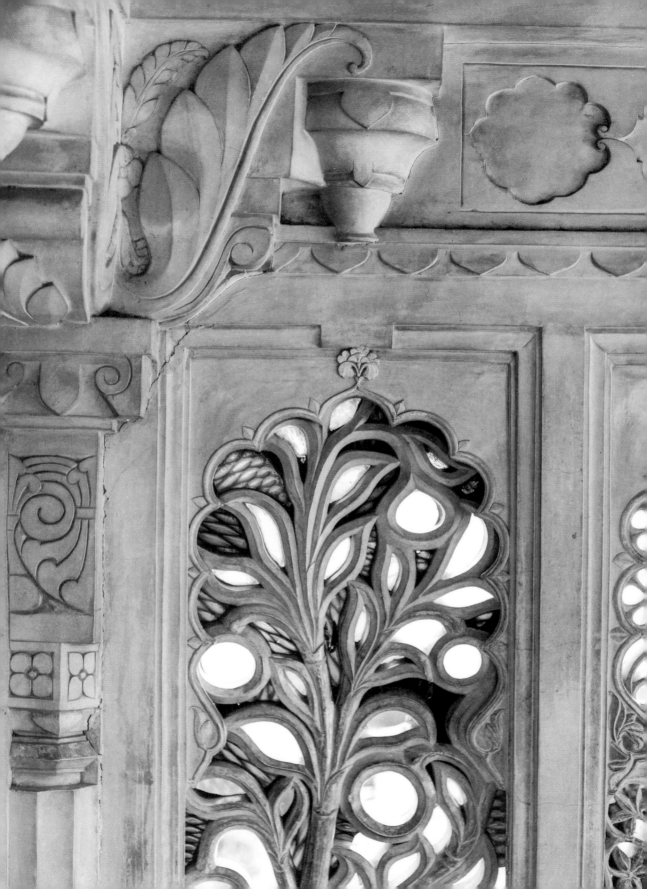

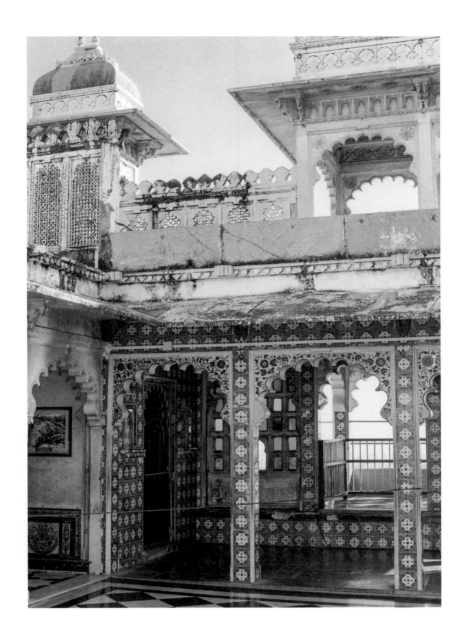

⟵ The Jai Mandir (Hall of Victory) in the Amer Fort is surrounded on
three sides by a veranda featuring extensive mirror work and white marble.

⟵ The carved marble windows of Badi Mahal, the highest point of the Udaipur
City Palace complex, offer stunning views of the city and Lake Pichola.

↑ The blue Chinese tiles and colored-glass windows of the Badi Chitrashali
Chowk (courtyard) at the Udaipur City Palace.

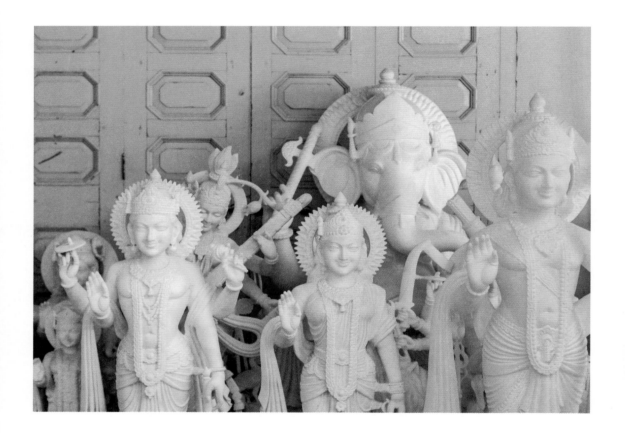

↑ Marble statues of Hindu gods and goddesses, including
Ganesh and Lakshmi.

→ The Ahar Cenotaphs contain nineteen *chhatris,* elevated,
dome-shaped pavilions built as memorials to commemorate the
maharajas who were cremated here.

⟶ The elaborate sculpted interior of the largest *chhatri*
glows warmly from the early morning sun.

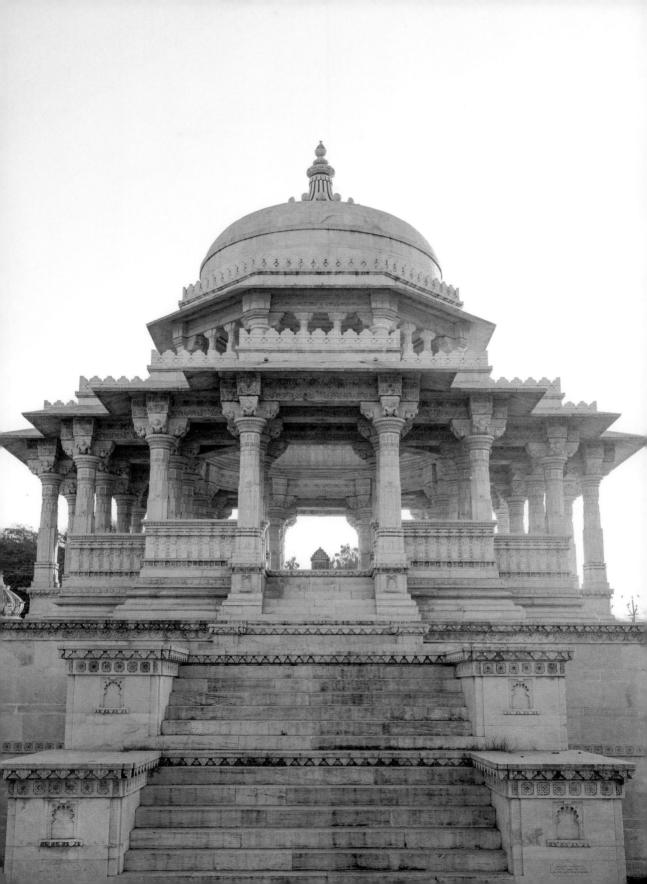

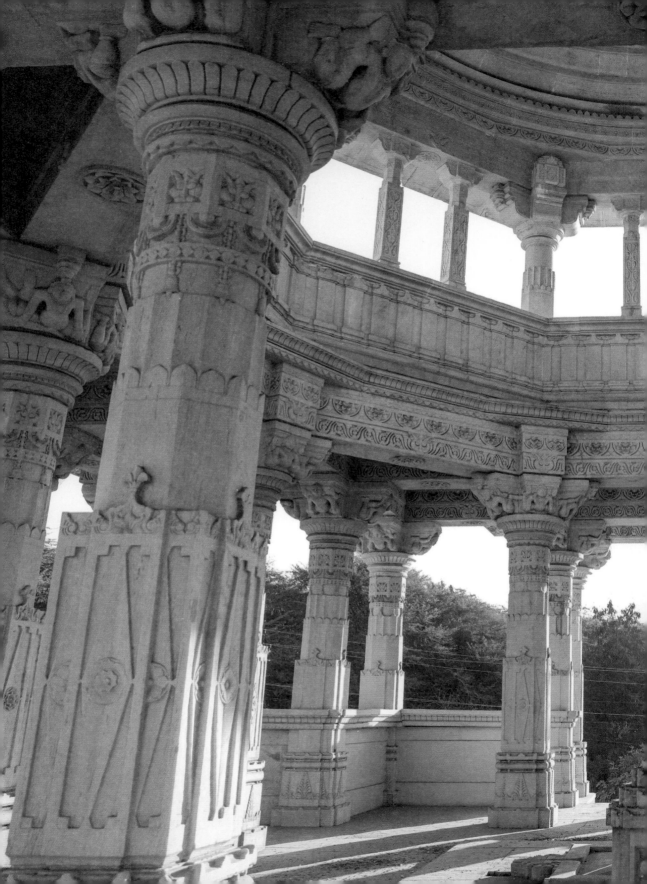

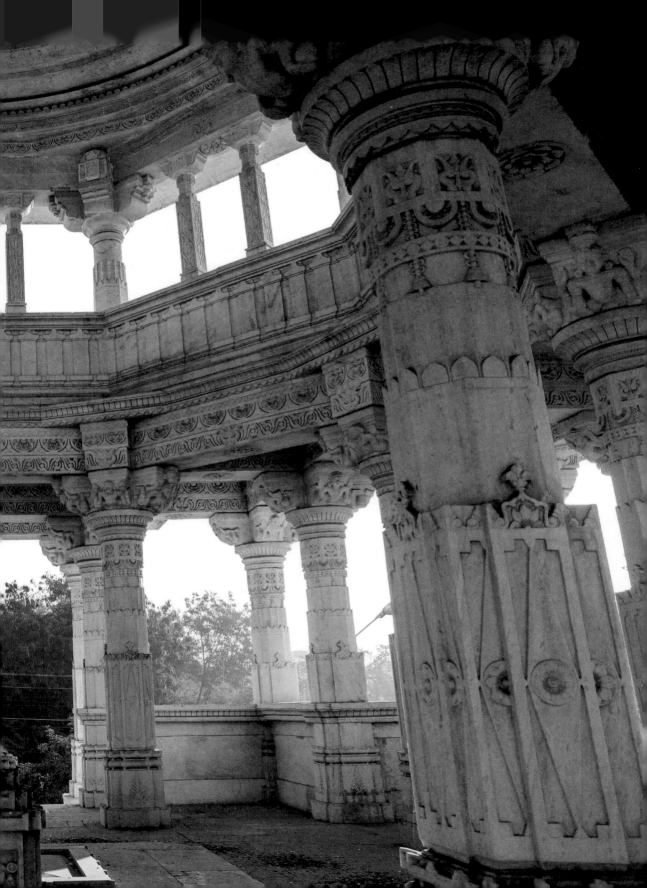

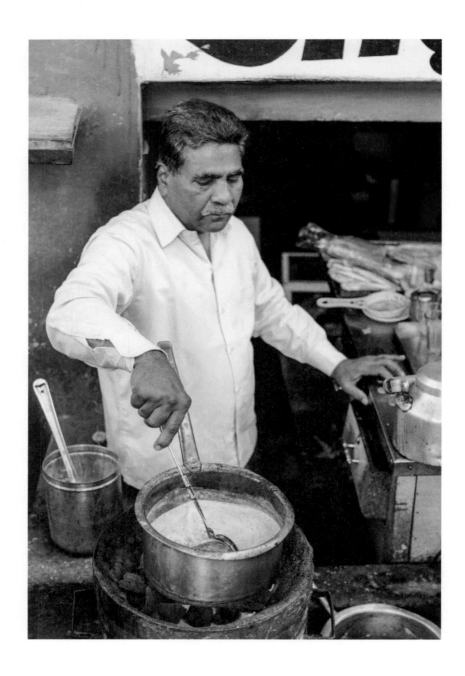

↑ → Sahu ki Chai, one of the most popular tea stalls in Jaipur, serves rich, creamy, sweet cups of masala chai and draws crowds from dawn to dusk.

⟶ A weaver warping his traditional loom.

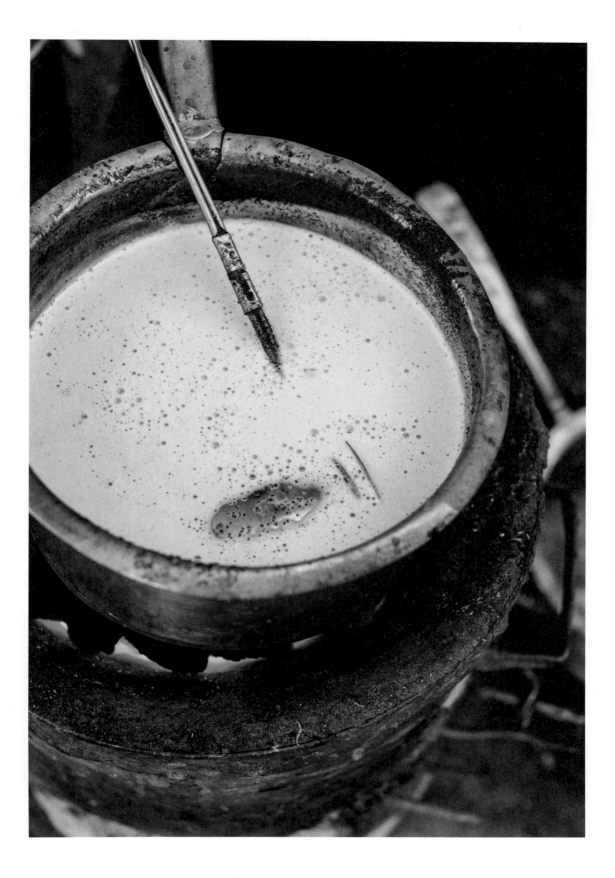

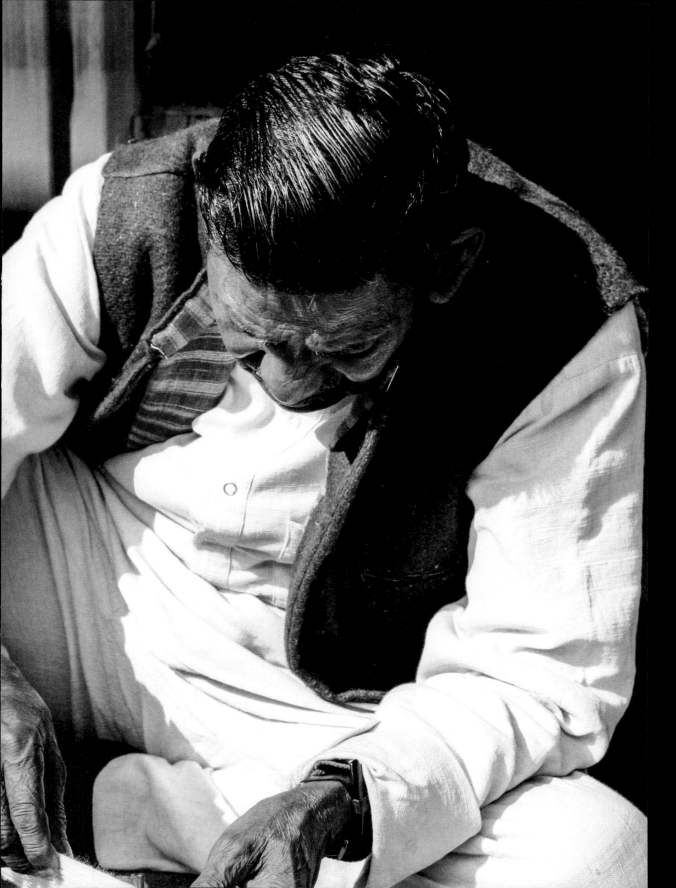

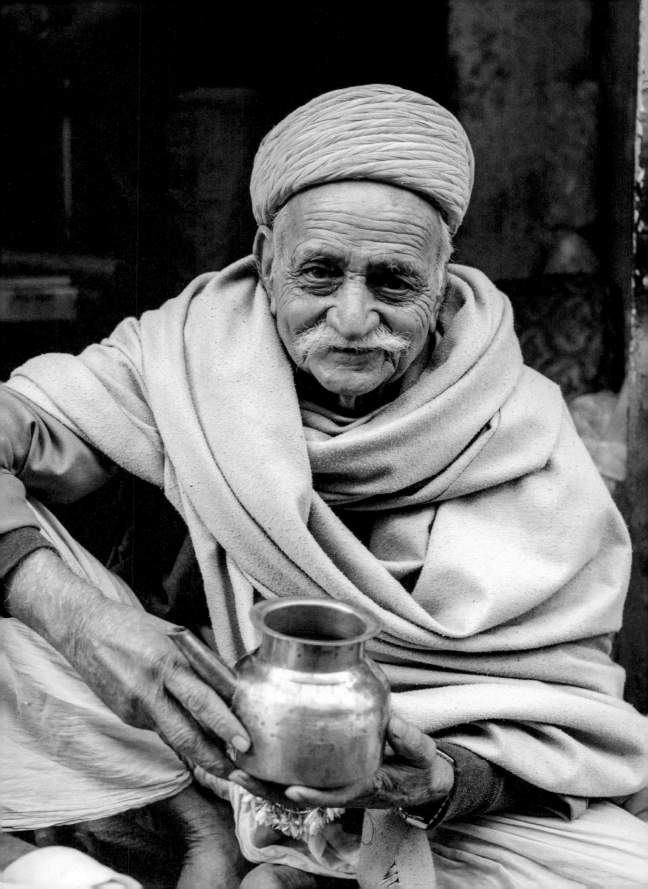

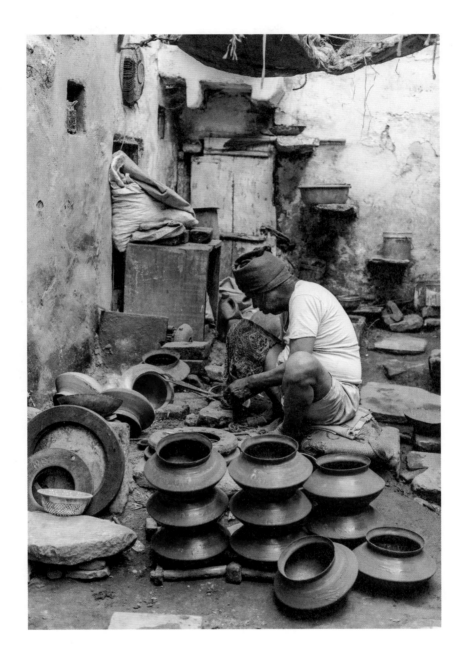

← ↑ Various artisan quarters around the old city of Jaipur house marble statue makers, lacquer bangle makers, and metalworkers (seen here).

⟶ The large, loose style of turban traditionally worn in Rajasthan offers farmers and herders protection from the desert elements.

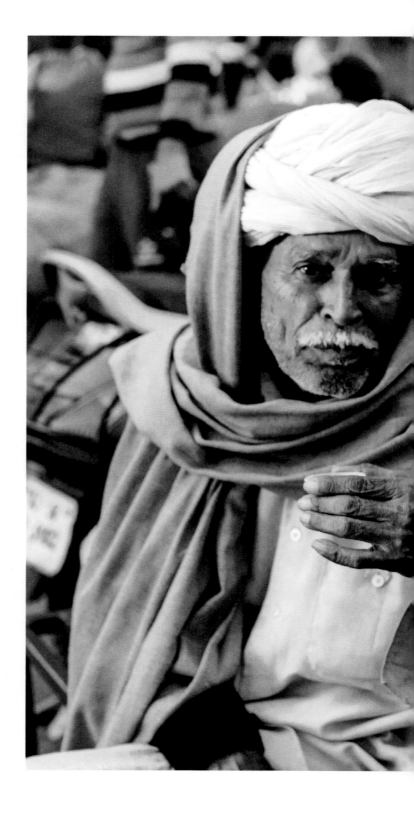

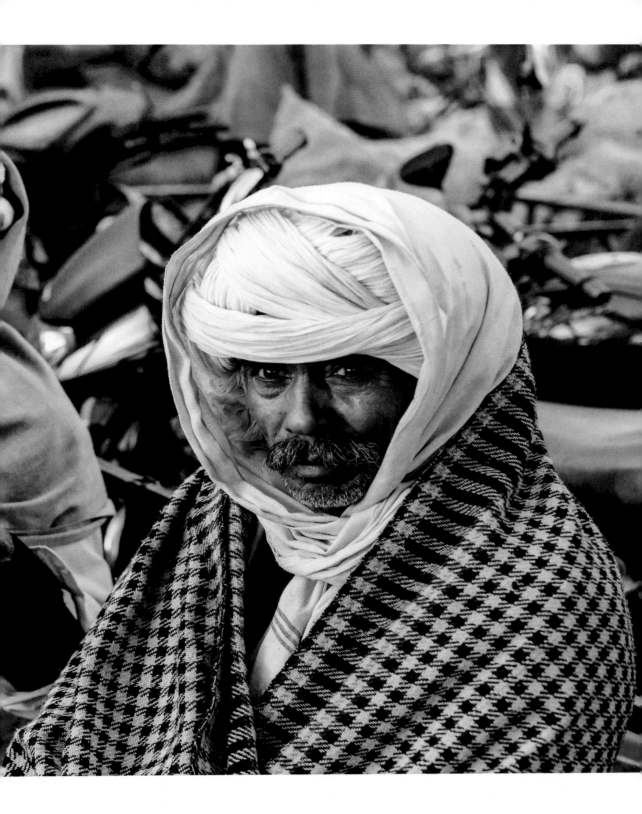

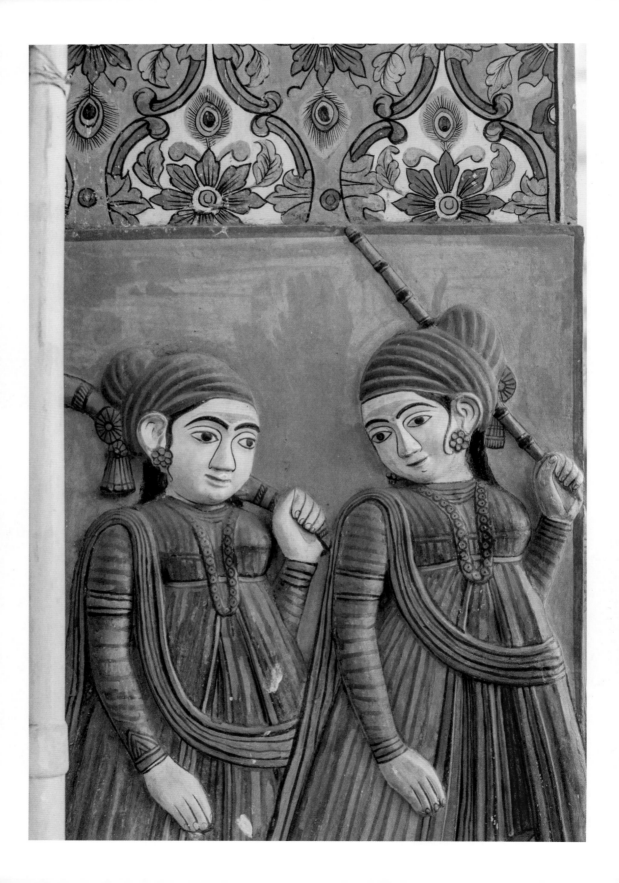

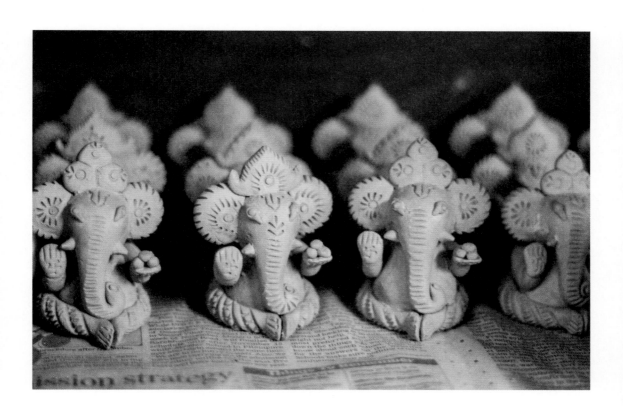

← Carved figures adorn the Peacock Gate at the Jaipur City Palace,
which represents autumn and is dedicated to Lord Vishnu.

↑ Hand-carved miniature clay Ganesh statues laid out to dry.

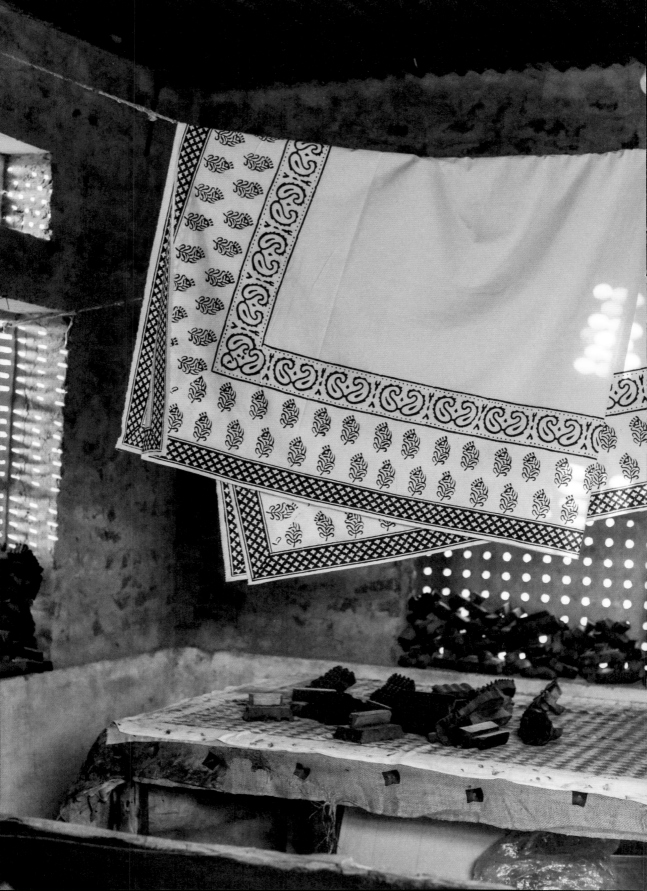

COTTON: A BRIEF HISTORY

Spinning, weaving, dyeing, and decorating cotton formed the heart of ancient India's economy, and today it is still the most widely used fiber for cloth. There are several reasons for India's dominance as a producer of textiles: an abundance of raw materials, the expertise and adaptability of artisans who work with an international clientele, and the country's social structure—a system in which specialization and accumulation of hereditary skill are expected, encouraged, and supported by the ruling class.

The humble cotton fiber became a powerful tool in India's revolution and independence from British colonization, thanks to Mahatma Gandhi's peaceful resistance centered around the revival of traditional craftsmanship and skills. Gandhi encouraged his fellow countrymen to boycott British imported goods, specifically cotton textiles, and instead work to produce handspun and handwoven khadi, a simple yet versatile cloth that became the catalyst for economic independence.

In its pure form, cotton cloth acts as a canvas on which a variety of dye processes can be applied, including block printing, resist dyeing (a pattern stamped with a resistant material before applying dye), and tie-dyeing. Indian craftsmen's knowledge of natural dye, color chemistry, and mordants is nearly as ancient as the growing of cotton itself and just as vitally important to their dyeing success. Fragments of madder-dyed cotton cloth dating back thousands of years have been found intact. Plants, minerals, and insects were used to achieve bold colors: lac and madder for red, indigo for blue, and turmeric and pomegranate for yellow.

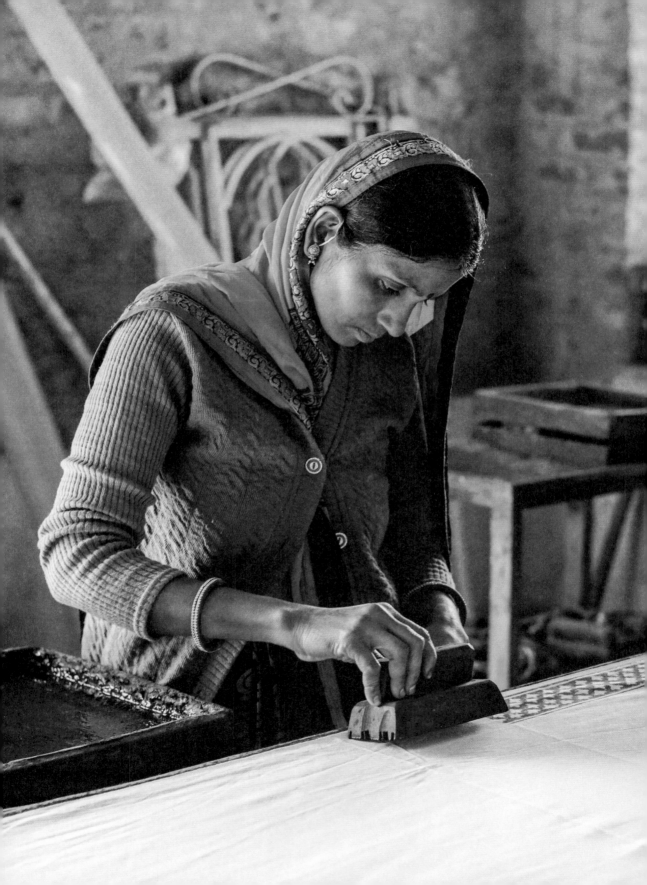

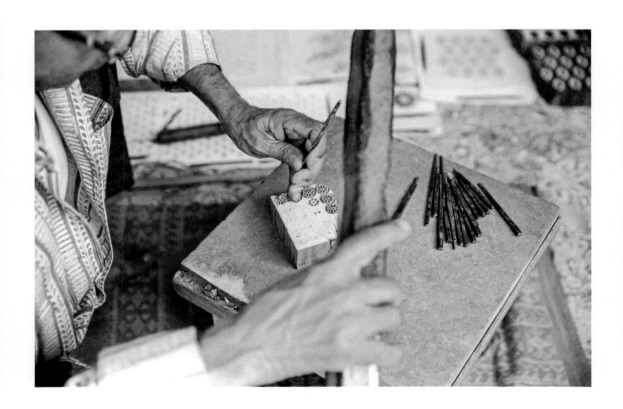

←---- Sushila Chhipa prints a border design in
black pigment at Studio Bagru.

↑ The highlight of visiting the Anokhi Museum of Hand
Printing is watching block-carving demonstrations.

→ The workshop of Ridhi Sidhi Textiles is a favorite source
for block-printed fabric sold by the yard in Jaipur.

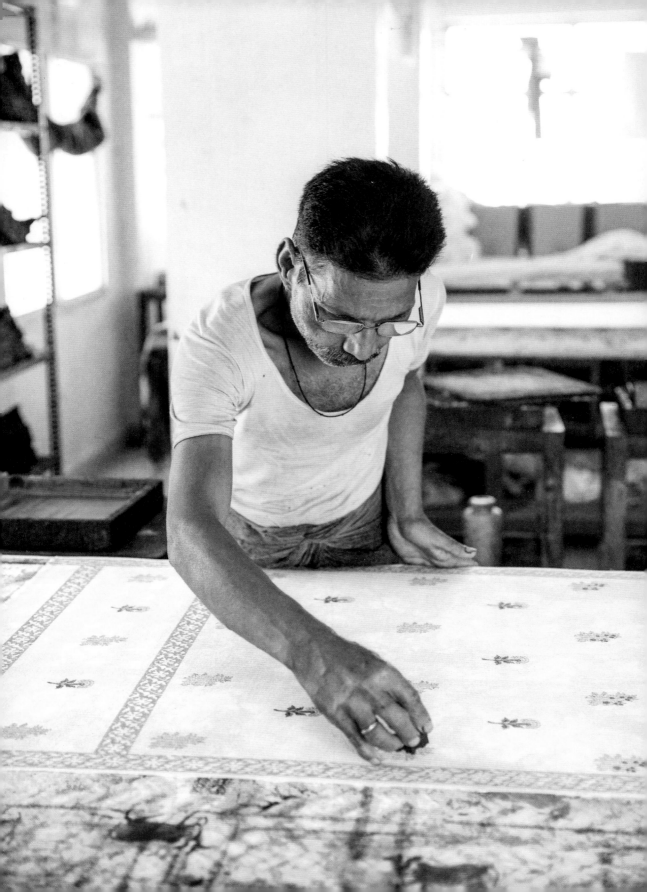

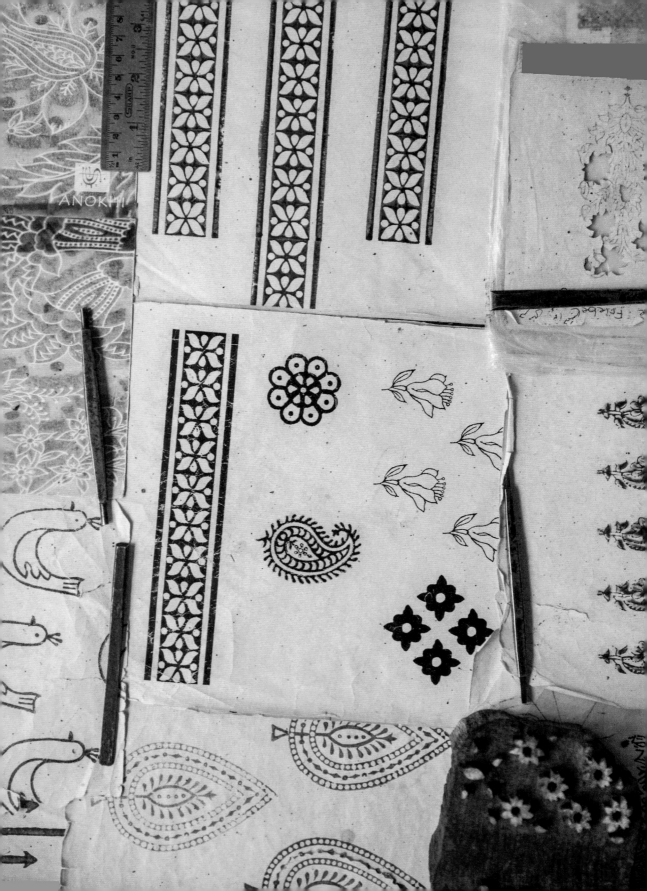

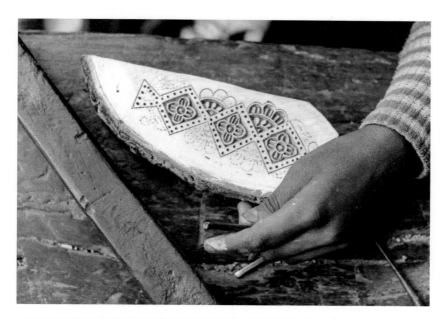

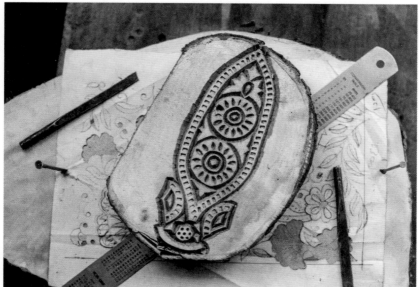

← Examples of block-print patterns seen here at the Anokhi
Museum of Hand Printing.

↑ Relying on traditional hand tools, craftsmen may take several
days to complete an intricately patterned block.

↑ Paper drawings are used to trace designs onto the whitened
surface of the wood block, providing an outline for the carving.

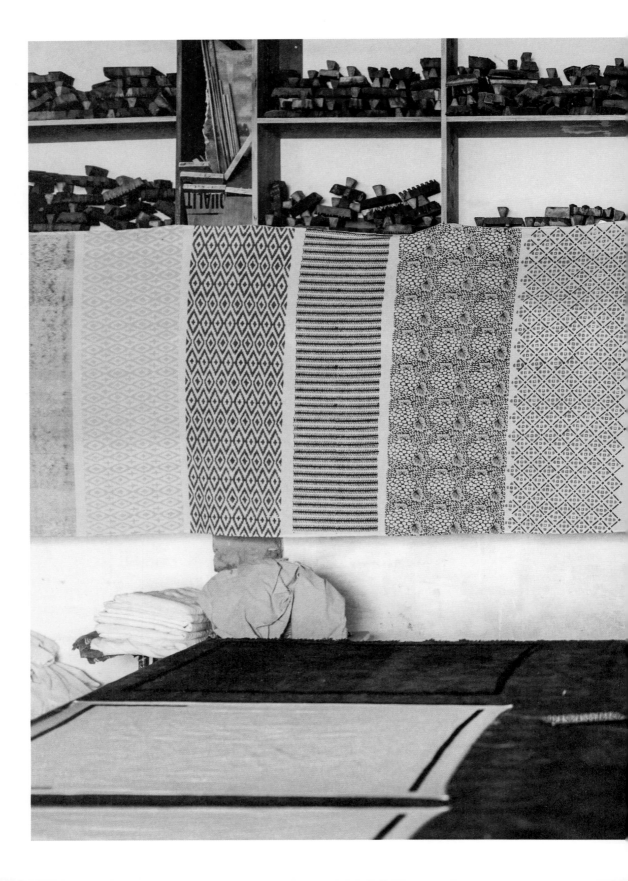

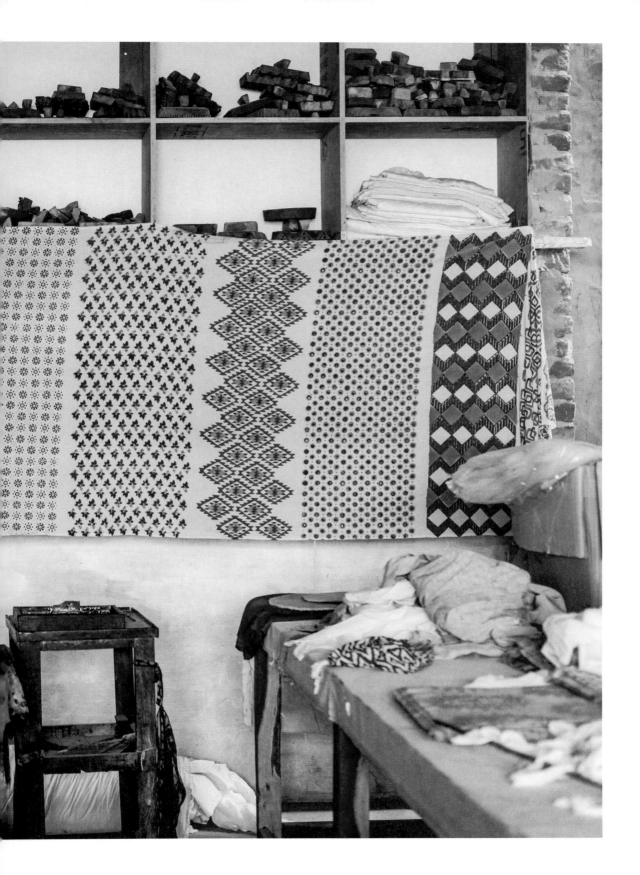

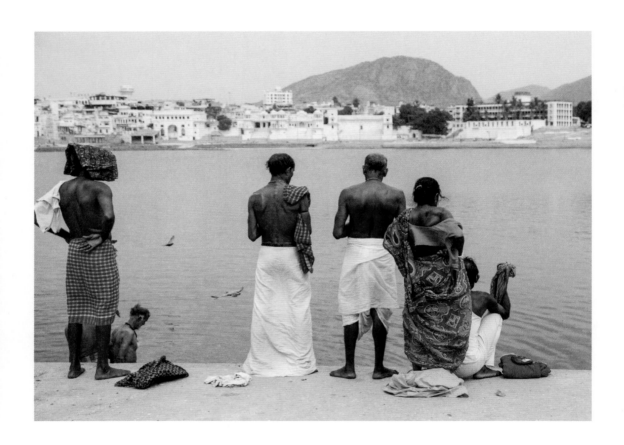

↑ —→ Hindu pilgrims who have made the journey to Pushkar
gather on the ghats to bathe in the holy waters.

→ Scenes from Bagru: cows and pigs wander the street;
boys fly kites off a rooftop.

←—— Vijendra Chhipa, the master printer and founder of Bagru Textiles,
displays modern geometric block-print samples in his workshop.

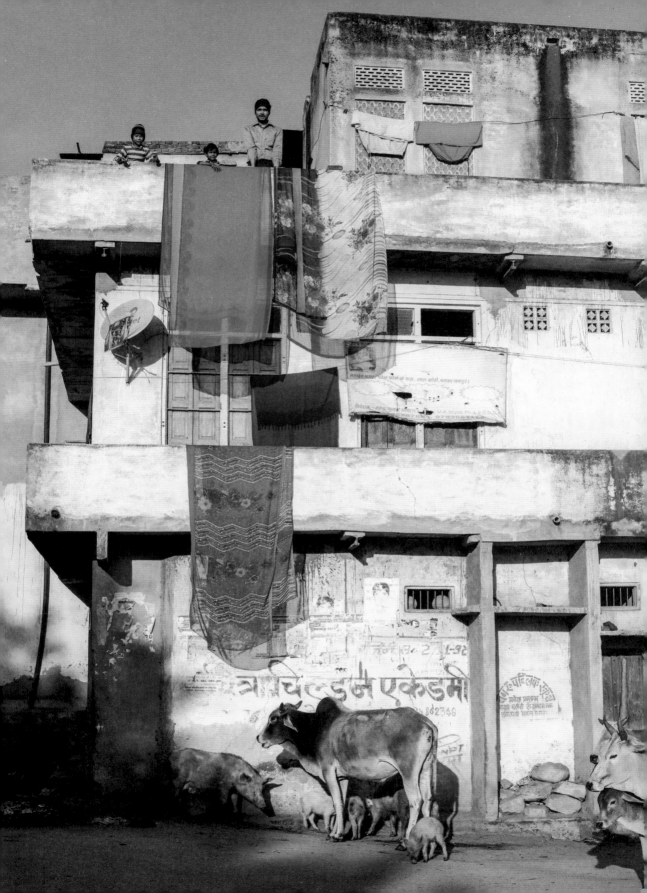

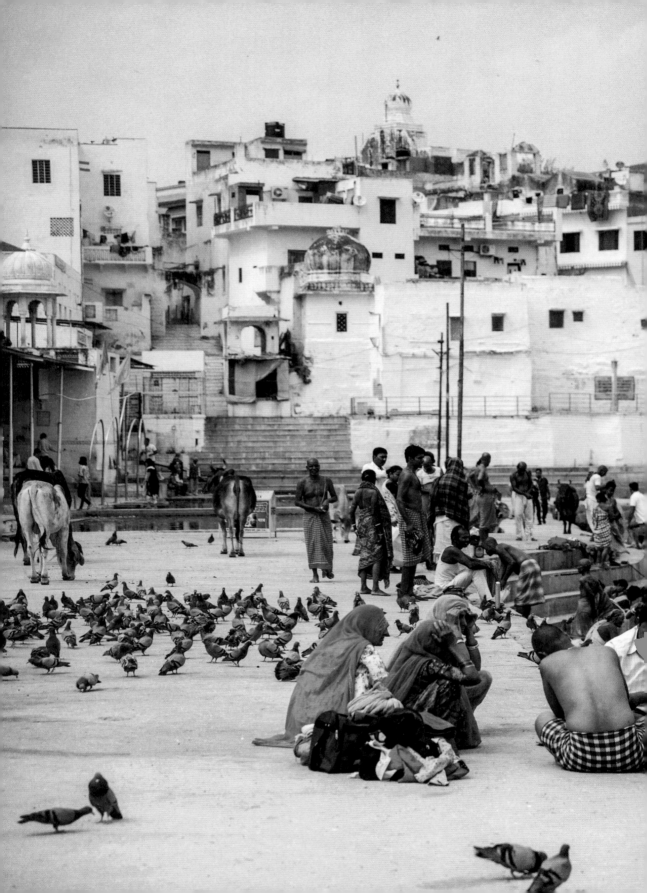

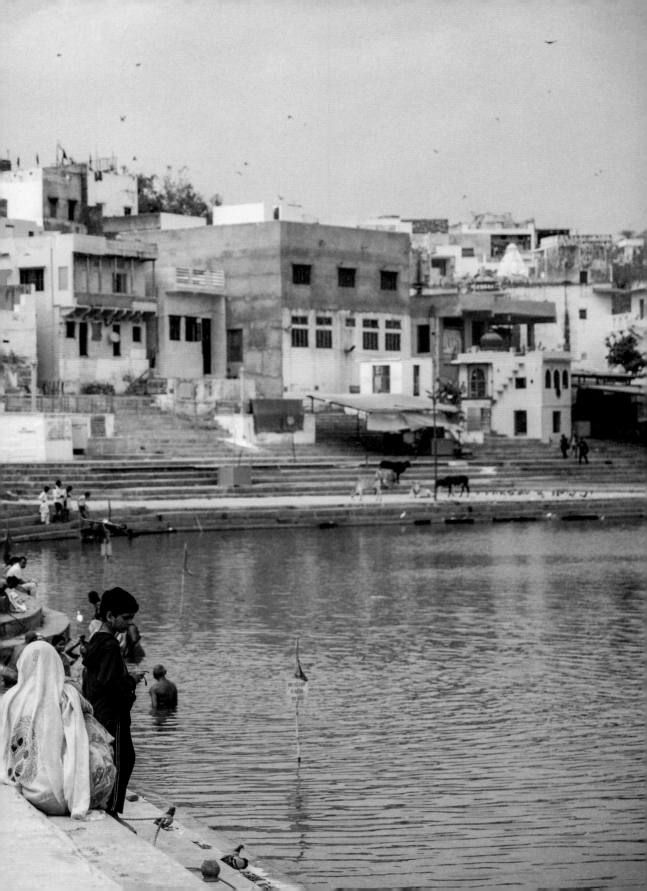

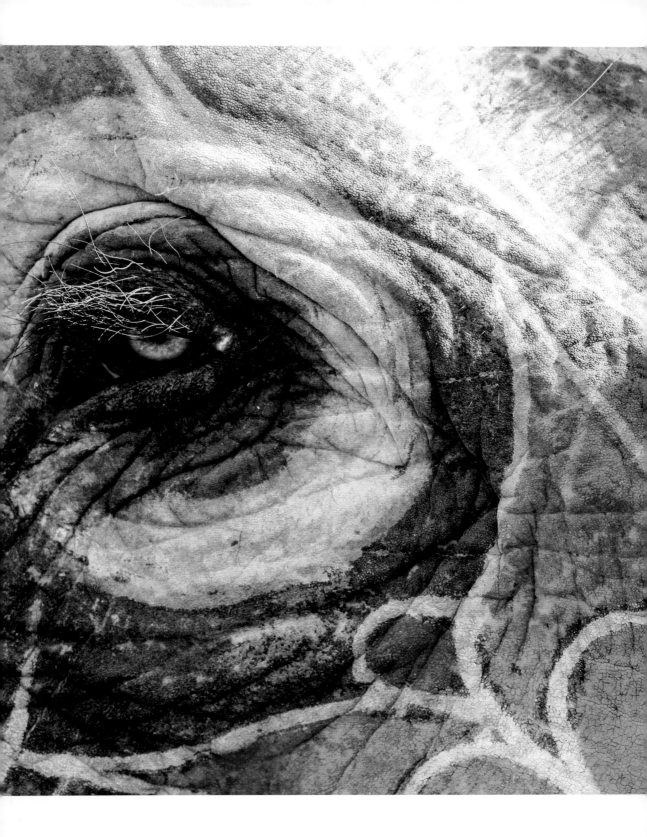

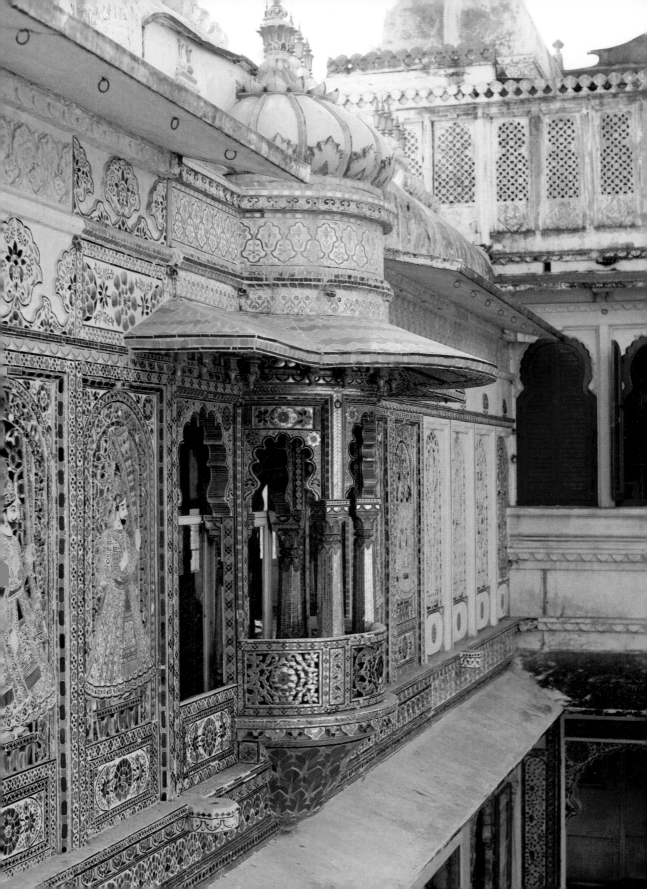

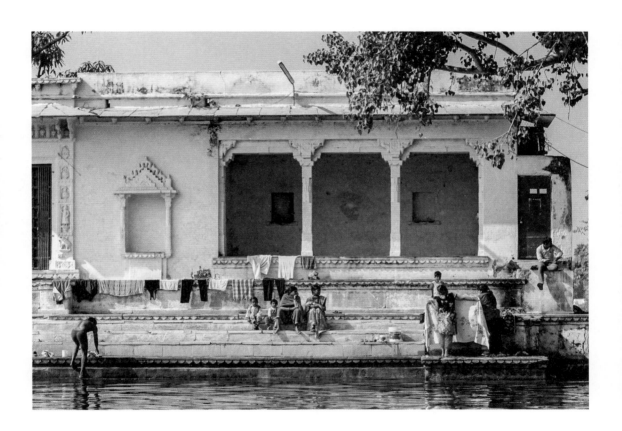

↑ The Ambrai Ghat on Lake Pichola attracts tourists drawn to its
beautiful views as well as locals who come for a swim or to do their laundry.

← The stunningly ornate Mor Chowk (Peacock Courtyard)
at the Udaipur City Palace features exquisite glass inlay work.

←— The soulful eye of an elephant adorned with paint and festooned
with textiles for a wedding procession.

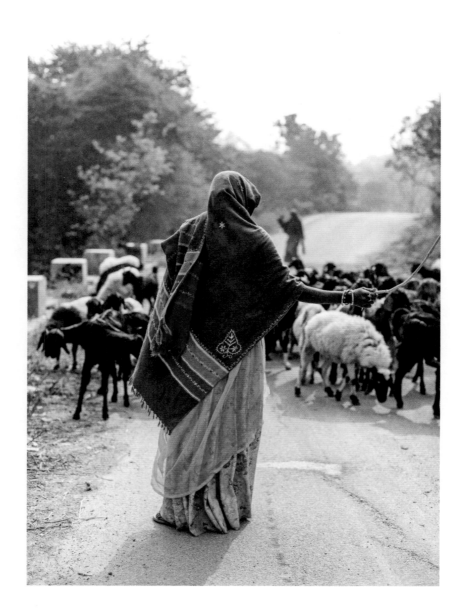

↑ Goat herders move their flock down the road in rural Rajasthan.

→ In addition to being a provider of labor and a source of milk,
the sacred cow plays a prominent role in Hindu society.

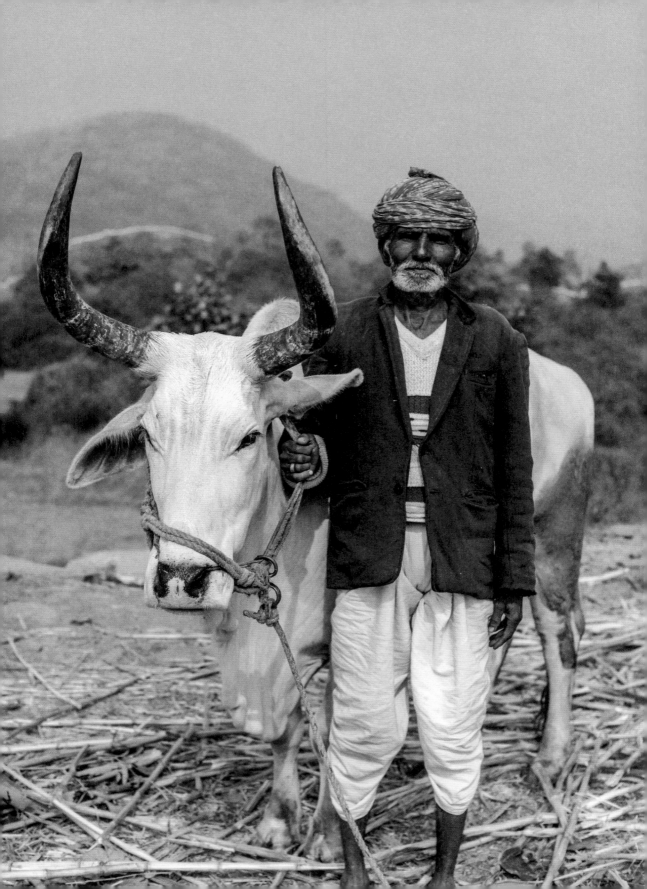

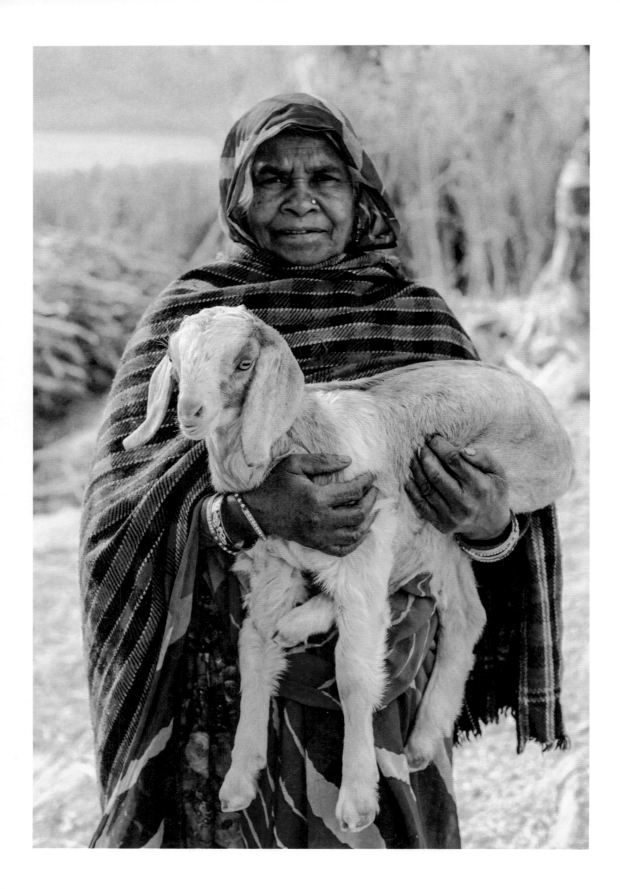

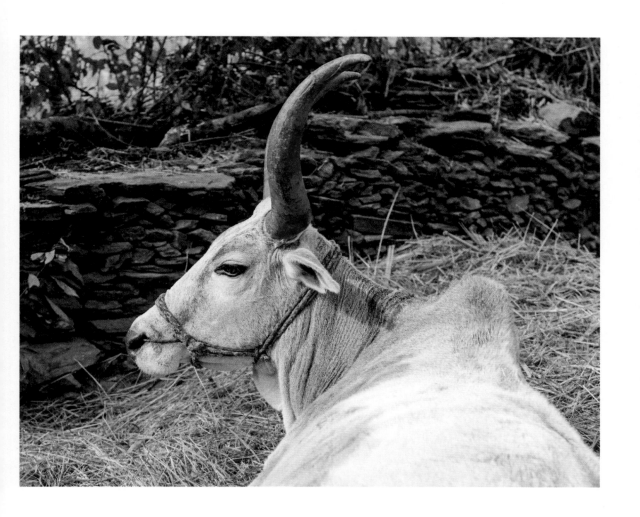

← ↑ Scenes from farming communities in rural Rajasthan.
⟶ The luxury hotel Taj Lake Palace is set in an eighteenth-century marble palace that encompasses the entirety of Jag Niwas, an island on Lake Pichola.

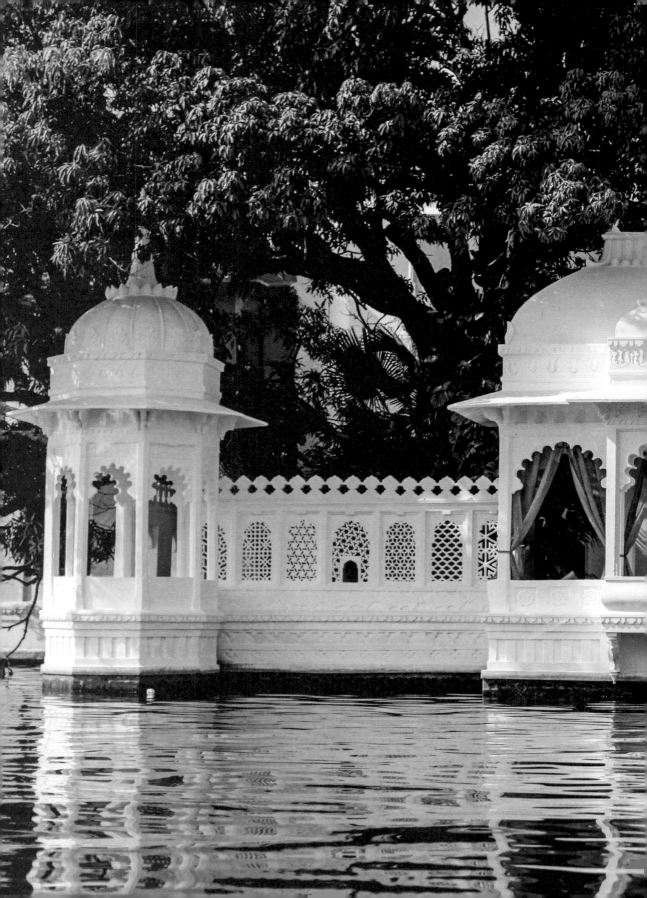

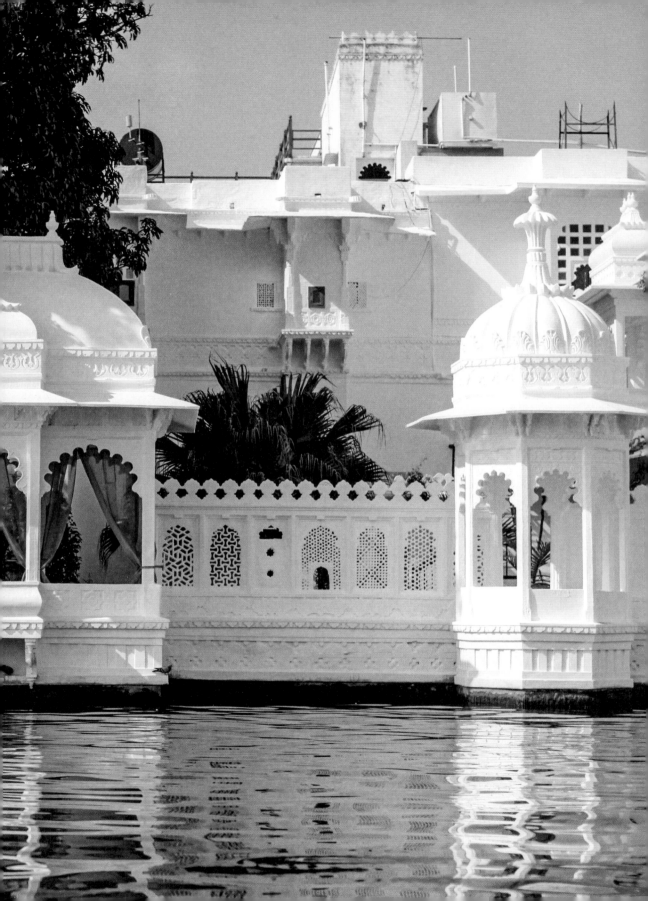

ROYAL
BLUE

Each major city in Rajasthan has distinct characteristics, the most noticeable of which is color. Jaipur is famed for its pink hue, and Udaipur is defined by its white marble structures. Jaisalmer, the Golden City, is known for its yellow sandstone architecture, and Pushkar's white temples rise from the ghats that surround Pushkar Lake. The Blue City of Jodhpur reveals its color palette with every twist and turn through the chaotic, winding streets of the old town.

On my first visit to Jodhpur in 2017, I didn't see so much as a single indigo wall on the way from the airport to the hotel. Why was it called the Blue City? Hours later, after ditching the car, I discovered that the famed epithet actually refers to Jodhpur's oldest quarters: a labyrinth of narrow streets accessible only on foot or by moped, motorcycle, or rickshaw.

Situated on the edge of the Thar Desert, Jodhpur is the second largest city in Rajasthan. The top of the majestic Mehrangarh Fort, one of India's largest and best preserved citadels, affords visitors a view of the striking blue for which the city is known: the effect is of a blue sea in the midst of the arid desert landscape. Why were the homes in Jodhpur's old town painted blue? One theory is that the color was used to indicate that Brahmins, or members of the priest caste, dwelled there.

Colors hold deep significance in the Hindu religion. They transcend decorative values and play a very important role in the culture. Lord Krishna, a god favored for his bravery and protective powers, is strongly associated with the color blue because it's symbolic of the infinite and immeasurable, much like the sea and sky.

Indians have been making lightfast and colorfast dye for textiles from indigo leaves for at least four thousand years. Dyeing with indigo is a complicated process that requires the addition of other substances, such as lime and wood ash, as well as the careful maintenance of temperature and acidity and alkalinity levels.

In Bagru, a village outside of Jaipur, the art of indigo dyeing still thrives under the care and craftsmanship of skilled artisans. Various

techniques of resist dyeing are used to create patterns; for example, in *dabu* printing, fabric is stamped with a mud-resist paste, sprinkled with sawdust, left to dry in the sun, dyed in a vat of indigo, and finally set to dry. The pattern is revealed after the *dabu* mixture is washed off. Because every element affects the outcome of color in natural dyeing—weather, water quality, indigo crop conditions—it is rare that any two indigo dye baths produce the exact same shade of blue.

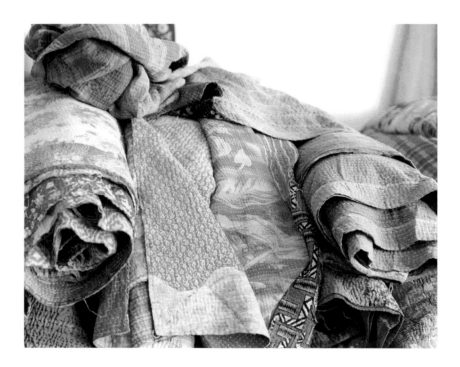

↑ A stack of colorful *kantha* quilts for sale. *Kantha,* the Sanskrit word for rags, are made by hand stitching several layers of old silk sari scraps together into blankets.

→ Colorful wooden doors in Jodhpur are often painted to complement the surrounding shades of blue.

⟶ Sitaram Bhanji of Bagru dips fabric in a vat of indigo. The fabric appears green when it first emerges but quickly turns a rich blue through oxidation.

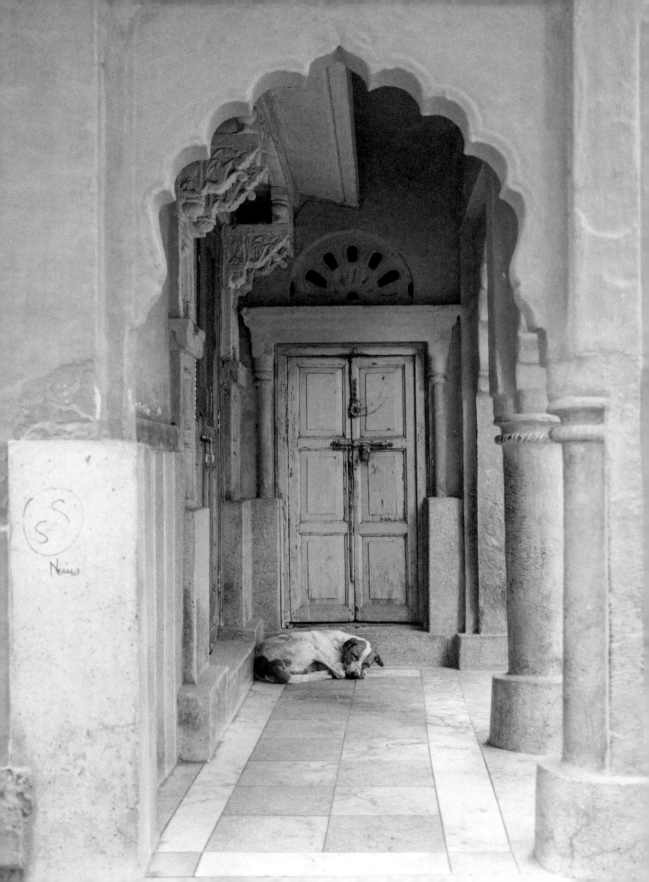

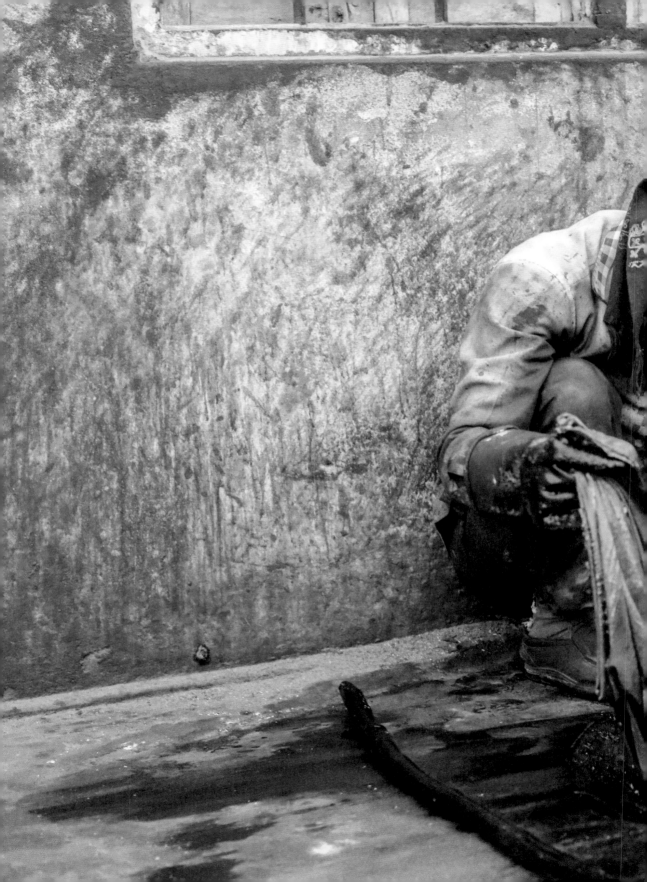

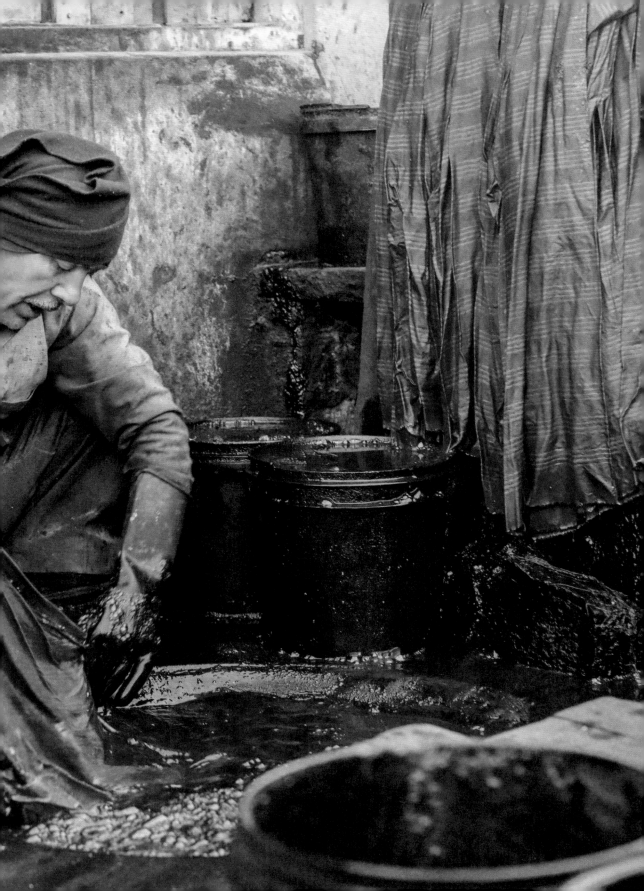

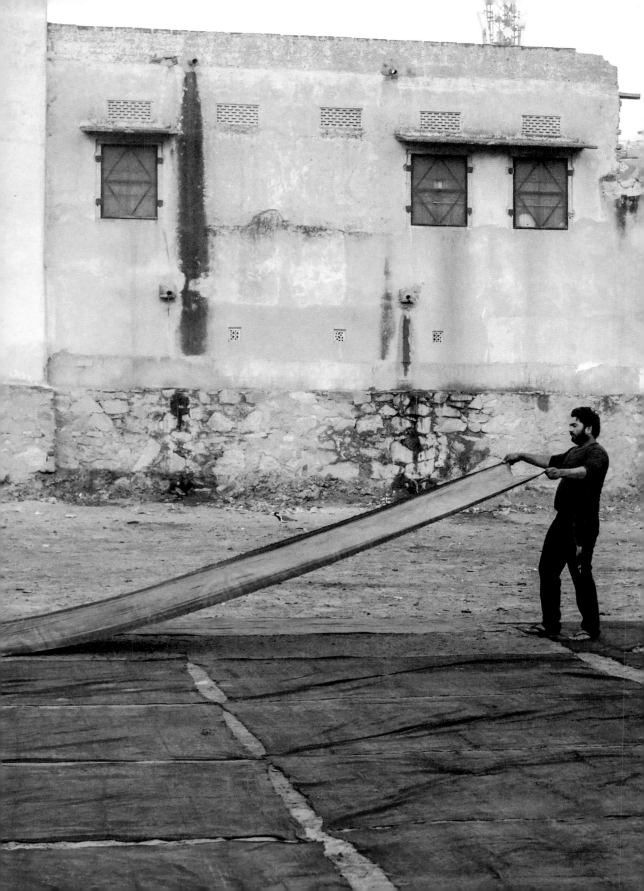

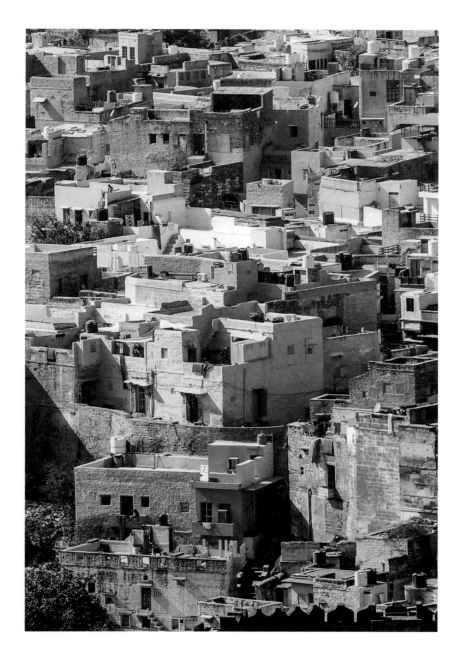

← Bholu Bhanji spreads indigo dyed fabric out to dry at Namdev Krishi Farm in Bagru.

← ↑ The vibrant blues of Jodphur, seen here at street level and from atop the Mehrangarh Fort.

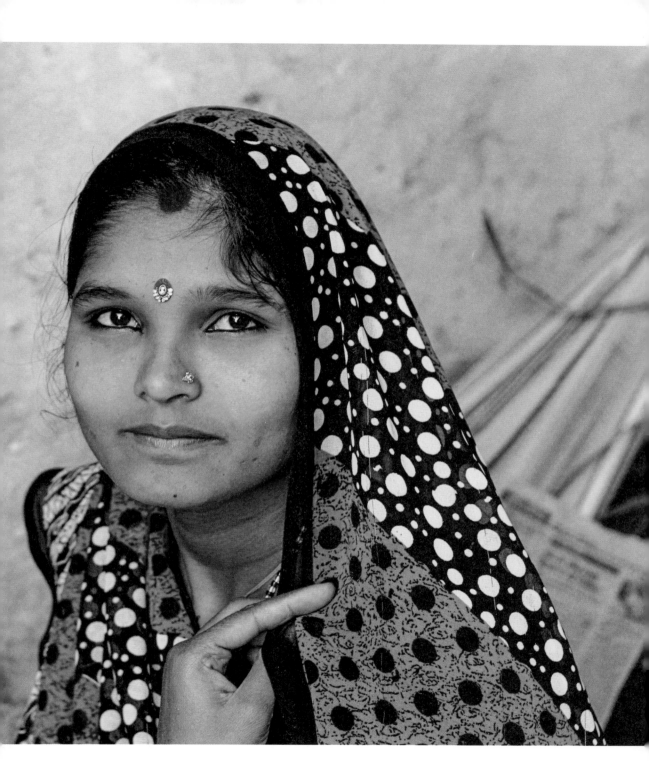

↑ Portrait at the Udaipur market.

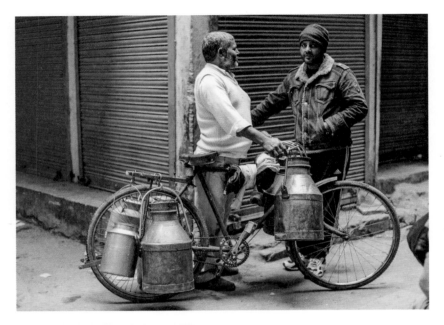

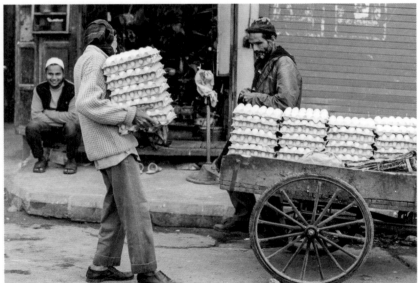

↑ A milkman makes deliveries by bike; eggs are stacked
onto a food cart, to be pulled to market.

→ A small shop sells handwoven baskets of every shape and size.

⟶ A baby peeks over its mother's shoulder while she
makes her way through the Udaipur market.

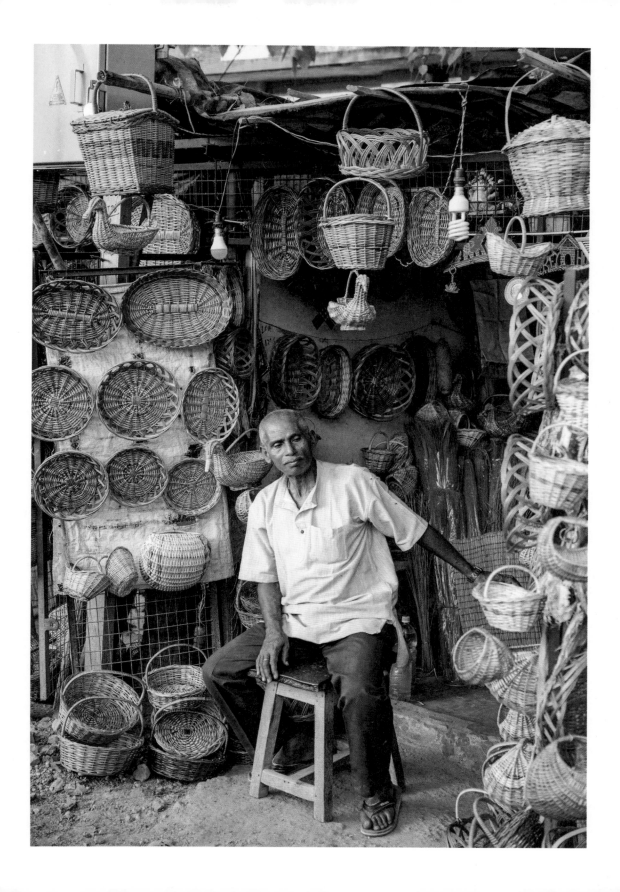

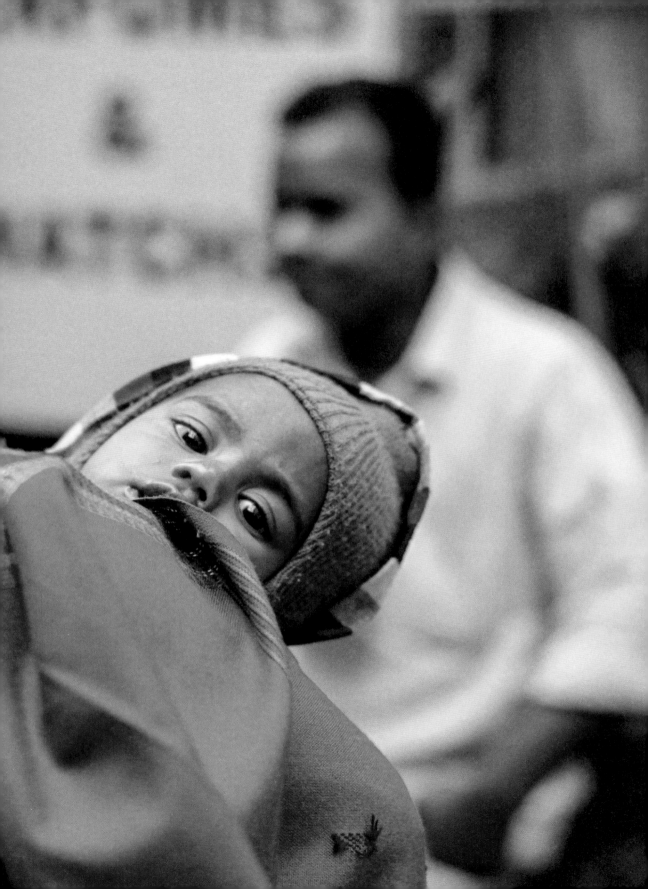

↑ Rajasthani women have been celebrated for their beauty and bravery
through ballads, poems, wall paintings, and many other art forms.

→ Large metal bowls are used to display mounds of spices for sale
at a stall in Udaipur.

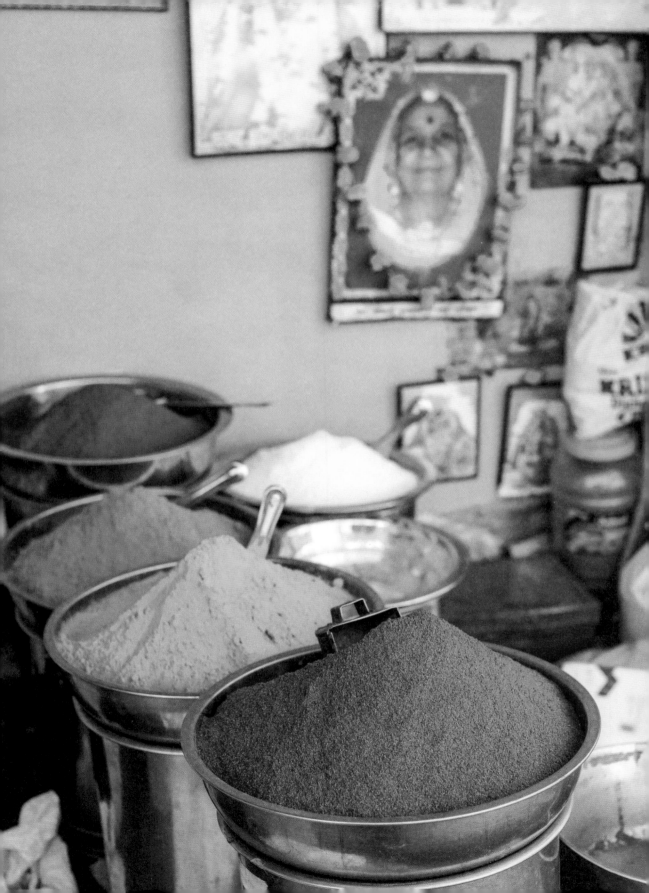

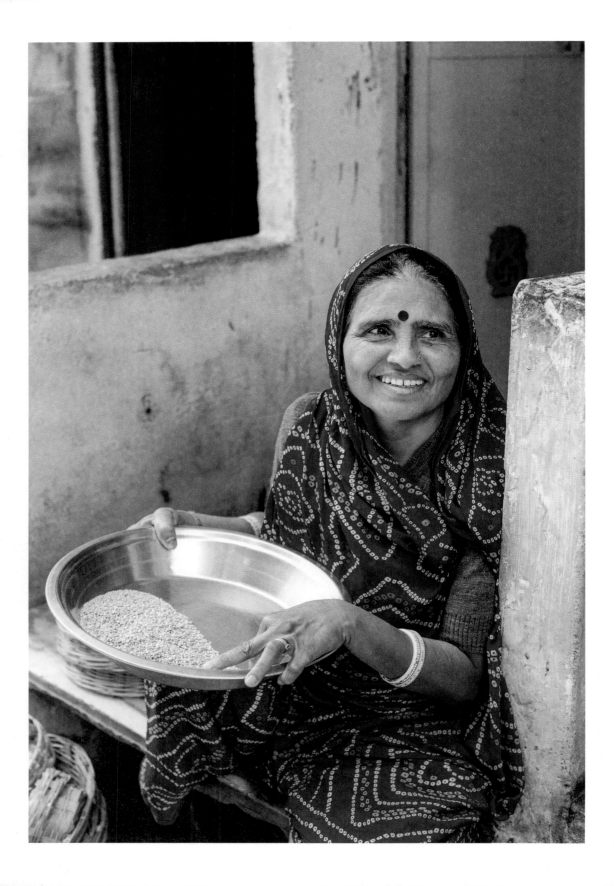

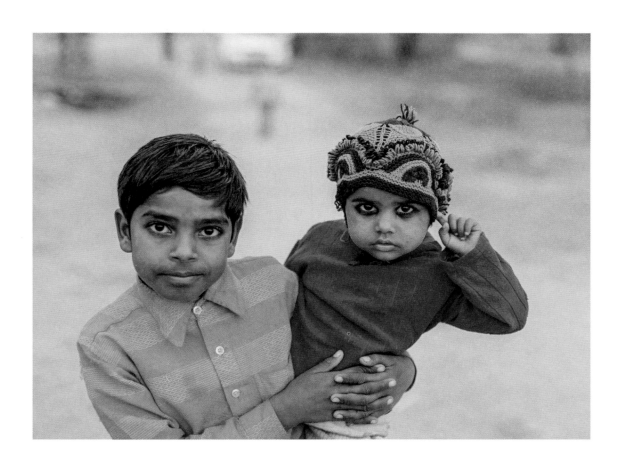

← A woman sits on her stoop sifting through rice and
picking out small stones.

↑ Putting *kajal,* or black eyeliner, around a baby's eyes
is a common practice in some parts of India; it is believed
to ward off the evil eye and improve sight.

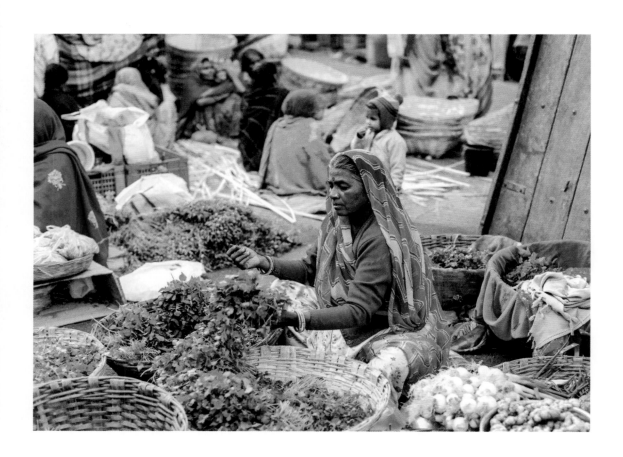

↑ → Scenes at the Udaipur vegetable market.

⟶ Keeping the desert dust at bay is a never-ending task
for this shopkeeper in rural Rajasthan.

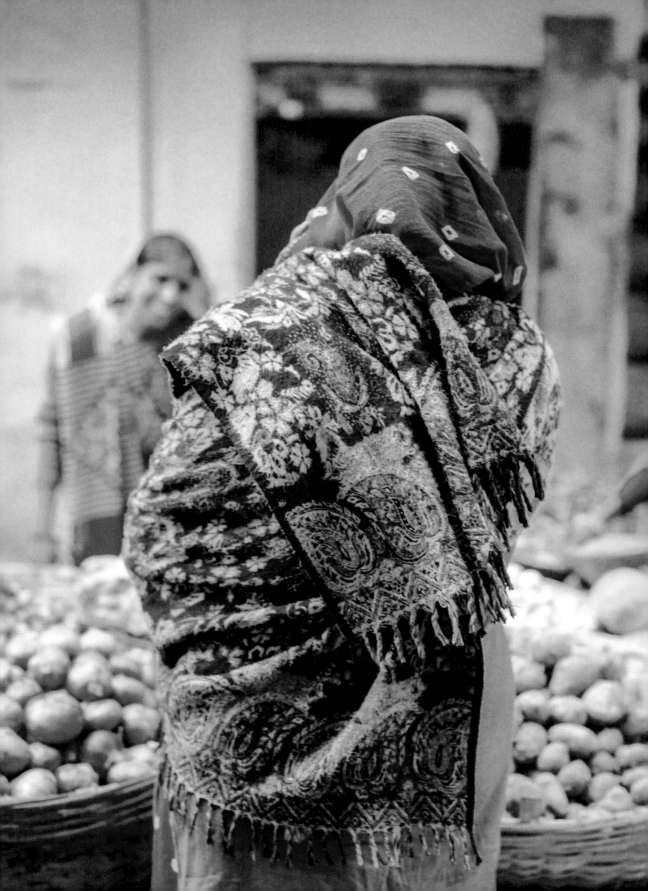

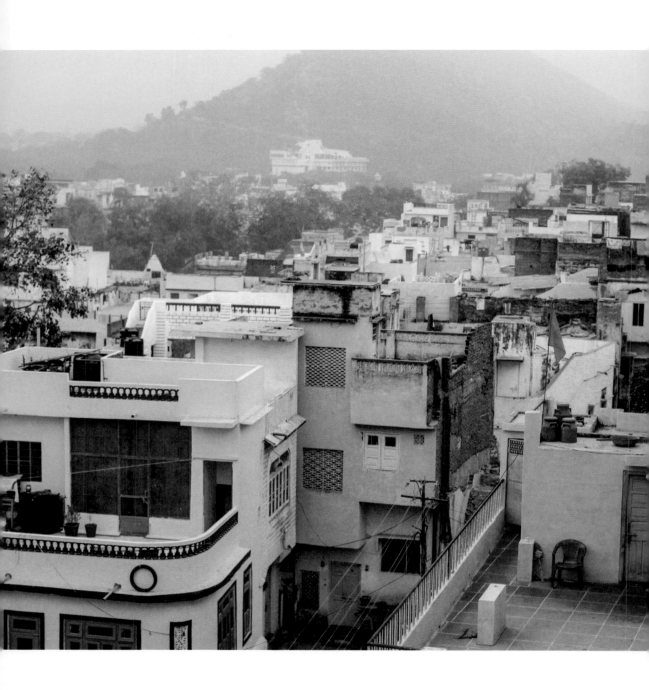

↑ Looking out over the rooftops of Udaipur.

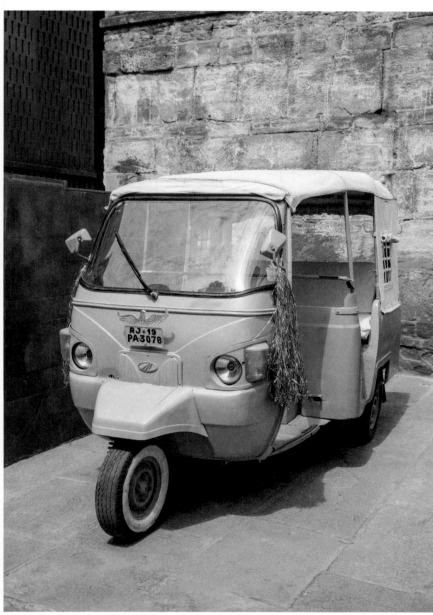

↑ RAAS Jodhpur, a boutique heritage hotel, matches the color of its auto rickshaw to the city's famous blue buildings.

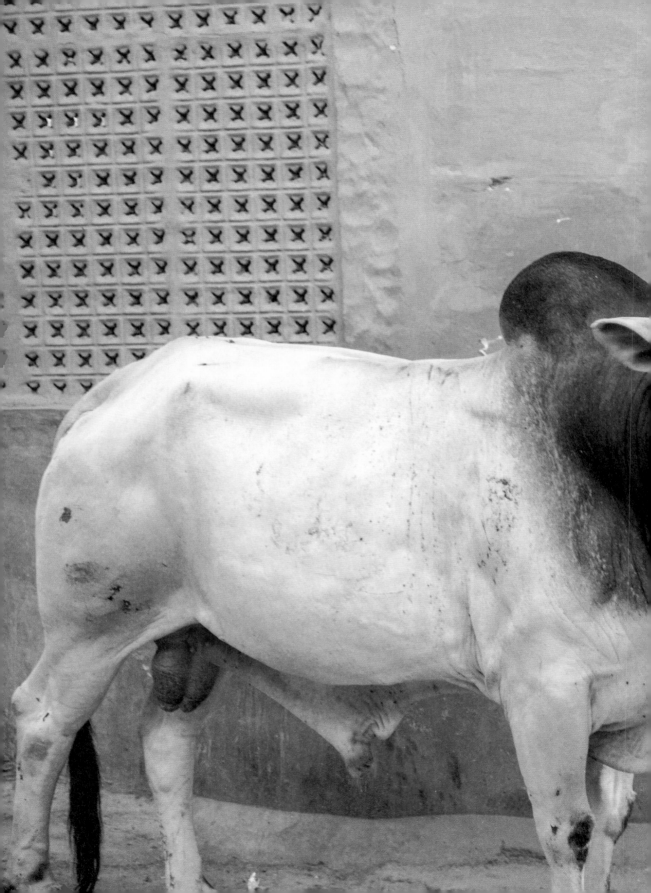

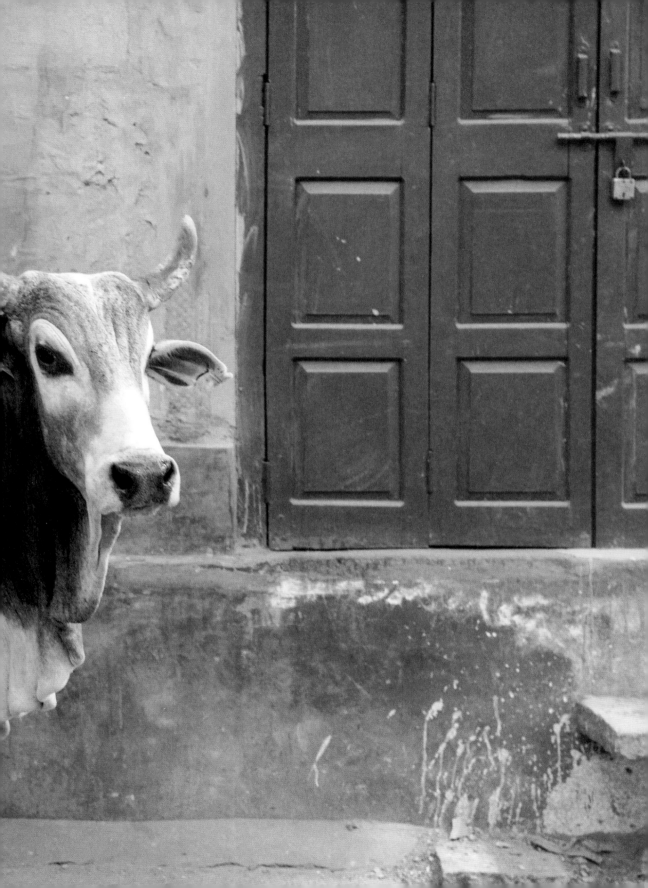

टाईप इन्स्टीट्यूट शिव पुस्तक भण्डार

यहाँ पर हिन्दी एंव अंग्रेजी में टाईप सिखाई जाती है ! पाठ्य, पुस्तकें, कॉपियों एंव स्टेशनरी के विक्रेता

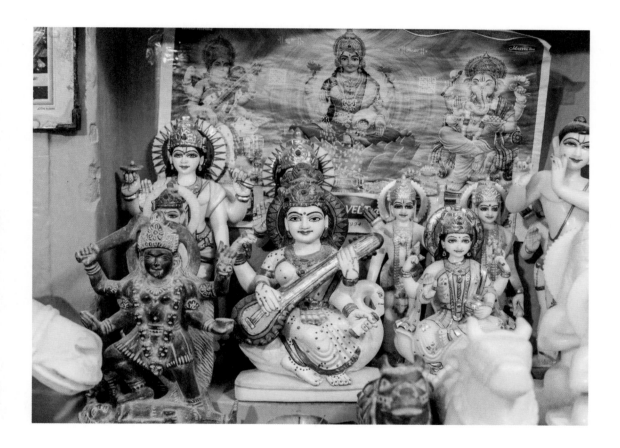

←— A sacred cow lazily meanders down the narrow
streets of Jodhpur.

← A storefront in Jodhpur sells everything from kites to candy.

↑ Carved and painted marble sculptures for sale in Jaipur.

—→ The artisan quarters in Jaipur where marble workers
carve statues of the deities.

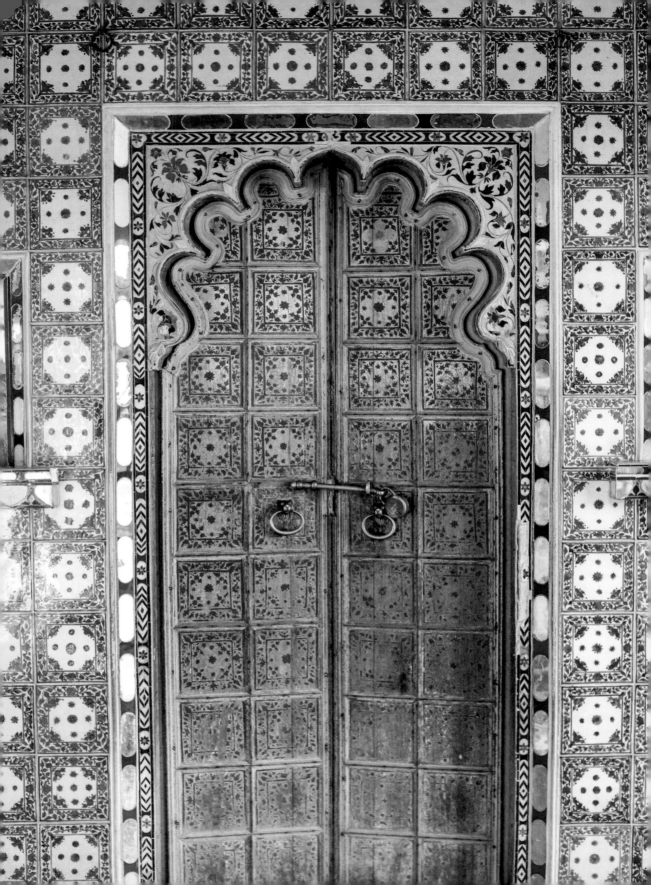

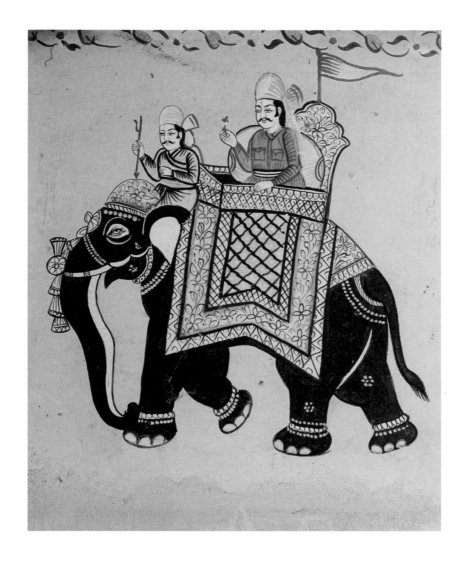

← At the Udaipur City Palace, a doorway in the Badi Chitrashali Chowk
is decorated with Chinese tiles.

↑ Texts from 1000 BC refer to elephants being domesticated in India, and
rulers since then have considered them to be powerful assets, especially in battle.

⟶ Garden roses in a scrolling pattern adorn the ceiling of this
vibrantly painted room in the Udaipur City Palace.

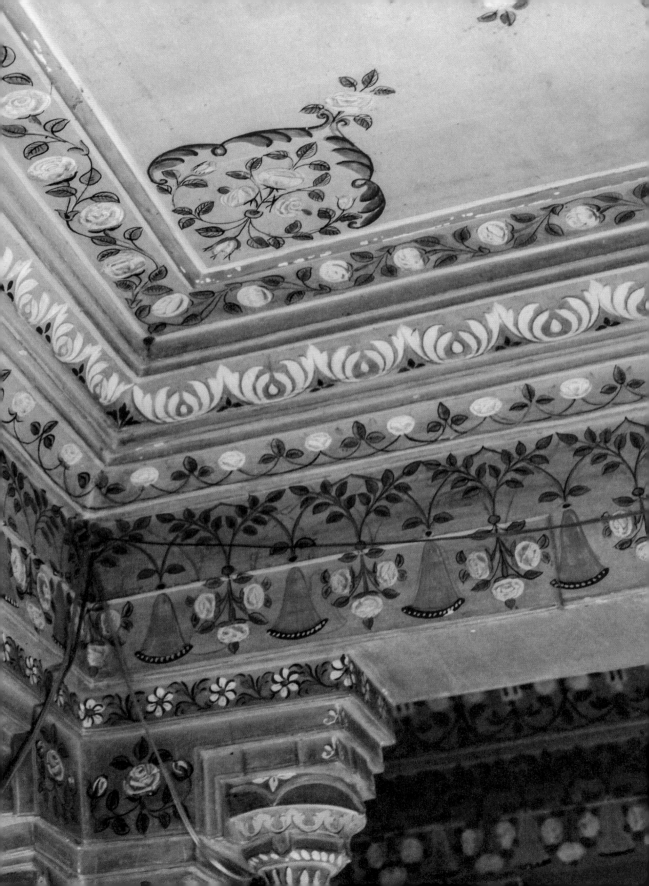

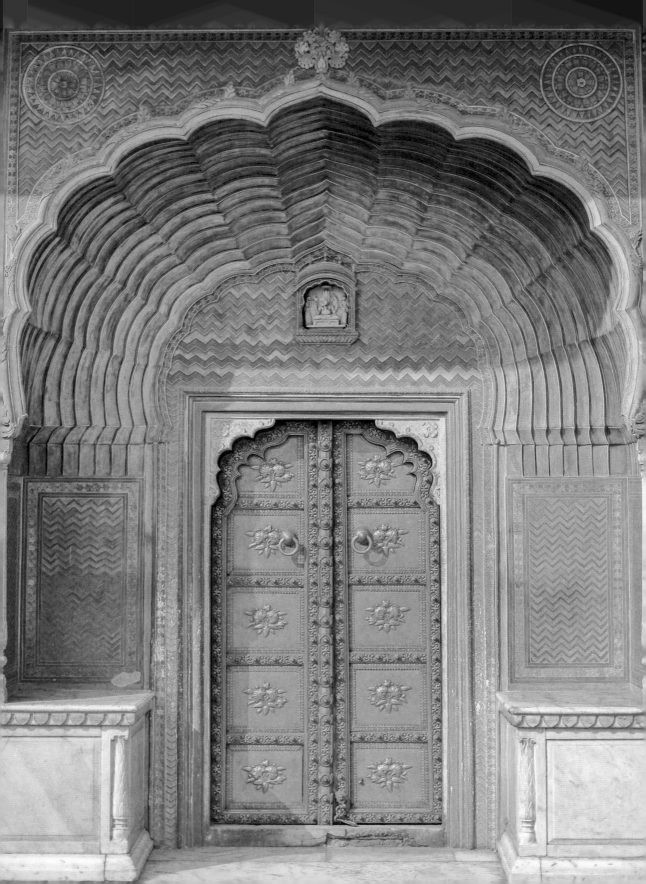

PATTERN IN ARCHITECTURE

If there was a hierarchy to the arts in Rajasthan perhaps the highest honor would be bestowed upon the region's elaborately constructed, sculpted, and adorned fortresses and palaces. Magnificent in their complexity, architectural feats such as the Amer Fort in Jaipur and the Junagarh Fort in Bikaner have provided Indian craftsmen with nearly limitless opportunities to decorate surfaces with pattern and ornamentation using glass, marble, textiles, and paint. Every square inch comes alive to tell the story of the region and its patrons. Throughout history few countries have so joyously celebrated the decorative arts and crafts as India.

The subjects depicted in the embellishments and patterns of Rajasthan reflect the influences of the region's rulers. Rajput nobles, with their Hindu belief system and strong connection to the natural world, drew inspiration from the flora and fauna with which they shared their homeland. Then as now, scorching summer months gave way to the monsoon season, and once the rain ceased, the landscape appeared reborn in its lushness. Patterns were inspired by the beauty of the land: sprays of garden roses repeated in flourishing swirls; blossoming mango trees intertwined with majestic peacocks; and a plethora of marigolds to represent the omnipresent fields of the flower in rural Rajasthan. These depictions of verdant gardens and landscapes stand in direct contrast to the harsh desert landscape once the brief monsoon season has passed.

The Mughals brought a variety of mathematically based, geometric patterns to the forefront of surface design during their rule: stars with a fixed number of points enriched with hexagon or chevron motifs. Bold geometric patterns added drama to surfaces while maintaining the order and harmony prized by the Mughals.

↑ → Magnificent blues in Zenana Mahal, the Queen's
Palace, within the Udaipur City Palace.

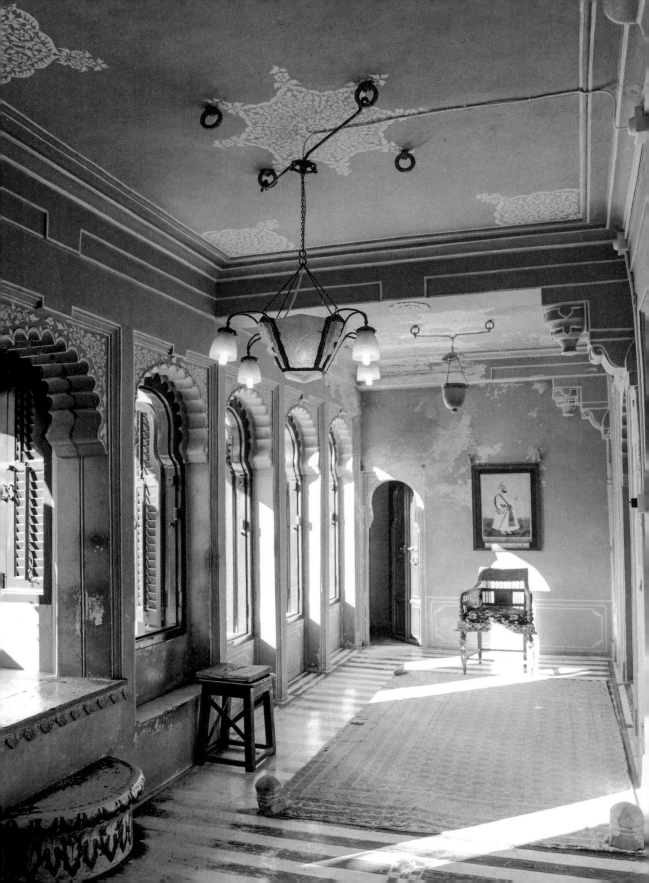

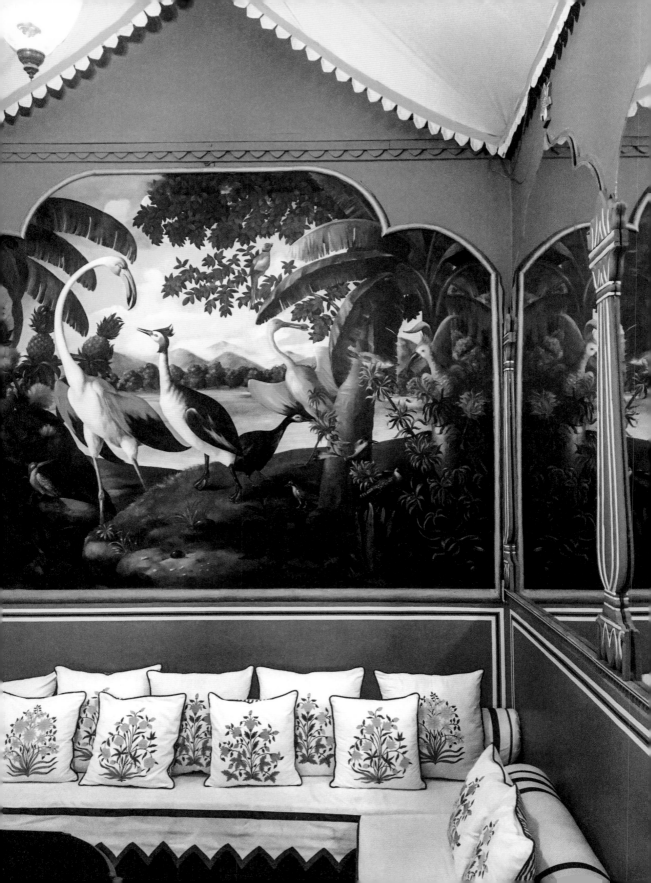

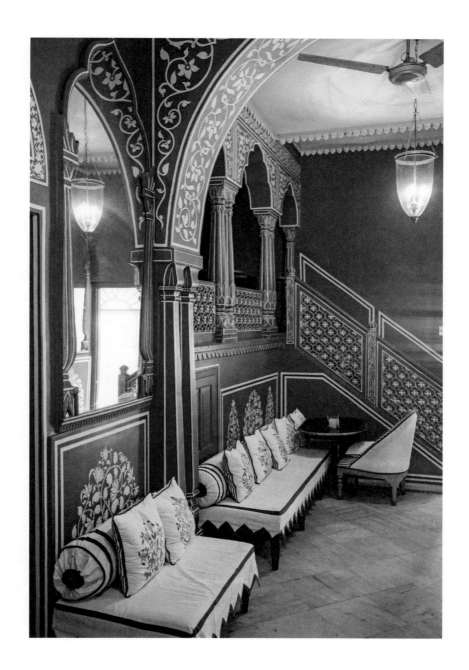

←↑ Barbara Miolini's Bar Palladio in Jaipur combines Italian
Renaissance style with Mughal design. It is located on the
grounds of the Hotel Narain Niwas Palace.

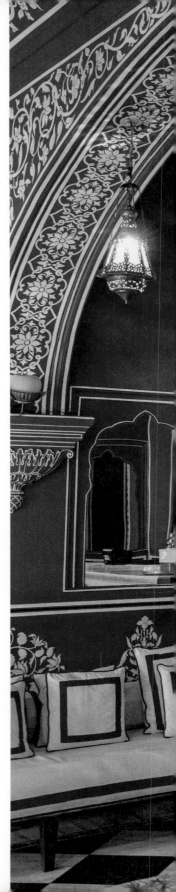

→ The stunning blue-and-white floral frescoes of the Chhavi Niwas (Hall of Images) at the Jaipur City Palace.

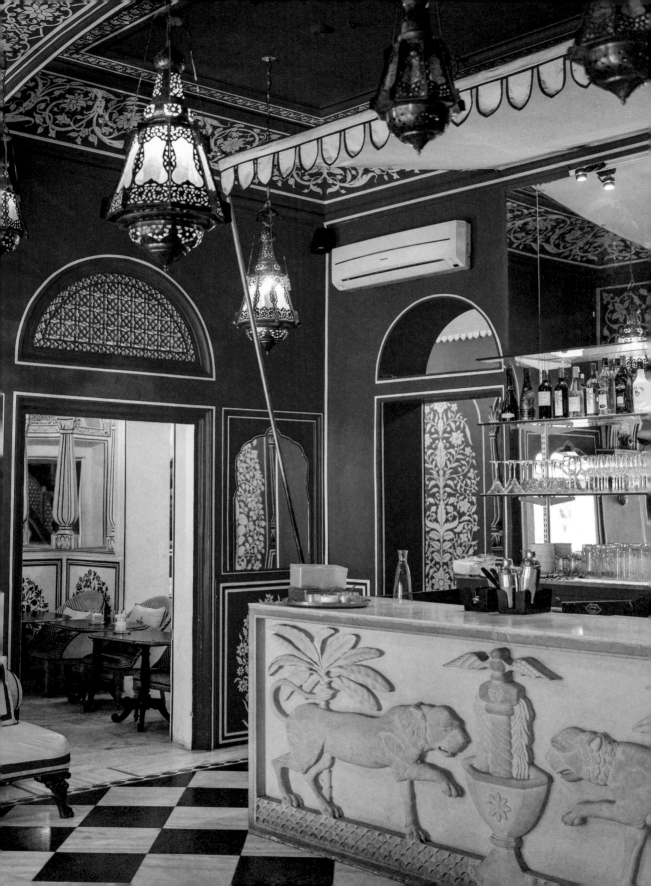

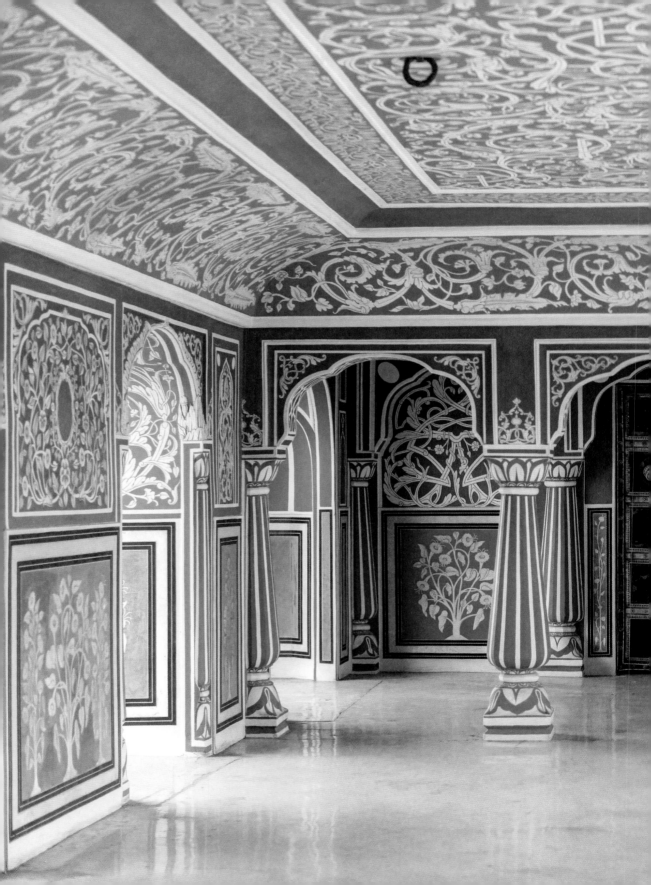

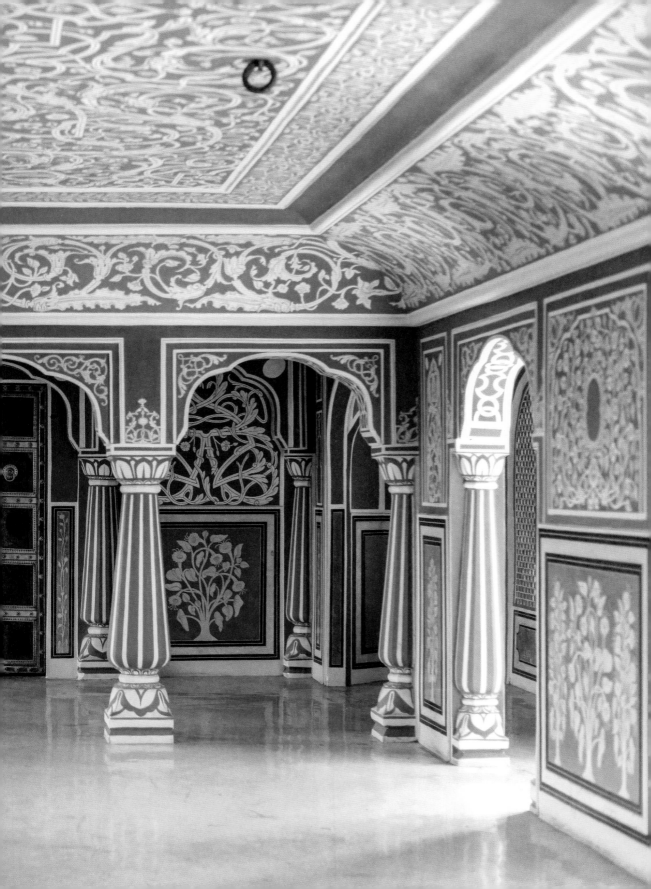

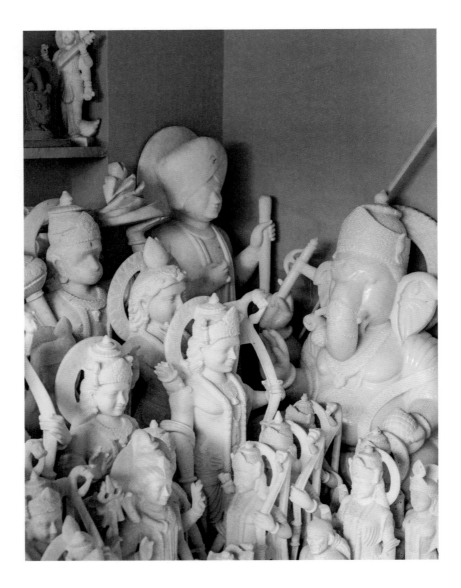

↑ The marble-carving quarter in Jaipur is the place to go to buy a sculpture of a Hindu god; the craftsmen there make their living carving devotional statues.

→ The custom wallpaper of the Colonnade dining area in the Suján Rajmahal Palace features polo players and cypress trees.

⟶ The inner courtyard of the Chandra Mahal at the Jaipur City Palace has four gates, each representing a different season and dedicated to a different deity. The Peacock Gate represents autumn and is dedicated to Lord Vishnu.

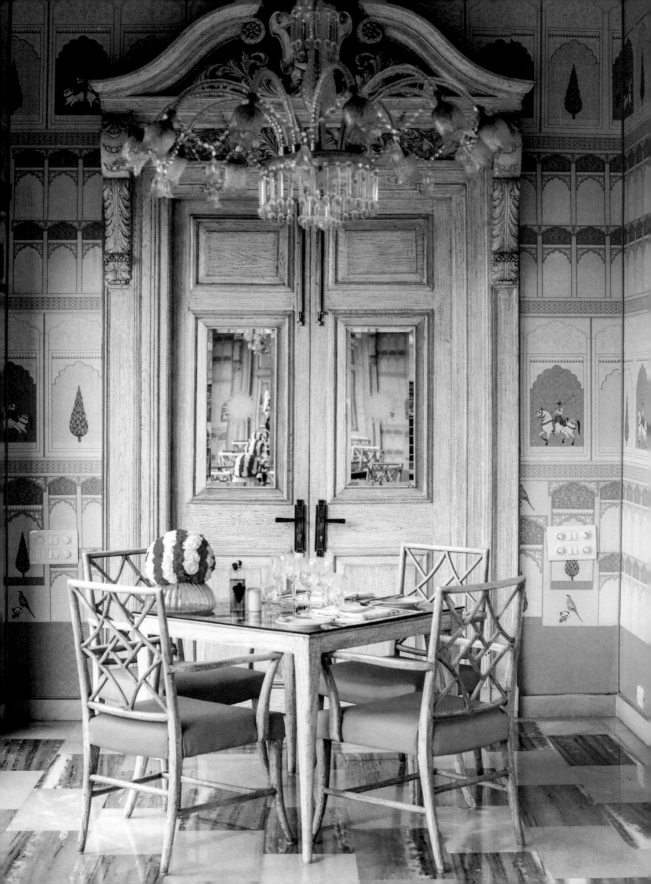

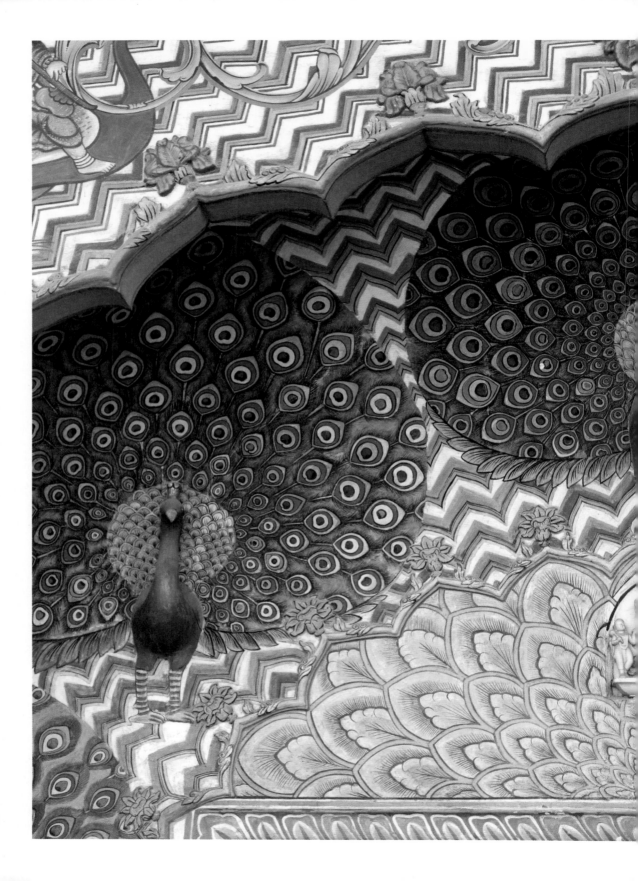

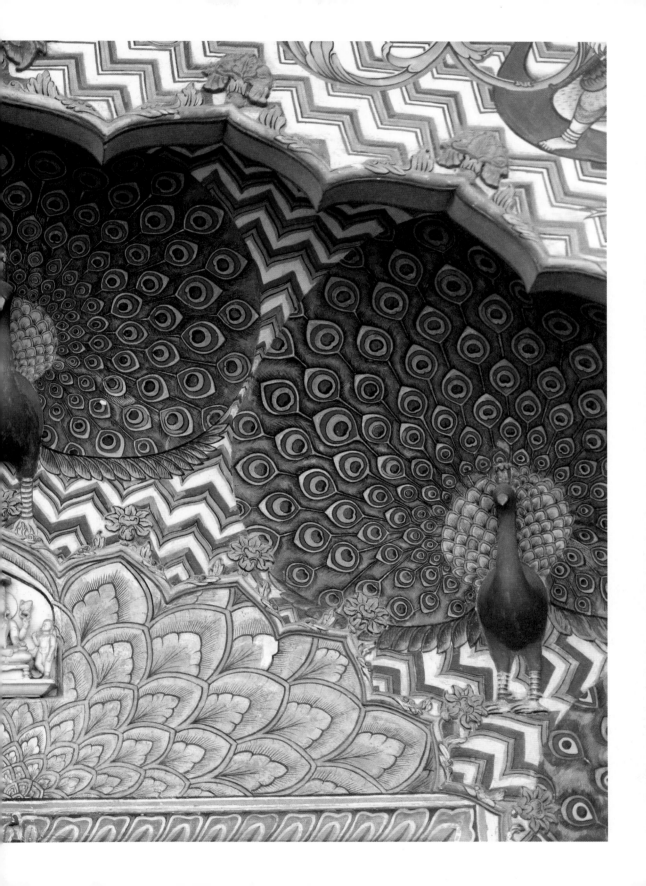

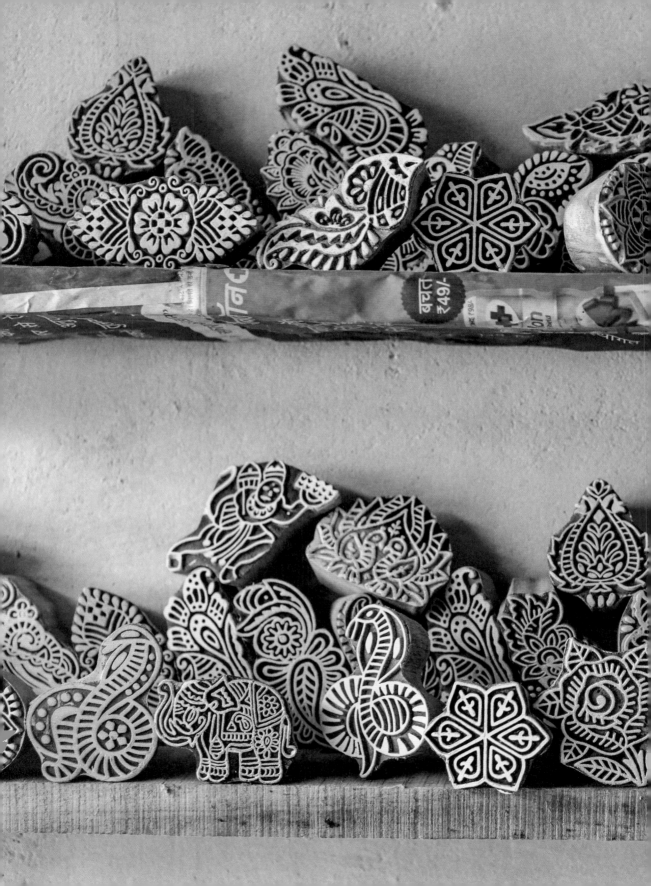

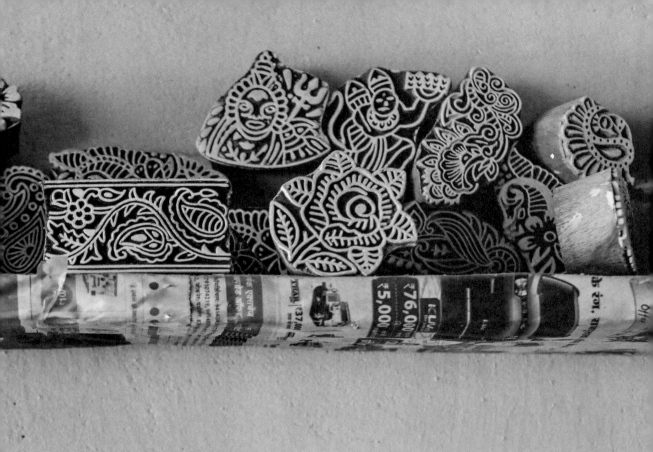
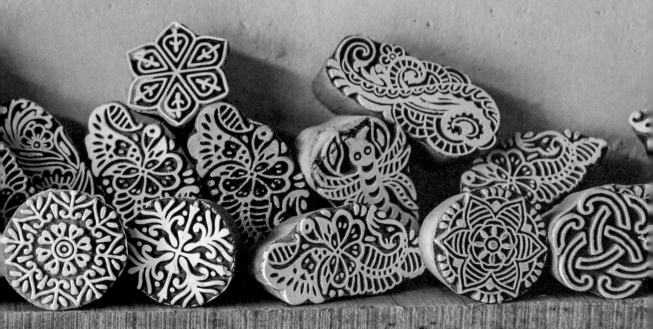

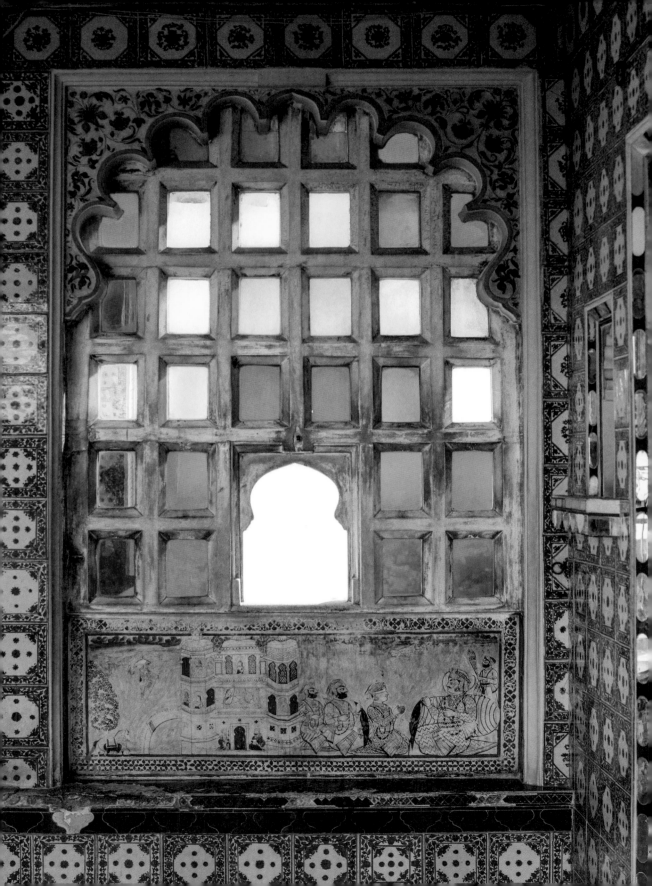

RESOURCES

•————————•

The following books have served as both references and inspirations
to my travels through India and this book:

Bhandari, Vandana. *Costumes, Textiles and Jewellery of India*.
London: Mercury Books, 2005.

Boo, Katherine. *Behind the Beautiful Forevers: Life, Death,
and Hope in a Mumbai Undercity*. Random House, 2014.

Caulfield, Fiona. *Love Jaipur, Rajasthan*. Hardys Bay Publishing, 2015.

Crill, Rosemary, ed. *The Fabric of India*. London:
V&A Publishing, 2015.

Gillow, John, and Nicholas Barnard. *Indian Textiles*.
London: Thames & Hudson, 2014.

Lahiri, Jhumpa: *Interpreter of Maladies*. Mariner Books, 2000.

Lahiri, Jhumpa: *The Namesake*. Mariner Books, 2004.

Mistry, Rohinton. *A Fine Balance*. McClelland & Stewart, 1995.

Ronald, Emma. *Balotra: The Complex Language of Print*.
Jaipur: Anokhi Museum of Hand Printing, 2007.

Roy, Arundhati. *The God of Small Things*. Random House, 1997.

Skidmore, Suki. *Hand Blockopedia*. Jaipur: Anokhi Museum
of Hand Printing, 2014.

Skidmore, Suki. *Sanganer: Traditional Textiles, Contemporary Cloth*.
Jaipur: Anokhi Museum of Hand Printing, 2009.

ACKNOWLEDGMENTS

Vijay, this book would not have existed—first in my imagination and now as a reality—without you. I owe you my deepest gratitude; you revealed to me the India that you love, in all her beauty and complexity. Your wisdom informs so much of what is written on these pages. Thank you for being my partner in adventure, travel, and life.

Meera, Vikram, and Vijay, I love you three more than I can express with mere words. You each live with passion, creativity, and wide-open hearts. My greatest joy in life is being your mother.

Mom and Dad, I have been endlessly supported by you both while undertaking this creative endeavor. I am so thankful to you two for lovingly taking care of the boys while Vijay and I traveled to Rajasthan to put the finishing touches on this book.

Liz Murray, you are the best travel companion we could ask for, and our memories of India with toddlers in tow will forever be associated with your good humor, generosity of spirit, and adventurous soul. Alva Cabrera, thank you for so lovingly caring for Meera while I put the finishing touches on this book.

We have been lucky to have the kindest, most knowledgeable guides during our India travels. Thank you to Manoj Sharma, Vineet Sharma, and Jeremy Fritzhand of Studio Bagru, for sharing your time and talents. Mona Singh Pancholi—thank you for your friendship and care.

I have been generously supported by an incredible team since the inception of this book. Thank you to Alison Fargis, for believing in me and understanding, from our very first conversation and every one since, the idea behind this slightly unconventional book; Toni Tajima, for your incredible work bringing my proposal to life; Amanda Englander, for your belief in and unwavering enthusiasm for this book, which gave me the courage needed to undertake this project; and Gabrielle Van Tassel, for keeping this project moving along so smoothly with your impeccable communication. The design team that brought this book to life has my deepest appreciation: thank you to Mia Johnson, for your immense design skills, and Stephanie Huntwork, for your vision and art direction. Thank you to the rest of the Clarkson Potter team for your hard work and support: Abby Oladipo, Heather Williamson, Kate Tyler, Jana Branson, Windy Dorresteyn, and Hannah Hunt. To Suki Skidmore: a huge thank you for so willingly giving your time and enthusiastically talking me through the details of block printing. To Dr. Vandana Bhandari: Your words open this book with such wisdom and beauty. Thank you for lending your expertise to this project.

Finally, I hope that anyone who travels to India does so with humility and an unwavering respect for her people and culture.

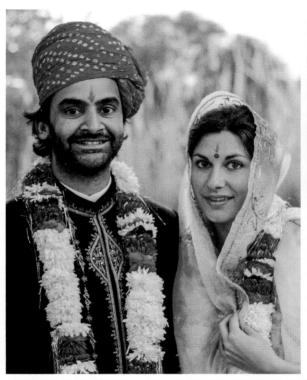

ABOUT THE AUTHOR

—◆—

Christine Chitnis is a photographer and writer. She lives
in Providence, Rhode Island, with her husband and
their three children, Vijay, Vikram, and Meera. You can
find her at christinechitnis.com.

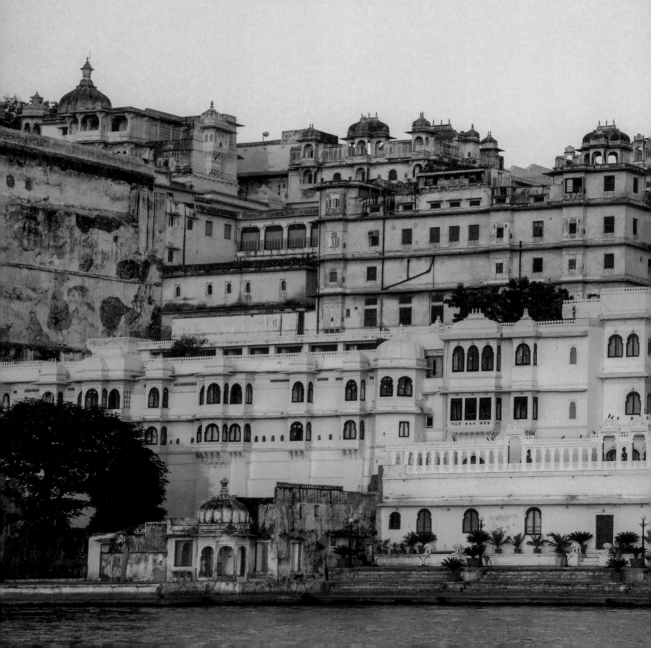

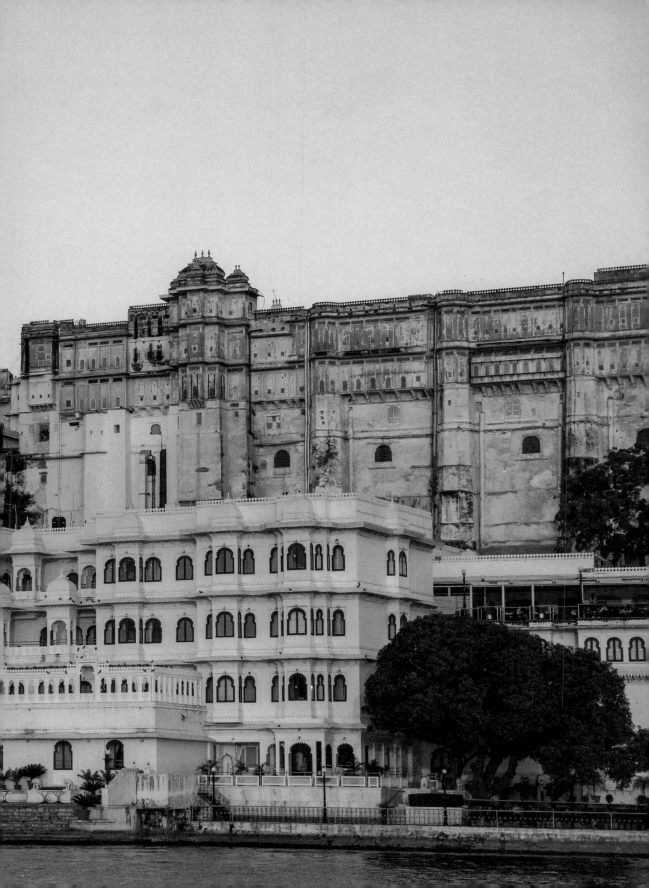

CLARKSON POTTER/PUBLISHERS

New York

clarksonpotter.com

Cover design by Mia Johnson
Cover photographs by Christine Chitnis